IMAGES
of America

HOWELL

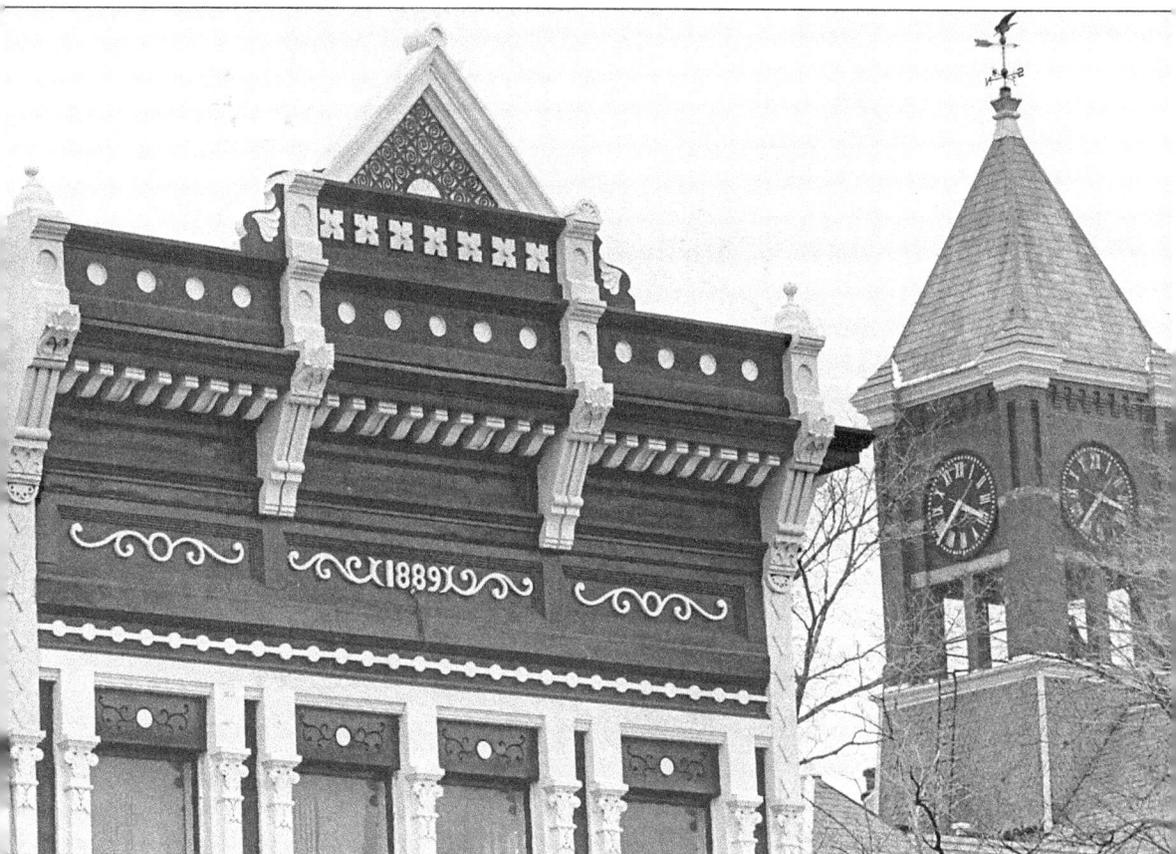

HOWELL'S VICTORIAN LANDMARKS. The Grand River Avenue skyline reveals many unique buildings. The iconic 19th-century Livingston County Courthouse, with it clock, bell tower, and weather vane, creates a single bold mark against the sky and is recognizable to all residents of the county. The 1889 structure to the left of the courthouse is adorned with an ornately decorated and detailed facade. The building's cornice is topped with a carved pediment and corners accented with finials. Through the decades, this building housed a jewelry store, drugstore, shoe store, and currently the local Dairy Queen. (Courtesy of Howell Area Archives.)

ON THE COVER: **POTATO SACK RACE ON GRAND RIVER AVENUE.** The annual county fair, homecoming activities, street fairs, and parades were all held at the end of summer. In this 1912 image, boys participating in a potato-sack race are hopping down the center of Grand River Avenue while spectators cheer them to victory. (Courtesy of Howell Area Archives.)

IMAGES
of America

HOWELL

David D. Finney Jr. and Judith L. McIntosh

ARCADIA
PUBLISHING

Published by Arcadia Publishing
Charleston, South Carolina

Library of Congress Control Number: 2013934481

For all general information, please contact Arcadia Publishing:
Telephone 843-853-2070
Fax 843-853-0044
E-mail sales@arcadiapublishing.com
For customer service and orders:
Toll-Free 1-888-313-2665

Visit us on the Internet at www.arcadiapublishing.com

*David D. Finney Jr. dedicates this book to his
children: Nancy, Benjamin, and David III*

Judith L. McIntosh dedicates this book to her daughter, Kristine

CONTENTS

Acknowledgments 6

Introduction 7

1. Founders and Pioneers 9

2. Street Scenes 17

3. Merchants of Howell 29

4. Keystones 49

5. All Roads Lead to Howell 65

6. Academics and Amazing Grace 79

7. Athletics and Recreation 89

8. Fairs, Festivals, and Parades 99

9. Clubs and Fraternal Organizations 109

10. The Bold Hearted 117

ACKNOWLEDGMENTS

Two local institutions, the Howell Area Archives and the Depot Museum, provided the majority of photographs, illustrations, and engravings for this publication. The writing and compiling of this book would not have been possible without the professional guidance of Joyce Fisher, director of the Howell Area Archives. She navigated the archives collection with great knowledge and skill while providing access to rare and scarce photographs, ephemera, genealogical files, newspaper clippings, and obituaries. Second only to the archives in providing historical photographs was Howell's Depot Museum. Judy Burns, director of the museum, provided an opportunity to view and scan numerous images in the collection. Joyce and Judy graciously provided their expertise, advice, and valuable time to help complete this Arcadia Publishing volume, which we acknowledge with great gratitude.

Furthermore, Sharon Fisher at the Howell Opera House provided various ephemera and a newly discovered photograph of the opera house. Richard and Mary Hutchins willingly granted us the opportunity to scan Civil War veterans' ribbons from their collection, which is appreciated. Mary Lou Hilton and Glen Fincham made available several photographs that are included in this publication, and Dave Getschman provided information regarding early firefighting equipment. The writing, editing skills, and valuable commentary of David's daughter, Nancy Finney, and her enthusiastic support of this project are also greatly appreciated.

Gratitude is expressed to many photographers, amateur and professional, who documented Howell's businesses, families, and religious, educational, and cultural institutions from pioneer days to the modern era. The majority of images in this volume were taken by unknown photographers, but there are two local photographers who deserve special recognition for their work. For several decades, W.E. Cleave captured the essence of 19th-century Howell. Cleave carried his camera equipment to the top of the old high school's 100-foot-tall tower and took many bird's-eye photographs of this community in the 1860s and 1870s. He also secured images of many fashion-conscious folks in Howell. Several photographs in this book reflect his work. Ed Beach, an amateur photographer, seemed to carry his camera with him on a daily basis. The images Beach captured of downtown businesses, merchants, social gatherings, and fraternal groups is unparalleled. The photographic collections of W.E. Cleave and Ed Beach at the Howell Area Archives provide priceless documentation of this community.

Unless otherwise noted, all the images in this Arcadia Publishing volume are from the Howell Area Archives and the Howell Depot Museum.

INTRODUCTION

Many early residents of Howell came from New York, Pennsylvania, and New England states, while other settlers arrived in the area from Canada, Scotland, Ireland, England, and Germany. These pioneers traveled to Michigan in the 1830s and 1840s, with some arriving by wagon and others via the Erie Canal, which was a primary conduit directing people to the state. Great Lakes steamers brought people from Buffalo to Detroit, where many continued their journey northwest to the area known as Livingston County.

Initially, the land in this region was considered too swampy to develop; however, it did not take long before word reached Eastern states that land in Livingston County was exceedingly attractive and desirable. Livingston Centre was the initial name of the community that later became Howell. In March 1836, it was selected as the county seat. It became the village of Howell on March 14, 1863, and was incorporated as a city in 1915.

Since the first settlers, Grand River Avenue has been the primary thoroughfare through Howell and continues as such today. The road evolved from a woodland trail to a dirt-and-gravel road and later to a heavily traveled modern highway. Principal merchants and businesses were established along Grand River Avenue. In December 1915, it was rumored that convicts from the Michigan State Prison in Jackson would be used as laborers to help pave Howell's central business district along Grand River. Prior to I-96, it was the primary road connecting Detroit to Lansing; Howell as the county seat was the most significant town through which Grand River passed.

Transportation was essential to the growth of Howell from early horse- and ox-drawn wagons to the Model T. Two railroads came through Howell and contributed to economic, agricultural, industrial, and population growth. On the south side of town, a depot was built for the Pere Marquette Railroad. Today, this is part of the CSX Transportation system. A depot for the Ann Arbor Railroad was also established on the north side of Howell. By the 1920s, occasional air traffic connected Howell to larger cities throughout Michigan.

Citizens of Howell always enjoyed parades, celebrations, and fairs. The earliest parade image is from Howell's Fourth of July Centennial Parade in 1876. Homecoming events and fairs were popular from the 1890s through the pre–World War I era. Floral parades were also a specialty during the 1890s, in which residents decorated horses, buggies, and eventually automobiles with flowers and bunting. Howell's main street, Grand River Avenue, was closed for annual street fairs, where one could watch acrobats, tightrope walkers, and even hot-air balloons ascend or observe daredevils parachute from gondolas. At the fairgrounds, horse racing was popular, and judges selected prize cattle, sheep, ducks, chickens, and geese. Buffalo Bill's Wild West Show, including Annie Oakley, appeared at Howell's fairgrounds on two occasions.

After the Civil War, Howell had become an agricultural center and was especially known for its sheep, dairy industry, and the popular Holstein-Friesian cattle. Local Holsteins established state and national records for production of milk and butter. Breeders from across the country came

to Howell to purchase stock for their herds. In the late 19th and early 20th centuries, Borden's Condensed Milk Company became one of Howell's largest employers.

Michigan obtained statehood in 1837, and that same year Howell's first school was built. Three marvelous cultural keystones were constructed in Howell in the late 19th and early 20th centuries: Howell's Opera House (1881), the second Livingston County Courthouse (1889), and the Howell Carnegie Library (1906). Three local newspapers were published in the 1840s and 1850s.

Small towns like Howell exhibited patriotism when the clouds of war appeared. Young men joined Michigan regiments to fight in the Civil War and the Spanish-American War. In the 20th century, Howell men and women again put on military uniforms and received training to fight in the world wars.

The images published in this Arcadia Publishing volume provide a glimpse into Howell's history from the 1850s to 1950s and reflect the spirit of early pioneer settlers. This book proves once again that a picture is worth a thousand words, and it provides snapshots of Howell's progress in civic, industrial, business, educational, religious, and social affairs. It is recognized that time soon erases what has gone before, and the past cannot be remembered for long unless there is a written and photographic record.

One

FOUNDERS AND PIONEERS

Pioneer families arrived in the Howell area in the 1830s and prepared the way for later settlers. They were trailblazers who went into unexplored territory in search of a new life, hoping to establish a permanent settlement. They possessed rugged individualism and were stalwart, hardworking, and resourceful. In the area adjacent to Livingston Centre, they discovered good forests and land that was quickly transformed into prosperous farms. This began a transition from wilderness to a surveyed, fenced, and populated region in a remarkably short time. The pounding hammers, the rasping saws, the squeaking wheels of horse- and ox-drawn wagons—the sounds of industry—were heard daily in the community. The pioneering spirit and entrepreneurial vision of those early settlers continued through the years and led to the growth and development of Howell.

Elisha Smith, who arrived here in the early 1830s, compiled the first *History of Howell* in 1868. In his publication, Smith identifies many of Howell's first settlers who provided names that decades later remain familiar in the county. Smith's listing includes the community's first physician, attorney, innkeeper, minister, and teacher. Of significance, two of the founders of the Republican Party were Howell residents. The following settlers were among the earliest pioneers to reside in the area: Amos Adams, David Austin, Icabod Kneeland, Henry and Garrett Lake, William McPherson, Solomon Pettingill, John Pinckney, James and George Sage, and Edward and Moses Thompson. The second wave of settlers helping to develop the village included Edward Gay, George Greenaway, Sardis Hubble, Josiah and George Jewett, George W. and Frederick Lee, Henry Tobias, Dr. Gardner Wheeler, Almon Whipple, and many others. In March 1863, Howell was recognized as a village, and in 1915 it incorporated as a city.

AMOS ADAMS'S EAGLE TAVERN. A true pioneer, Amos Adams constructed Howell's first building, the Eagle Tavern, which opened for business in December 1835. He was known as a hotel keeper and land surveyor. Adams also served as justice of the peace and county treasurer. His tavern provided space for public meetings and elections, religious services, school, and the post office. The tavern, located at the southeast corner of Grand River Avenue and Walnut Street, was destroyed by fire on September 28, 1857.

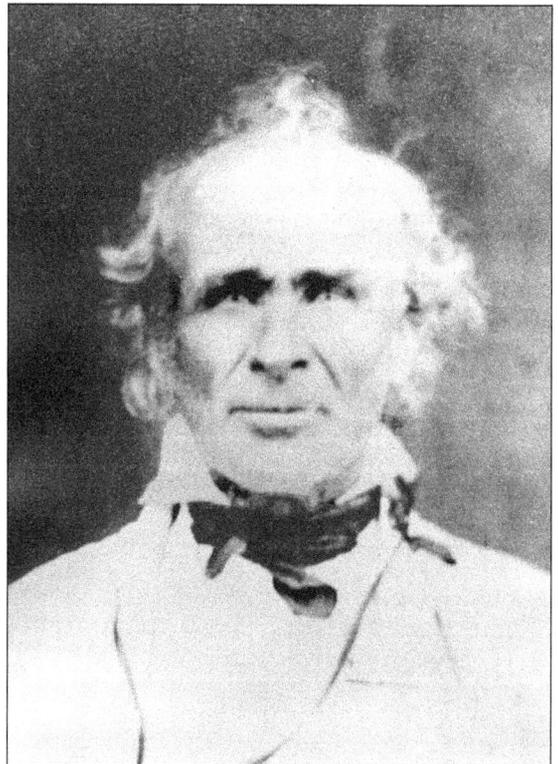

DR. GARDNER WHEELER (1794–1859). Dr. Wheeler settled in Howell in 1838 and was the first physician in the area. Wheeler practiced medicine in the community for more than 20 years. He served as the master of the Masonic Lodge, supervisor of the township, and due to his interest in education was appointed the school inspector. Dr. Wheeler died on January 11, 1859, and was buried at Lakeview Cemetery with Masonic rites and ceremonies. His son John A. Wheeler was the first medical student from the Howell area.

EDWARD F. GAY. A native of Connecticut, Gay settled in Howell in 1837 and became the first merchant in the community. In 1837, he erected, near the southwest corner of Sibley and Michigan Avenue, the second frame building in the village, which served as a dry goods and grocery store. At one time, his building contained a store, post office, lawyer's office, shoe shop, and tailor's shop. An ardent temperance man, in 1845 he constructed the first brick building in the community, the Temperance Hotel, directly across from the courthouse. His slogan was "Liberty and Temperance."

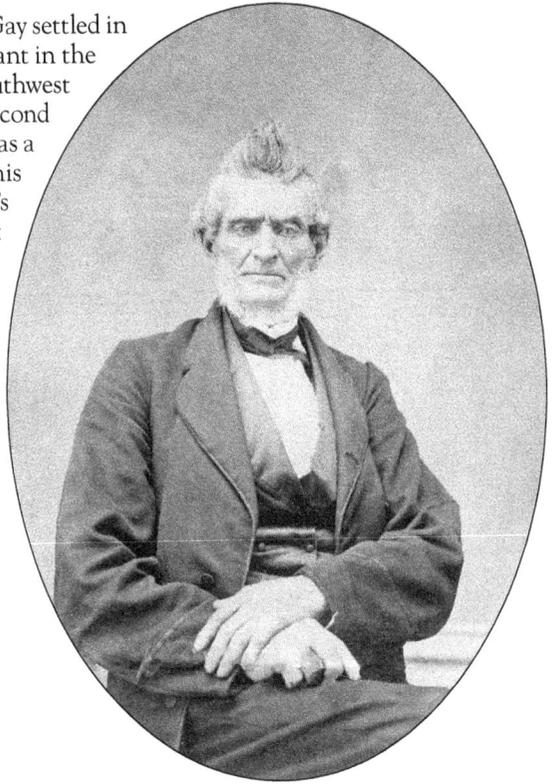

FREDERICK CURTISS WHIPPLE (1812–1872). A noted lawyer, Whipple migrated from Connecticut and settled at Livingston Centre in 1846. He also published a five-column newspaper, *The Livingston Courier*, the first paper in the county. Whipple served as a circuit court commissioner, prosecuting attorney, and judge of probate.

WILLIAM AND ELIZABETH RIDDLE MCPHERSON. After leaving their home in Inverness, Scotland, the McPhersons and their three children arrived in Howell on September 17, 1836. Elizabeth gave birth to six additional children, all born in the village. Adjacent to their log house, William operated a blacksmith shop. In 1843, he opened a general store that his family expanded and continued to operate until 1925.

HOME OF WILLIAM MCPHERSON JR. An engraving from Franklin Ellis's *Livingston County History* shows the beautiful home of William McPherson Jr., which was located on West Grand River Avenue. The family had become quite affluent from their successful business ventures.

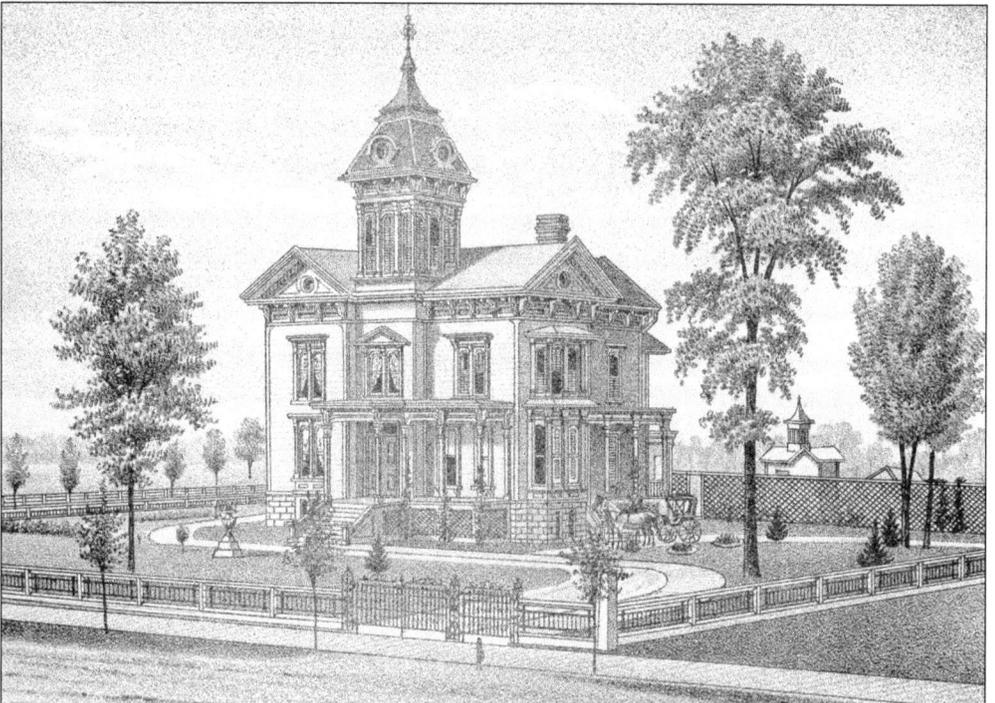

SARDIS HUBBELL (1820–1887). A Baptist, Democrat, and Mason, Hubbell was the first law student in the county. In the 1840s, he studied law in Wellington A. Glover's office and was admitted to the Michigan Bar in December 1846. In 1854, Hubbell established a successful legal practice. He was politically successful as a circuit court commissioner, prosecuting attorney, and in 1850 as a state legislator. On May 4, 1863, Hubbell was elected as Howell's first village president.

SARAH CORLIN HUBBELL. This carte de visite image of Sarah Hubbell was taken in the 1860s. She was elected president of the Ladies' Library Association in 1879 and was active with Howell's Women's Club.

MILO LEE GAY (1825–1884). Frederick Whipple invited Milo Gay to study law with him. Admitted to the bar in 1853, Gay established his business in the field of real estate and loans. He served as Howell's supervisor, clerk, justice of the peace, village recorder, and president. In the 1860s and 1870s, Gay represented Howell in the state legislature, serving in the Michigan House of Representatives and Senate.

MILO AND HARRIET GAY'S HOME. In 1880, Franklin Ellis published this steel engraving of Gay's home on West Grand River Avenue in his *Livingston County History*. It is evident that Gay's success in law, business, and political endeavors provided affluence for his family.

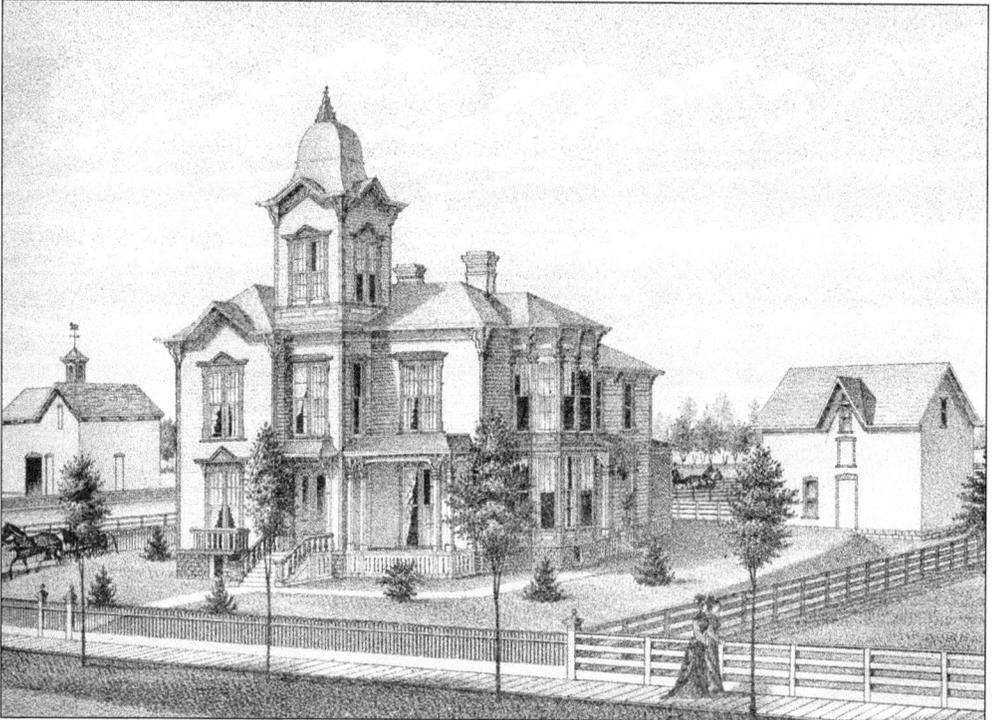

JOSEPH T. TITUS (1820–1908). Well known as a journalist and publisher in Jackson, Michigan, Titus moved to Howell and established the *Livingston Democrat* in August 1857. This publication continued until February 1899. He was a staunch advocate of the Democratic Party and a devoted member of the Freemasons.

HENRY H. HARMON (1823–1884). Born in Manchester, New York, Harmon came to Howell as a schoolteacher. He studied law and was admitted to the Michigan Bar in 1849. Harmon served as prosecuting attorney in 1854 and was judge of probate in 1864. He practiced law in the county for 35 years.

15

FREDERICK J. LEE. Frederick Lee and his brother George W. Lee settled in Howell in 1836. They started a mercantile business, mill, and newspaper and constructed several buildings in the business district. Frederick and his brother were active in the founding of the Republican Party, and during the Civil War Frederick was deputy US marshal and revenue collector for six counties.

POSTMASTER. Frank Wells was appointed postmaster serving from February 1855 to 1866. During his tenure, the post office was located in a local drugstore. Wells was active in Masonic affairs and during the Civil War was elected as worshipful master of Howell's Lodge from 1861 to 1863.

16

Two

STREET SCENES

Strolling the streets of Howell in the late 1800s and early 1900s, one would have enjoyed the sights—it was truly a vibrant and busy place. Howell had several hotels, two railroads, saloons, flour mills and sawmills, a cigar factory, clothing and hardware stores, restaurants, a library, and an opera house. It appeared a very cosmopolitan place and was a rapidly growing community.

Businesses lined the north and south sides of Grand River Avenue. Its intersection with Michigan Avenue (previously known as East Street and later Division Street) created the main four corners of the town. Two- and three-story brick buildings were constructed and quickly rented to enterprising entrepreneurs.

The emergence of railroads and the automobile brought Howell new forms of transportation and also new businesses and manufacturing opportunities that engendered and have had a lasting effect on the city. Horses and wagons had to share the road with motorized vehicles. A multitude of economic opportunities provided growth and prosperity for the village as it continued to expand.

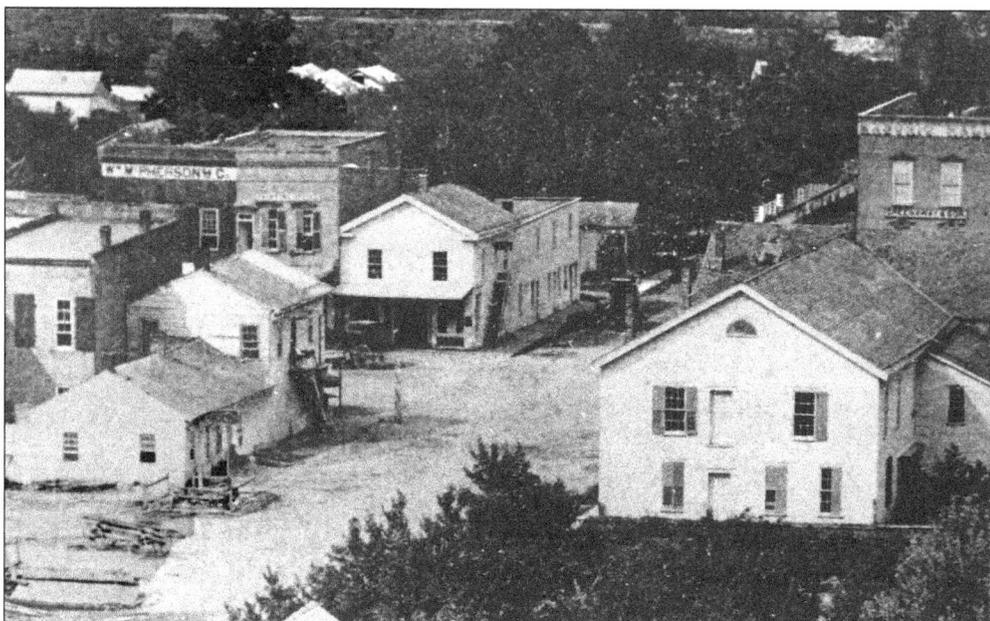

THE MAIN FOUR, C. 1870. One of the earliest photographs of Howell was taken from the tower above Central High School. This image looks north toward the main intersection of Grand River and Michigan Avenues. The McPherson Building is identified on the left, and to the right of it is a printing office. Located on the right is a three-story brick building identified as Greenaway and Son and signage identifying the Masonic hall.

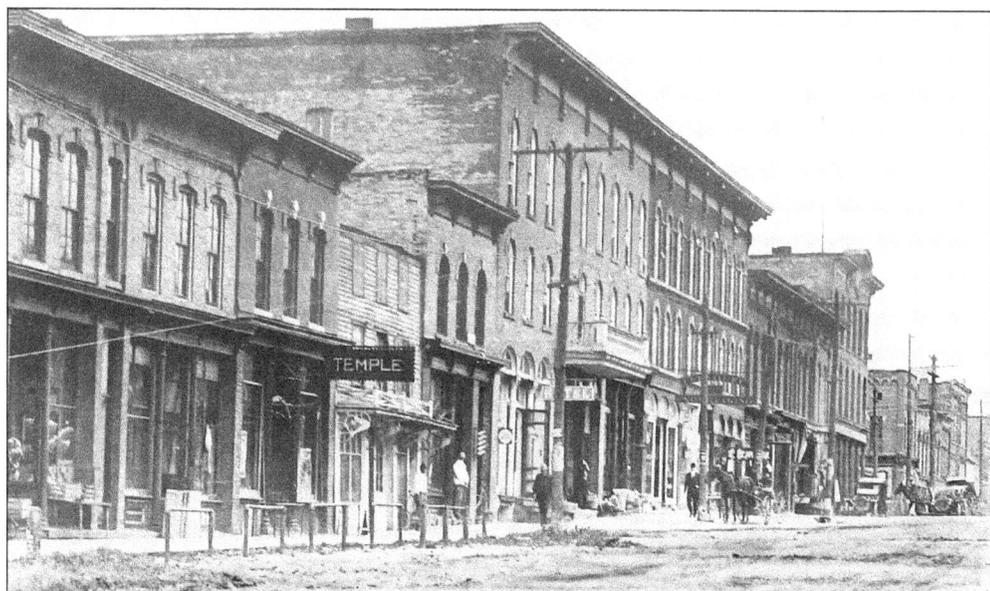

EAST GRAND RIVER BLOCK. Looking west along Grand River Avenue, this revealing 1900 image shows the south side of East Grand River Avenue. It has not yet been paved, and hitching posts are located along the main street to secure horses and buggies. During the day, a teamster with a water-tank wagon sprinkled the streets in front of the stores to help control dust. Three large watering troughs for horses were placed in the central business area. Across from the county courthouse was a town pump complete with a tin cup to provide folks with a source of drinking water.

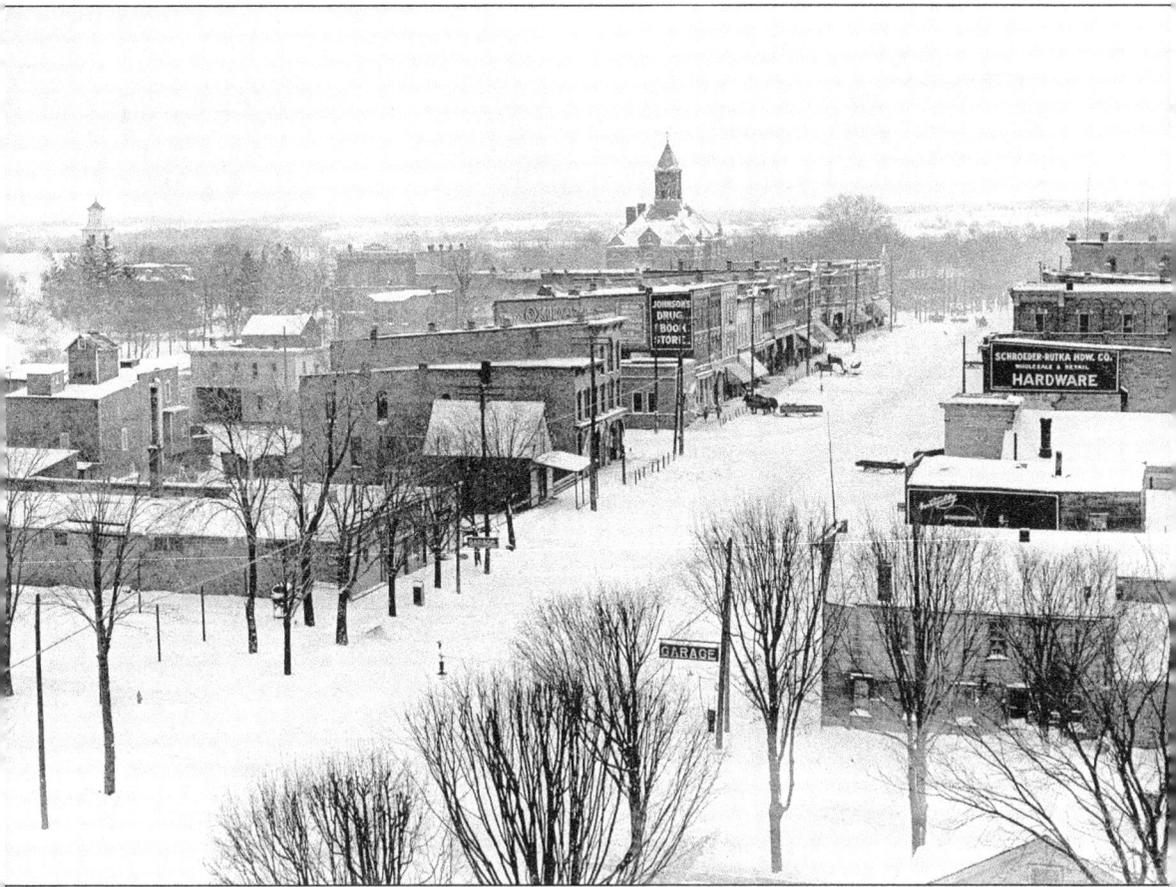

Tranquil Winter Scene. The magical beauty of new-fallen snow blankets old Howell in this winter scene. An advertisement for a hardware store is emblazoned on the side of a building. On the distant horizon, the clock and bell tower of the Livingston County Courthouse point skyward, and several horses and wagons are tied to hitching posts along Grand River Avenue. This c. 1910 image looking east on Grand River Avenue was photographed from the belfry of the First Presbyterian Church of Howell. The horses pictured are wearing winter blankets and pulling wagons converted to sleds and sleighs.

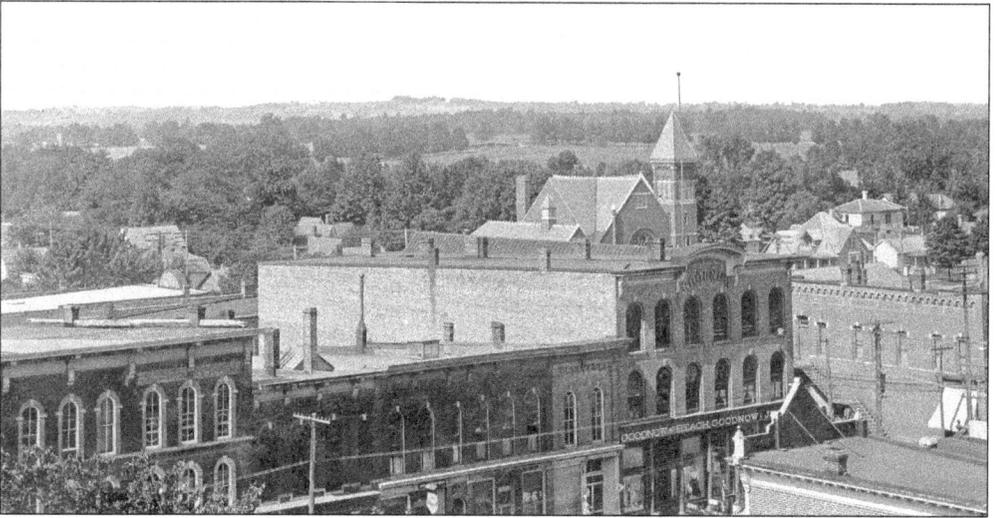

ROOFTOP VIEW. This image, taken from the courthouse clock tower, provides a southwesterly view of several stores along Grand River Avenue. Included in the photograph are the Goodnow Building, the First United Methodist Church of Howell, and the distant countryside.

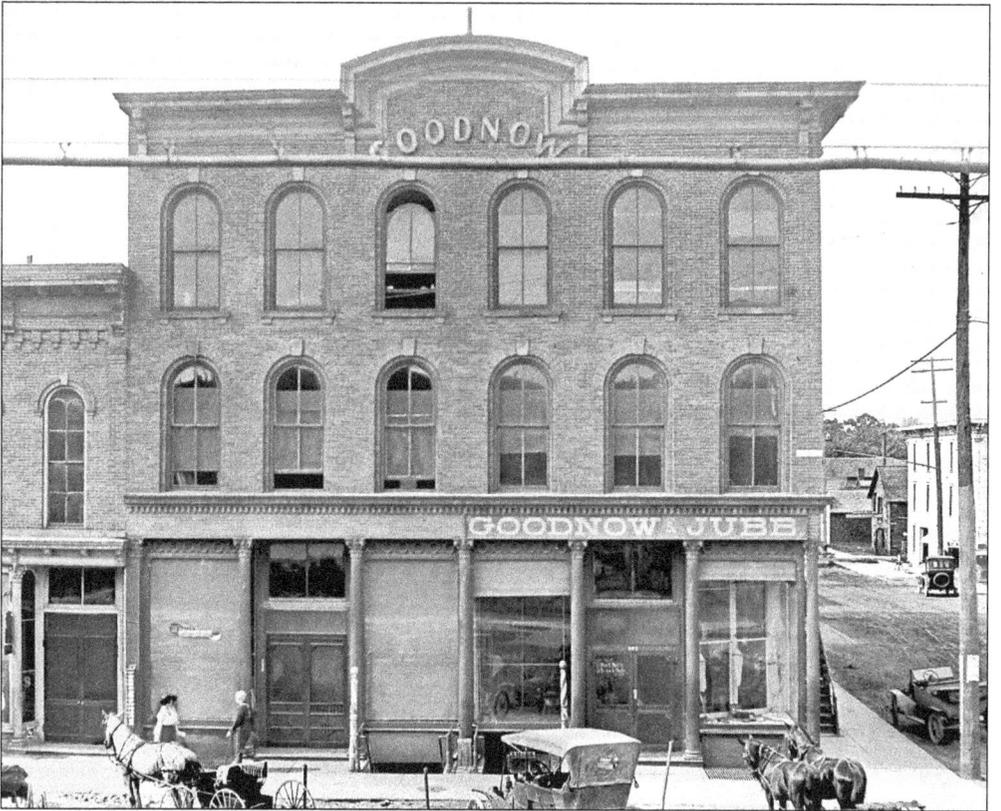

GOODNOW BUILDING. This c. 1915 photograph shows Goodnow & Jubb's hardware store. The men were dealers in general hardware items, including stoves, ranges, furnaces, oils, paints, wire, fencing, and plumbing. The building, located at the corner of Grand River and Michigan Avenues, is currently the First National Bank of Howell.

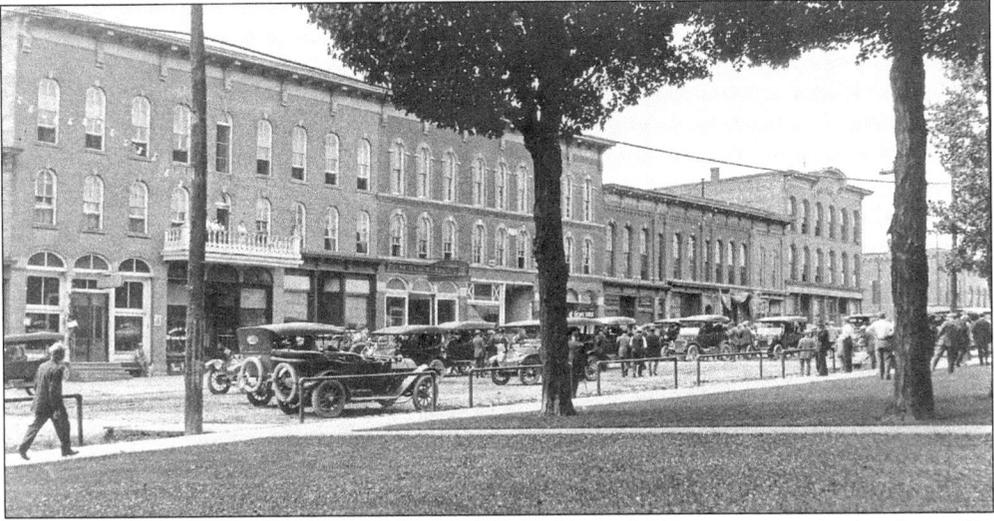

PHOTOGRAPH FROM THE COURTHOUSE LAWN. The summer of 1915 saw increased vehicular traffic on Grand River Avenue. Cars are parked in the middle of the street, while pedestrians watch from the sidewalks and a hotel balcony. Hitching posts are located along the sidewalk for horses, and Grand River Avenue has not yet been paved.

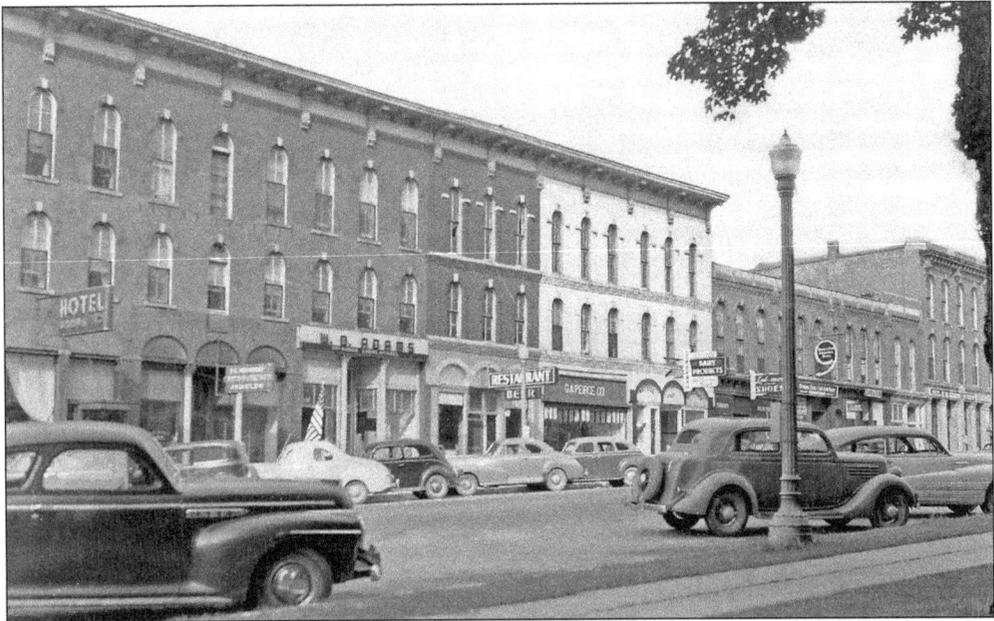

SAME VIEW, 1940s. This was taken from almost the identical spot as the previous photograph but 30 years later. A contrast of neon signs advertising businesses, automobiles, street lighting, paved roads, and sidewalks are visible in this image and show the rapid change technology and industry brought to the community.

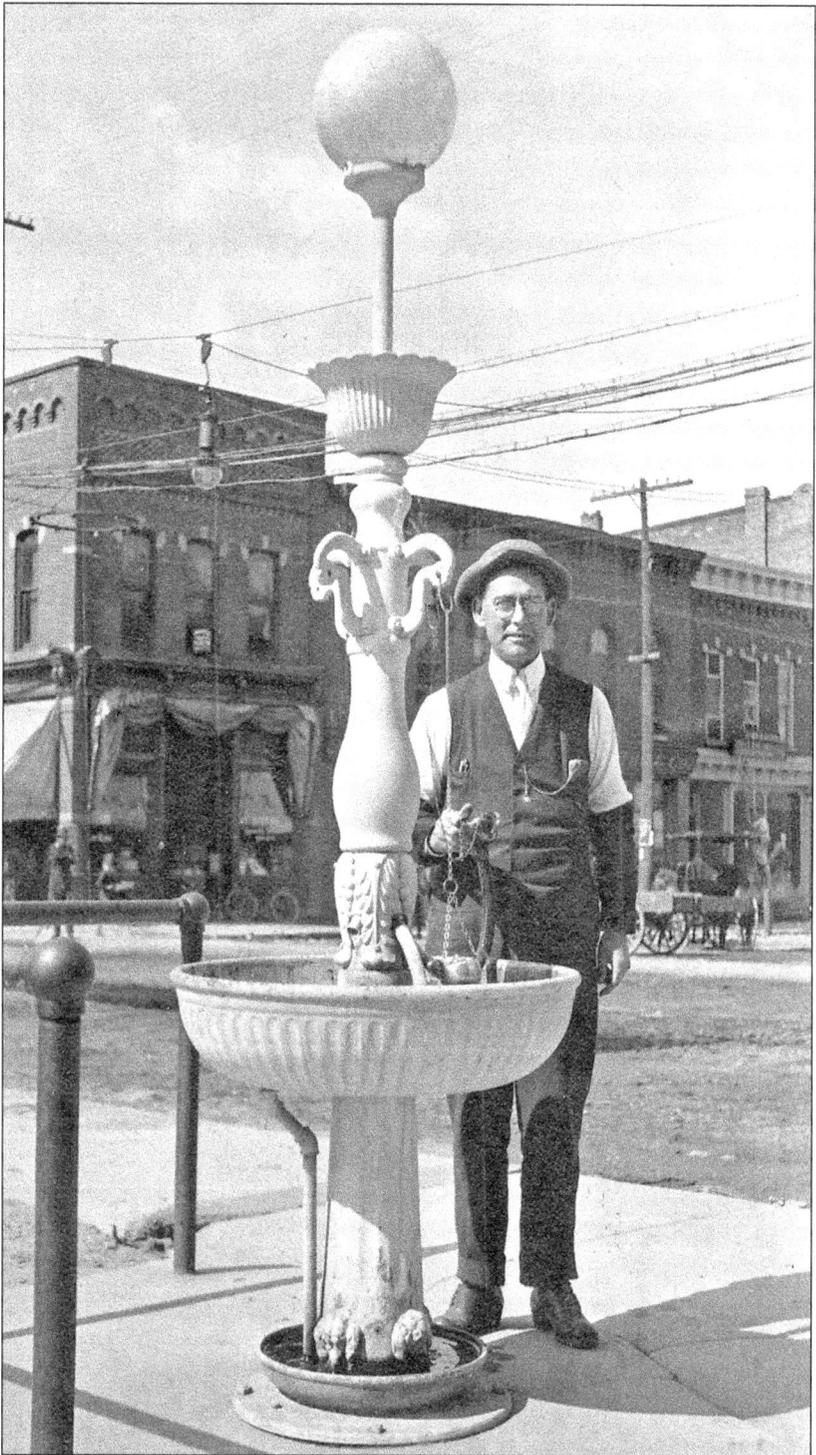

PUBLIC DRINKING FOUNTAIN. This summer image, taken around 1912 by Roy Newcomb, provides a view of John Hamilton with a ladle in hand as he dips for a refreshing cup of water from the public fountain. This fountain was on the corner of Grand River and Michigan Avenues.

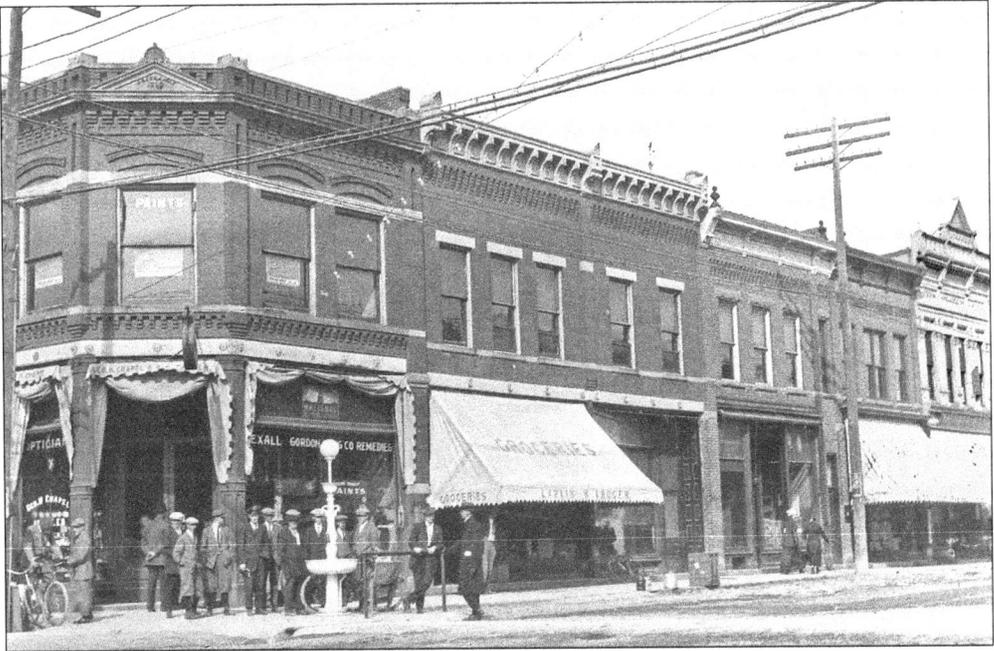

HOWELL'S MAIN FOUR, C. 1914. A group of gentlemen has gathered at Howell's main four corners, the intersection of Grand River and Michigan Avenues. The men stand in front of a Rexall Drug store next to the community drinking fountain, which contained four attached cups for the use of all thirsty people. A hitching post is adjacent to the fountain.

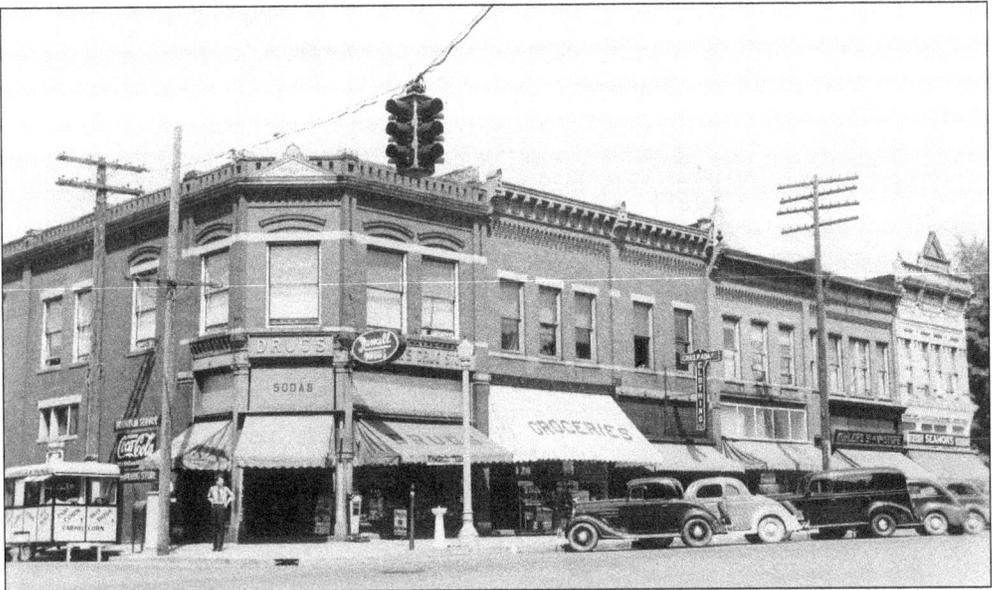

HOWELL'S MAIN FOUR, 1936. In contrast to the previous image, Henderson's hot dog, popcorn, and caramel corn wagon is located at the corner of Grand River and Michigan Avenues 22 years later. Notice the angled parking along the north side of Grand River. Near the entrance to the Rexall Drug store are a 1¢ weight scale and public drinking fountain. The drugstore offered fountain service Coca-Cola and other sodas. Adjacent businesses included a grocery and Chas. P. Adams Clothing store.

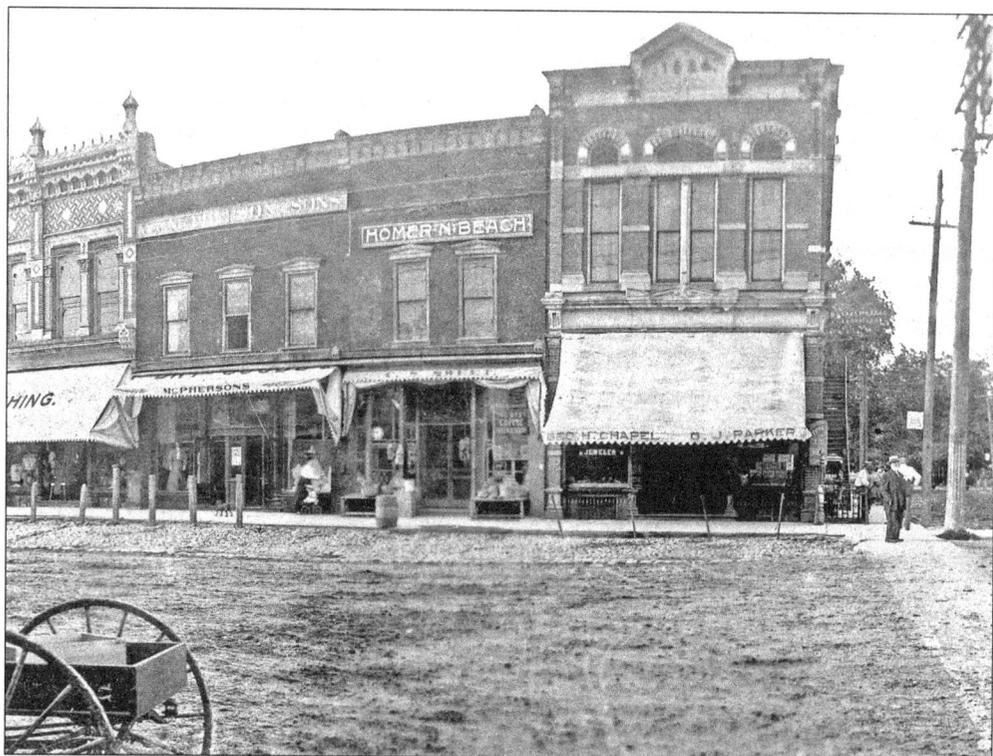

NORTH SIDE OF GRAND RIVER AVENUE, PRE-1915. This scene shows several businesses, including the 1886 building at the northwest corner of Grand River and Michigan Avenues that housed Chapel's Jewelry; Homer Beach, C.S. Sweet, and McPherson and Sons are adjacent. Electricity has arrived, but the roads are still dirt.

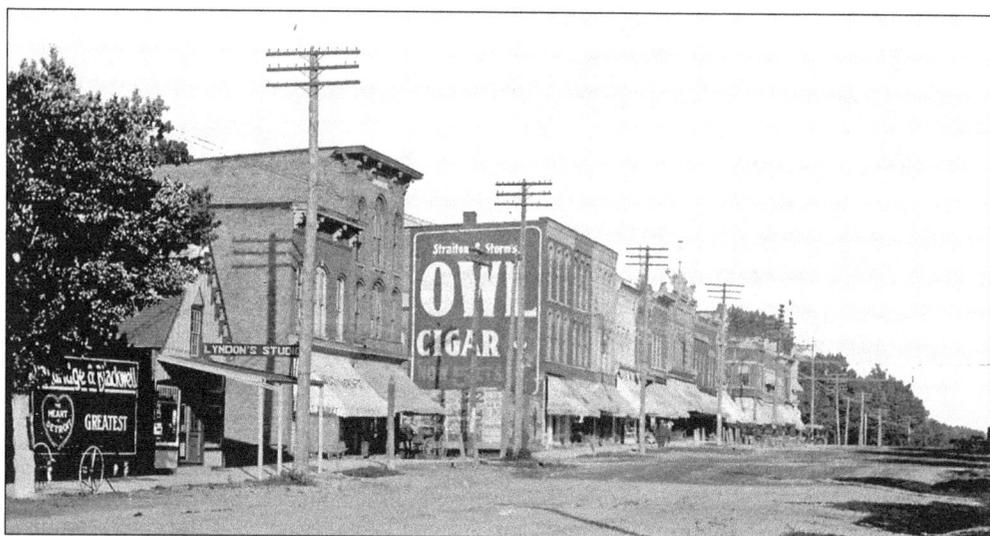

OWL CIGARS, BEFORE 1915. This image faces east on Grand River Avenue toward the north side of the street. Lyndon's Photographic Studio, a meat market, and Straiton and Storm's Owl Cigar signage are prominent. In the distance is the McPherson building.

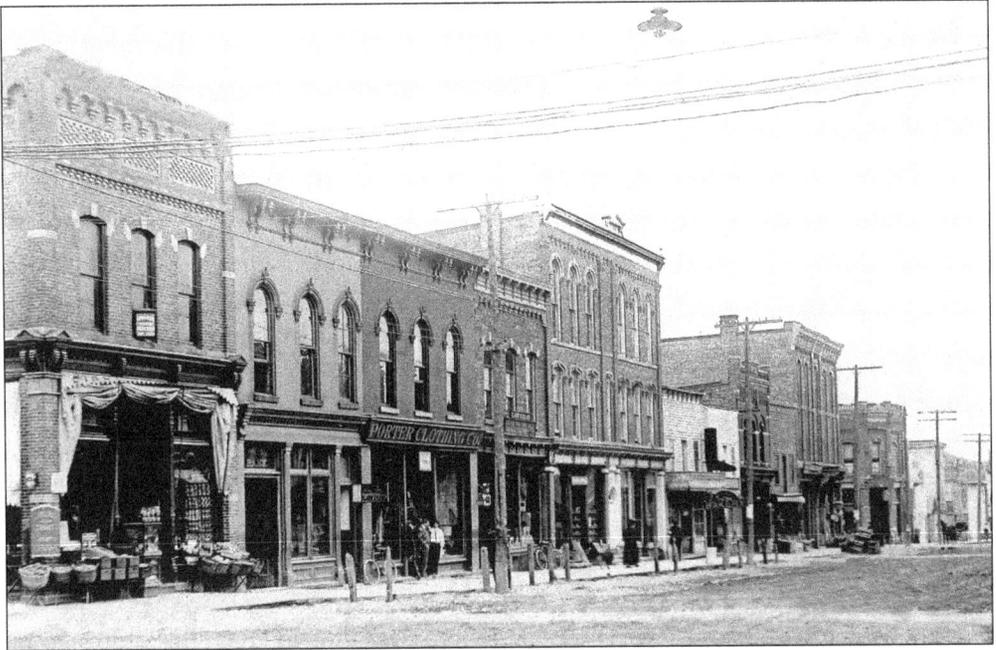

SOUTH SIDE OF GRAND RIVER AVENUE. This is a pre-1915 view down the street toward the Opera House. Located along this block are a grocery store, bank, Porter Clothing Company, a cigar and tobacco factory, a boot maker's shop, and an electric light hanging in the intersection.

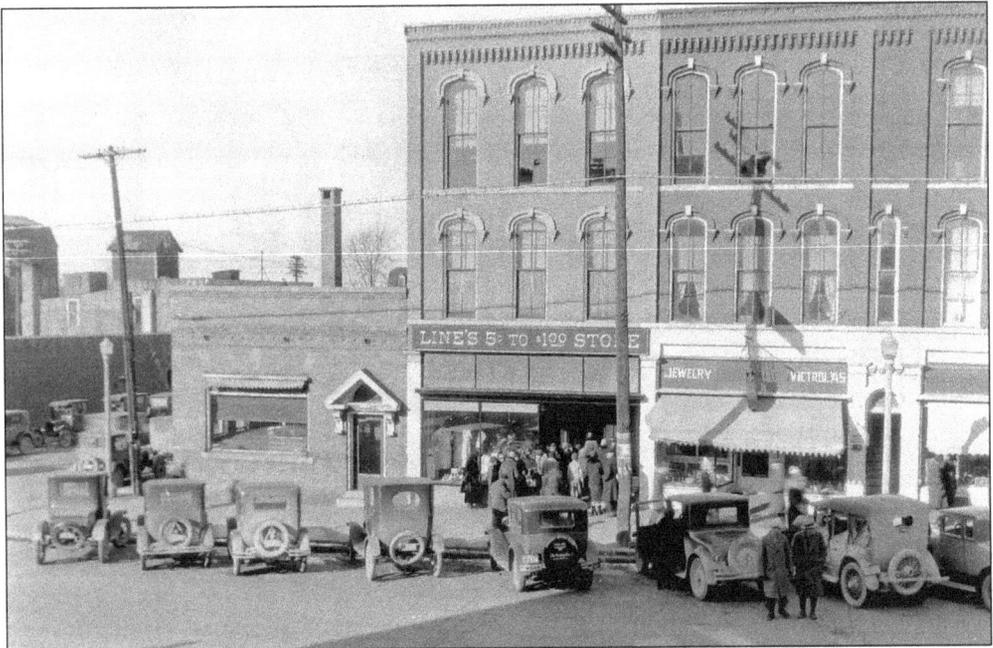

THE OLD LINE DOLLAR STORE. Customers are waiting to enter Line's store to purchase sale items. In this late-1920s image, the cars are parked at an angle on Grand River Avenue. Behind the McPherson Oil Company building in the upper left is one of Howell's flour mills.

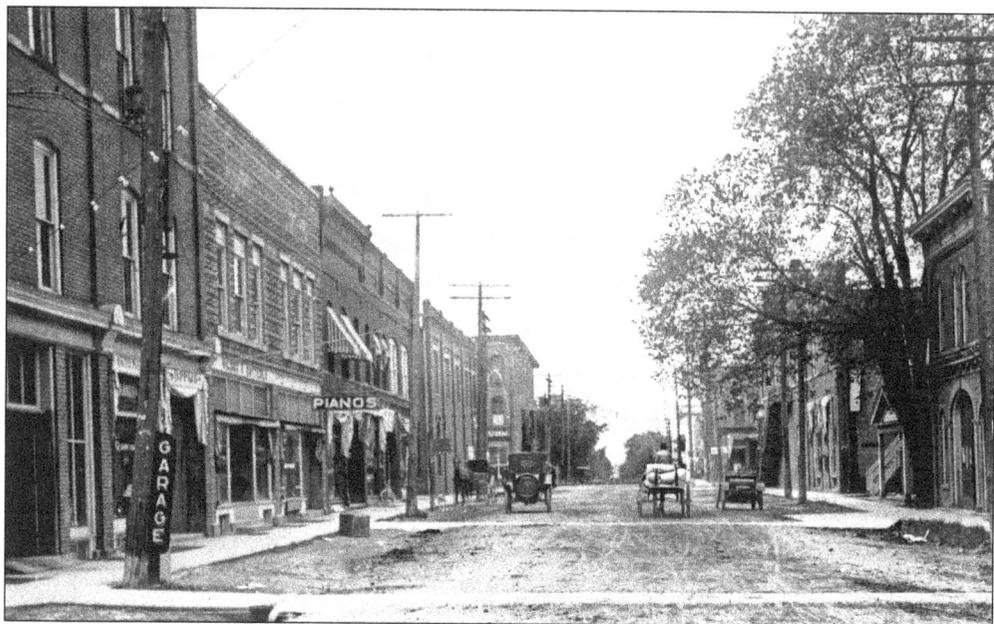

CORNER OF CLINTON STREET AND MICHIGAN AVENUE. Looking south on Michigan Avenue sometime before 1915, cars share the road with horses and wagons. On the east side of the street is a garage and music store. The fire station is located on the west side.

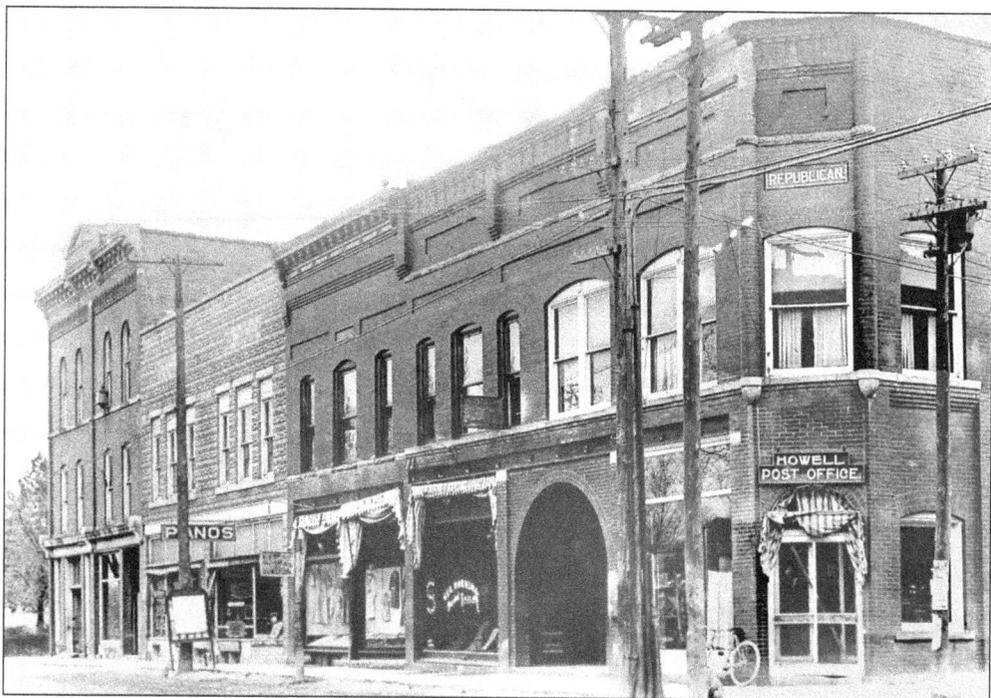

NORTH MICHIGAN AVENUE, PRE-1915. The post office and the *Republican* newspaper shared the building on the right. A tailor's shop, physician's office, piano store, and Masonic building are on the east side of the street.

STRINGING LINES. Winter's snowy weather in 1913 did not stop these linemen from ensuring that Howell's citizens had electricity and telephone service. Dressed for frigid weather with warm hats, clothing, and gloves and boots, these men have climbed telephone poles along north Michigan Avenue.

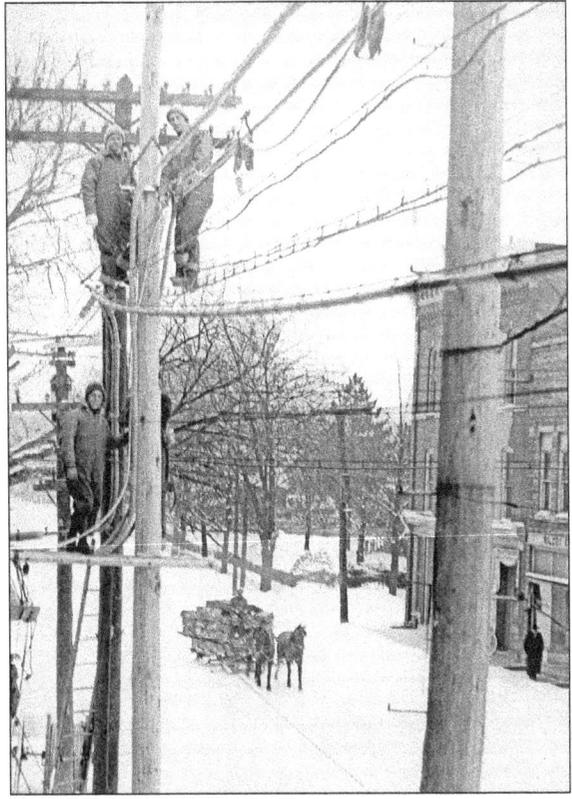

GRAND RIVER AVENUE AND STATE STREET, JUNE 22, 1932. The buildings at the corner of Grand River Avenue and State Street that are identifiable businesses include Monroe and Newcomb's Florsheim Shoe Store and Richard's Electric.

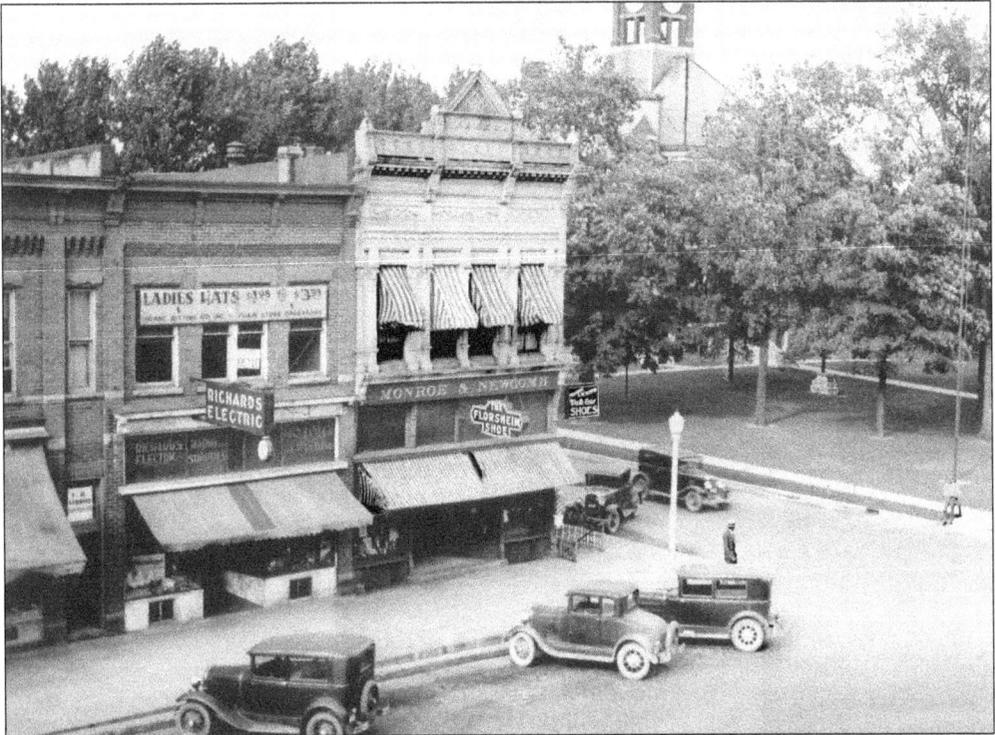

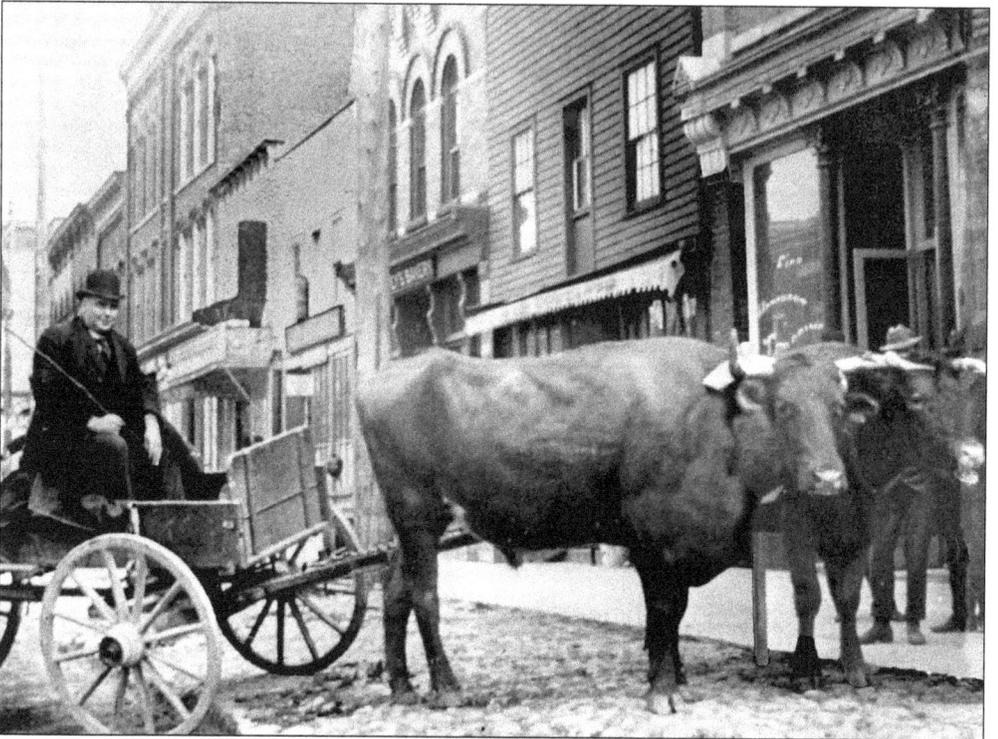

OXEN AND WAGON. This c. 1900 image shows oxen and a wagon parked on cobblestone streets in front of the Howell Opera House. Hovey's bakery and a boot maker's shop are seen in the left background.

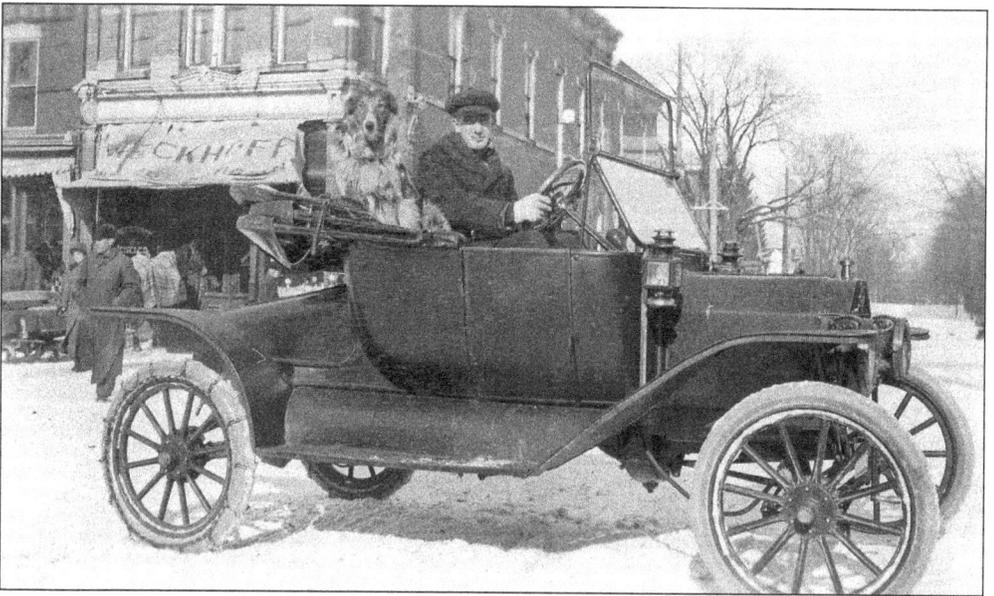

EARL SHARPE AND HIS DOG. R. Bruce McPherson sold this 1914 Ford Model T to Earl Sharpe, a test driver for REO Oldsmobile in Lansing. Sharpe was a real estate salesman, chauffeur, and groundskeeper for Alice McPherson Spencer. Sharpe served for 25 years as chief of Howell's volunteer fire department. His car has snow chains on the rear tires.

28

Three

MERCHANTS OF HOWELL

The post–Civil War years witnessed rapid growth for Howell's business and industry. It was accelerated by the construction of railroads into Livingston County and specifically through Howell, which opened the area to an increase in population and new businesses as well as agricultural and industrial expansion.

Historically, the two major streets in town are Grand River Avenue and Michigan Avenue, with commercial buildings erected along them. This was also true around the courthouse square, where businesses known as "Peanut Row" were constructed. In the late 19th and early 20th centuries, a cornucopia of enterprises existed in town. In each store, a tapestry of merchandise was available to the consumer. The central business district included a bakery, restaurants, hotels, taverns, billiard parlors, blacksmiths and harness shops, butcher shops, clothing stores, millinery and shoe stores, furniture stores, flour mills and sawmills, grocery stores, tobacco shops, hardware stores, wagon shops, and a foundry.

After the introduction of the internal-combustion engine, automobile dealerships, garages, and gas stations opened in the community. Several hardware stores sold stoves, farm implements, fencing, plumbing, wire, paints, brushes, garden tools, and nuts and bolts. Millinery stores stocked and sold a variety of fabrics, including calico, brocade, wool, cotton, and linen. At different outlets, a person could obtain custom-made or ready-to-wear clothing. There were three tailors in town, as well as several cobblers and boot makers. At the butcher shops, beef, lamb, poultry, and fish were available, and during holiday seasons residents could even purchase oysters. It appeared Howell's merchants had access to a seemingly inexhaustible supply of consumer goods.

At the beginning of the 20th century, Howell was a vibrant, busy, colorful, and friendly town. In 1915, its slogan was "Howell, the City of Homes," and in 1930 the city slogan became "Howell, the City Beautiful."

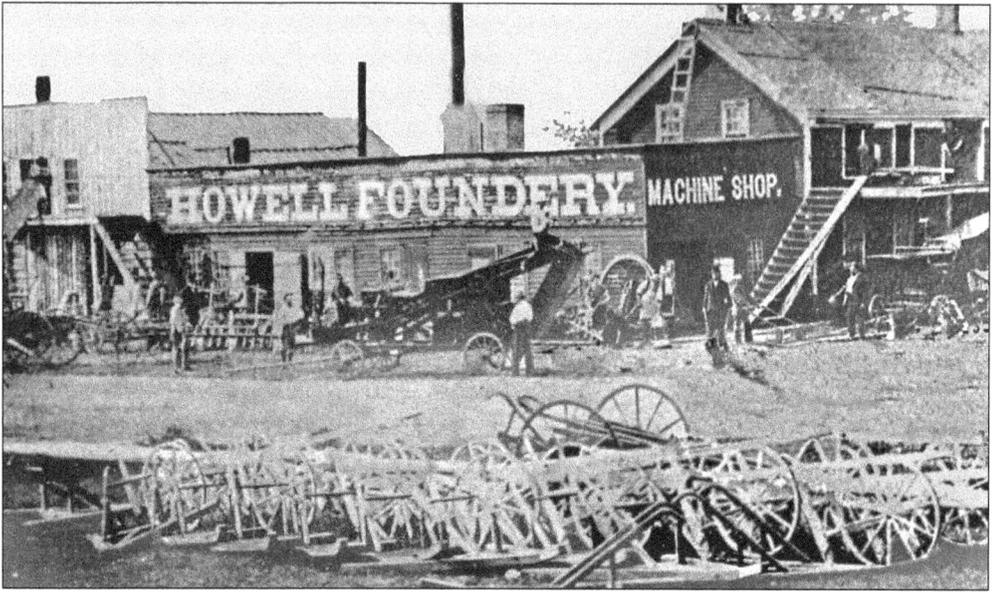

HOWELL FOUNDRY AND MACHINE SHOP. In 1849, Stephen Clark built a foundry on the north side of Grand River Avenue and west of Center Street. In 1859, George W. Taylor and George L. Clark became proprietors of the property. In 1864, Taylor sold his interest in the property, and John Galloway became Clark's partner. In the spring of 1867, Floyd Wykoff and Hudson B. Blackman joined the firm. The foundry was known for manufacturing agricultural castings and implements and stoves. In 1867, the plant, the most important manufacturing enterprise in Howell, was purchased by Josiah M. Clark. It did general iron and wood manufacturing, and its trade in the Howell handcar and tubular axel wagon was extensive. In 1903, these buildings were torn down to clear the square for the Carnegie library.

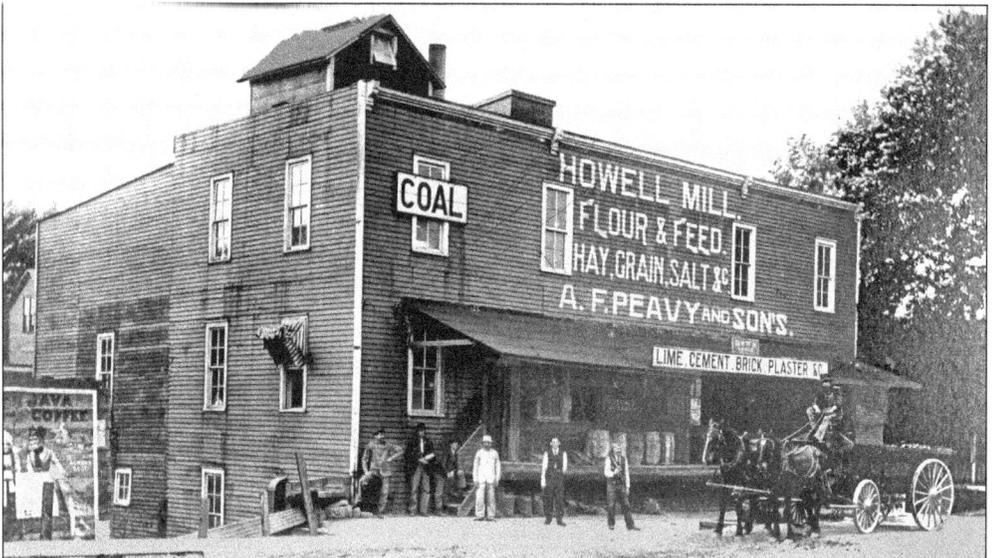

PEAVY'S MILL. This mill was located on North Walnut Street near the Ann Arbor Railroad depot. Adelbert F. Peavy, who had been a bugler and courier in the 10th Michigan Cavalry, purchased the mill in 1905 and specialized in flour, feed, hay, grain, salt, and coal. With the help of his sons Homer and Calvin, he operated the business until his death in 1921.

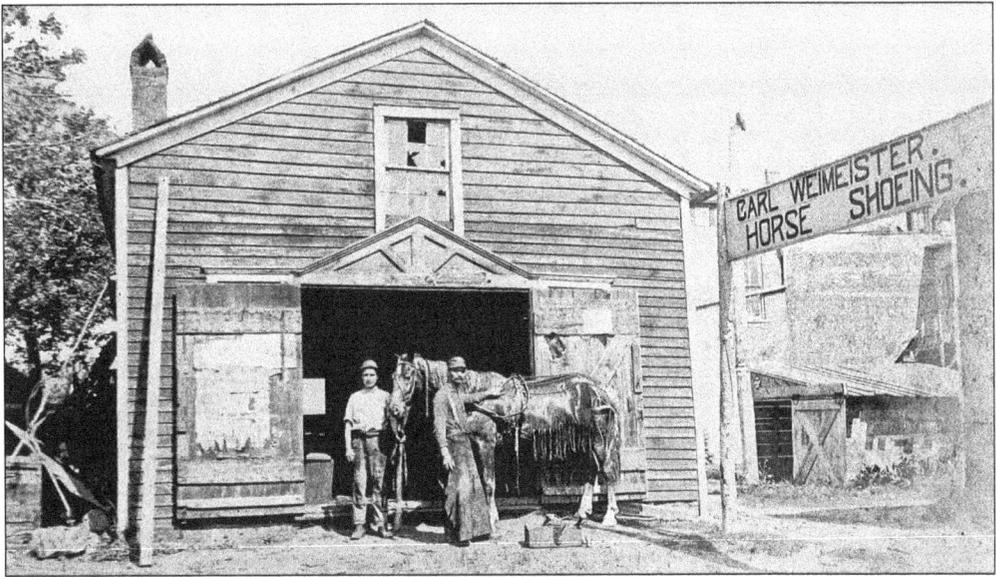

BLACKSMITH'S SHOP. Carl Weimeister, a blacksmith, located his shop near the old Ten Cent barn and close to the Ann Arbor Railroad depot. He shoed horses and mules and repaired buggies and wagons, preparing them for service. He also loaned, boarded, hitched, and rested horses and mules. Almost every 19th-century town had a blacksmith shop and stable, much like today's gas stations and garages.

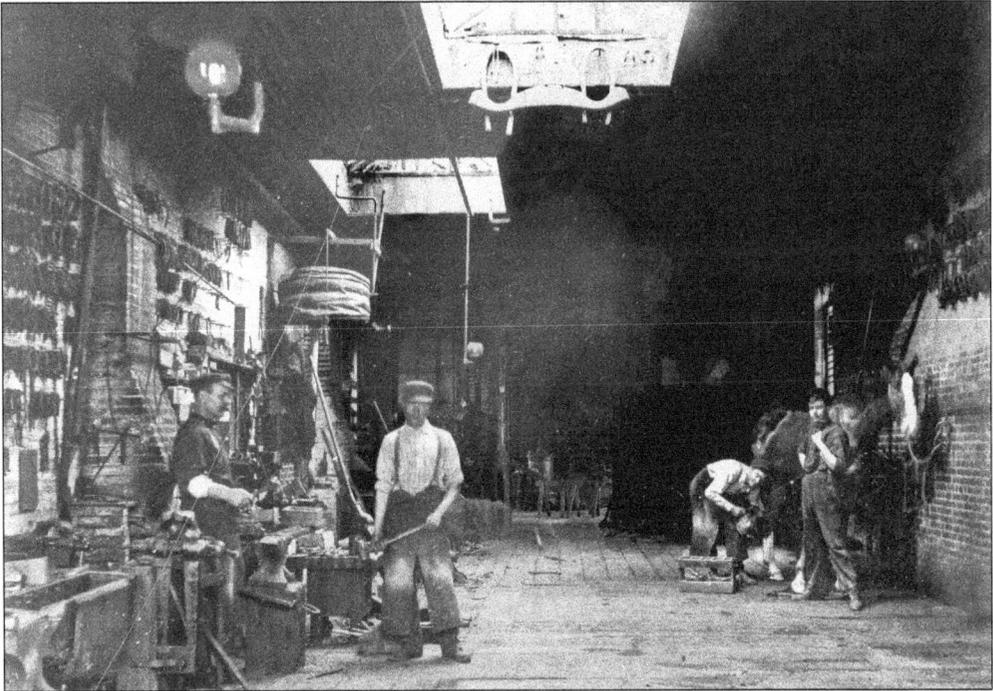

INTERIOR OF WEIMEISTER'S BLACKSMITH SHOP. This image reveals a smith at the anvil on the left and two men shoeing a horse on the right. In the upper left, a gaslight hangs from the ceiling, and below the skylight an oxen yoke is visible. Blacksmiths made iron shoes used to protect hooves, and farriers fit them to each animal.

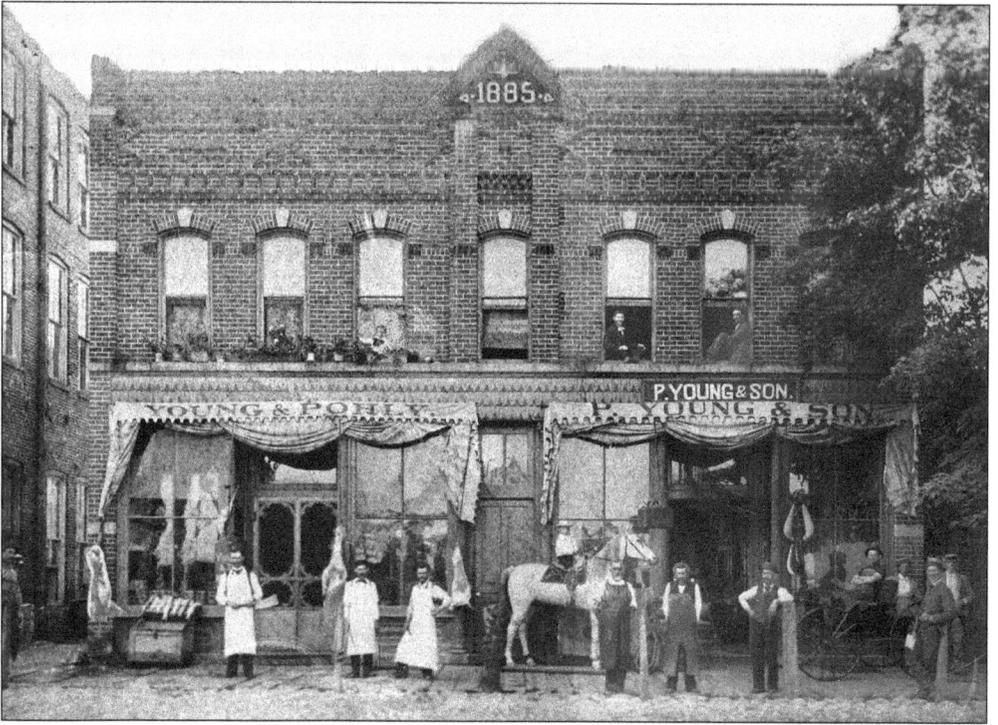

YOUNG AND POHLY. Located on the east side of Michigan Avenue in a building constructed in 1885 was a meat market on the left and a blacksmith's carriage, harness, and leather shop on the right. A butcher holds a meat cleaver in hand, while the others hold carving knives. On the right, a small boy sits in the saddle of a stuffed horse, and hames for horses hang in the window. This site is currently the parking lot behind First National Bank of Howell.

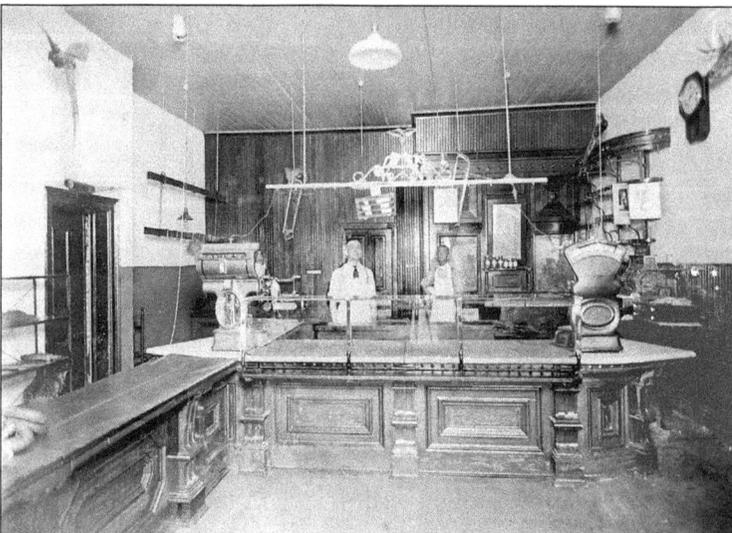

PALACE MEAT MARKET. In 1880, this butcher shop was well established at 120 State Street on Peanut Row. Butcher's saws hang within easy reach of the counter. Meat scales are located on the right and left side, a National cash register is on the far right, and an electric light hangs from the ceiling.

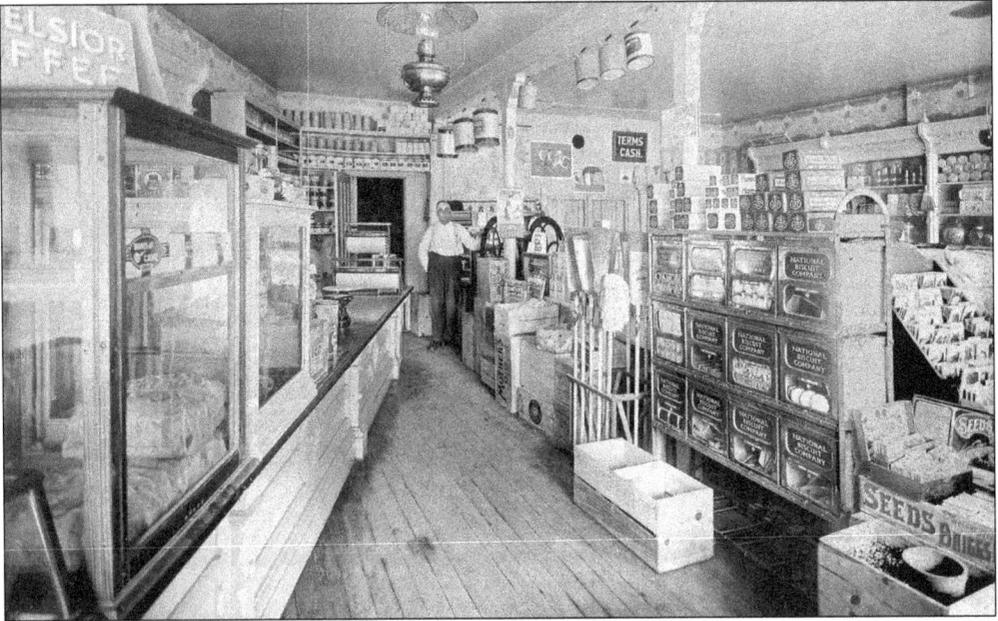

LARKIN'S GROCERY. Imagine walking into Larkin's grocery store to obtain coffee, flour, biscuits, seeds, or other staples. As the sign on the back wall indicates, all sales are cash. An oil lamp hanging from the ceiling provides light for the shopper. This photograph provides a glimpse into one of Howell's grocery stores about 1900.

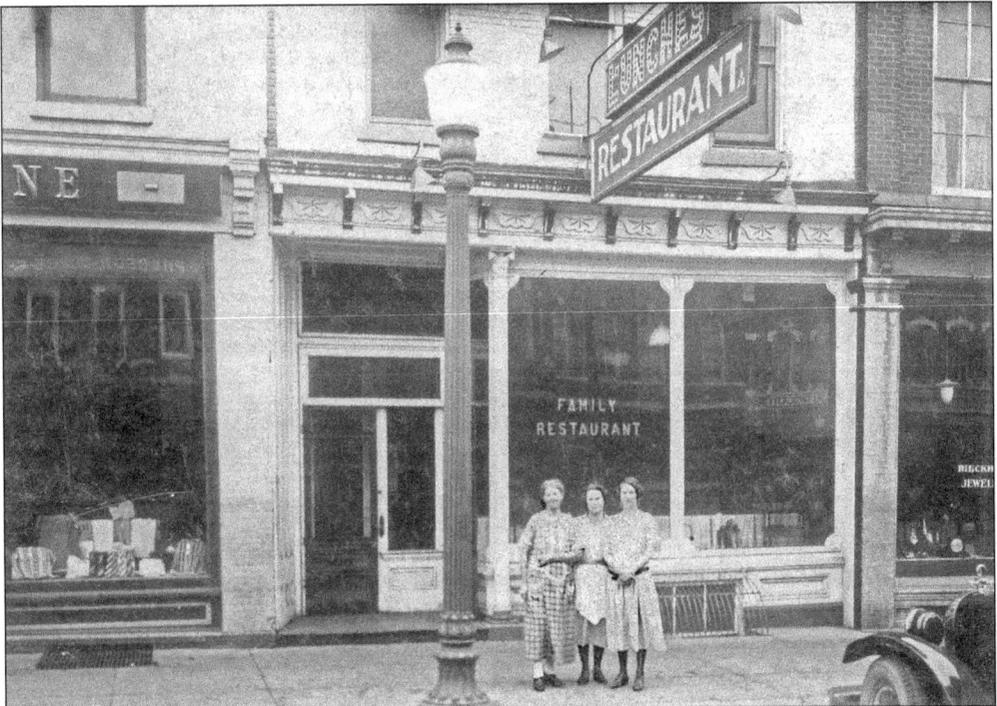

THE FAMILY RESTAURANT. Tucked in between Lines dime store and a jewelry store was the Family Restaurant. In this 1930s photograph, the cook and two waitresses proudly pose next to a streetlamp.

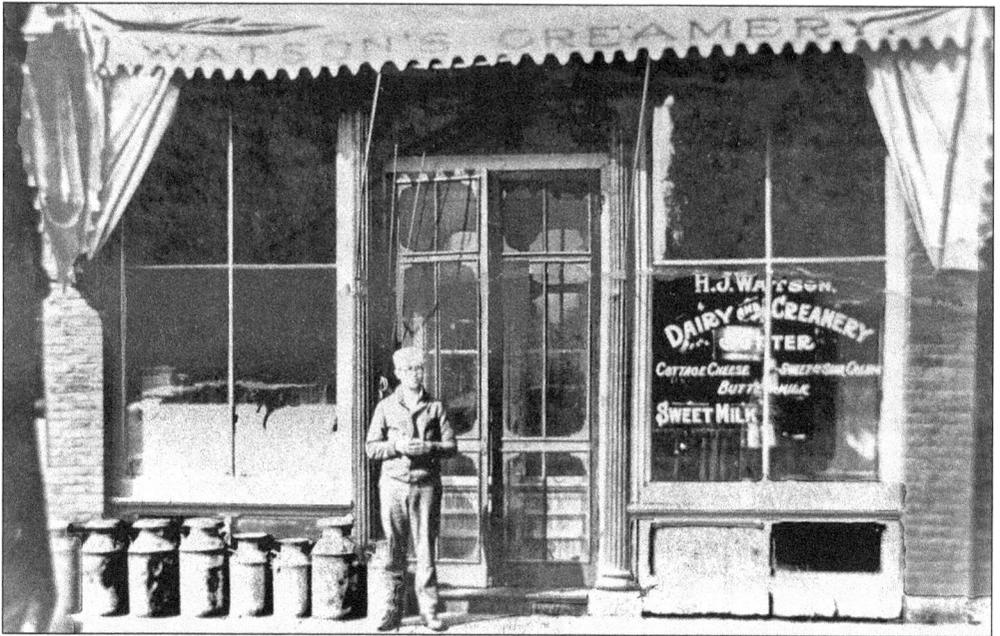

Hiram J. Watson's Creamery. This 1912 photograph shows Watson standing next to a row of milk cans at the door of his State Street Creamery. He also sold butter, cheese, buttermilk, and sweet and sour creams. Watson was 80 years old at the time of his death in January 1920.

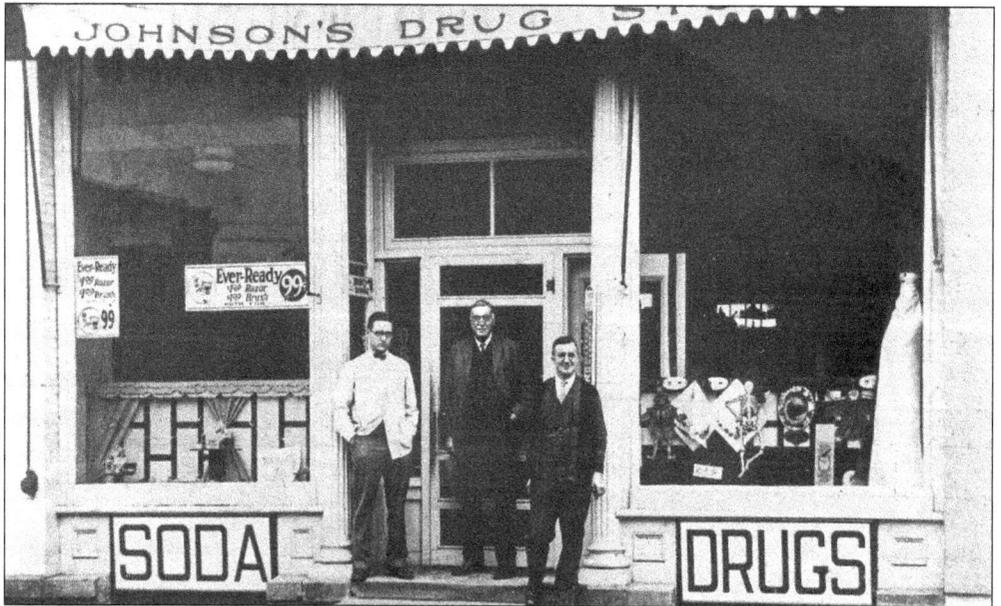

E.K. Johnson, Druggist. A prominent businessman and lifelong resident of Livingston County, he died at his home on Wetmore Street after an illness of a few days when he was nearly 77. Johnson opened a drugstore at 122 West Grand River Avenue in 1882, with a Mr. Stowe as a partner. In 1887, Johnson purchased Stowe's interest, after which he conducted the business alone until 1897, when his son became a member of the firm. This image was taken in October, as Halloween decorations are in the window as well as "Smoke Seminola Cigars five cents," and a Howell pennant hangs in the window.

34

BEACH'S FINE MILLINERY. Sweeping the sidewalk in front of his store, William M. Beach presents a satisfied smile. He worked as a teacher and was register of deeds for Livingston County from 1876 to 1880. He also opened a millinery store in the McPherson building on Grand River Avenue, which he operated for 30 years.

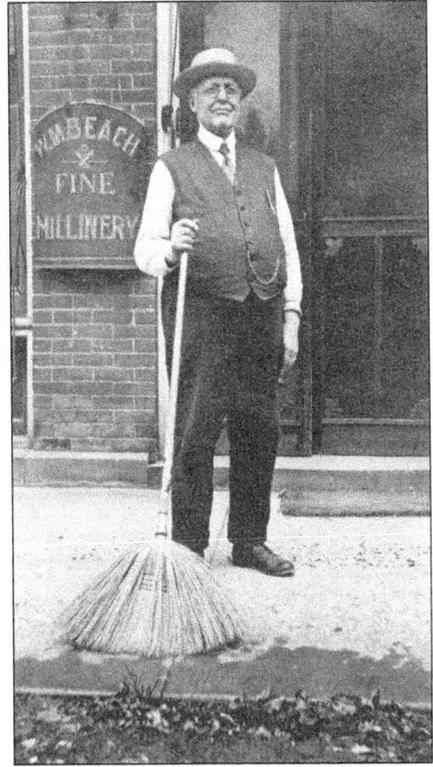

WILLIAM M. BEACH'S MILLINERY. Electric lights illuminate the interior of Beach's store and show the vast quantity of merchandise available to customers in the 1920s and 1930s.

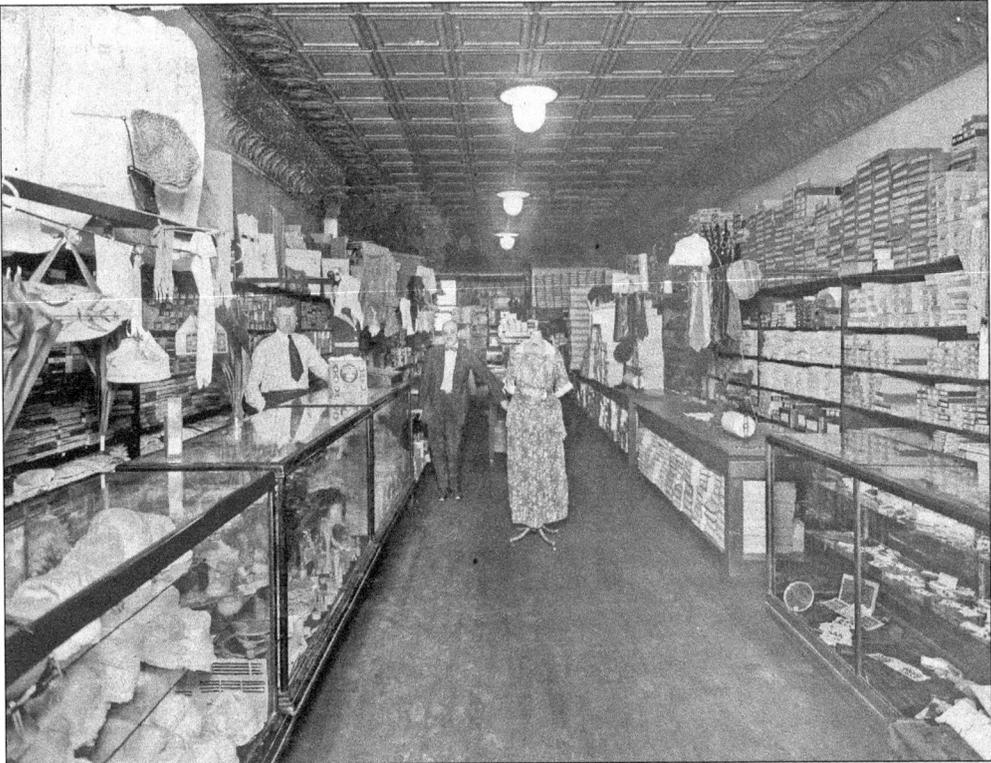

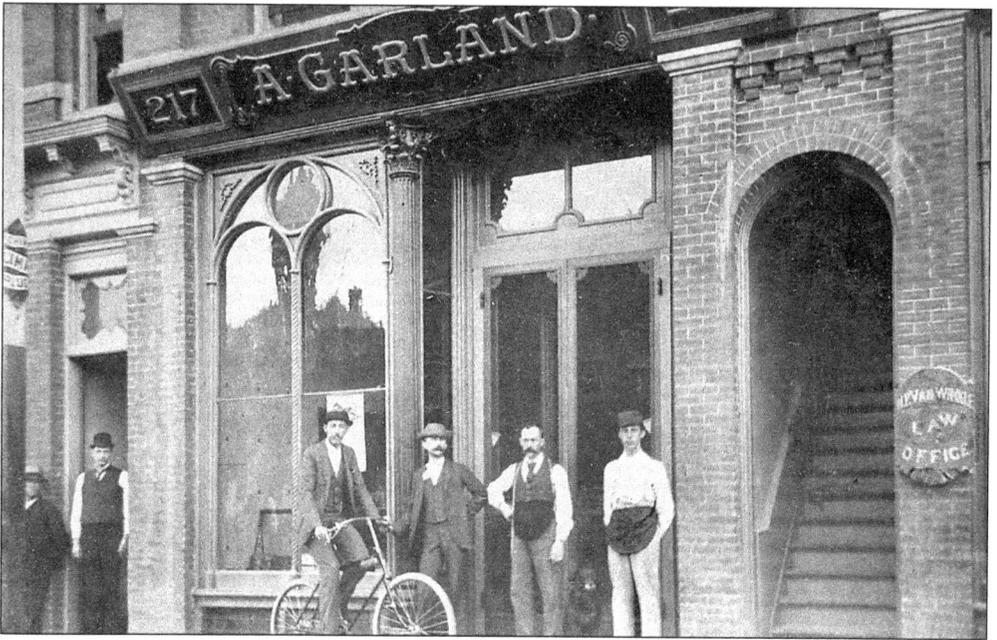

GARLAND'S HABERDASHERY. In 1879, Arthur Garland began a career in merchant tailoring and ready-made clothing. By 1892, his salesmen were traveling throughout Michigan and to the far western lands of the Dakota Territory taking orders. All the manufacturing of clothing was done in Howell, where he maintained a factory that produced rain gear made from lightweight waterproof fabric originally of rubberized cotton known as a macintosh. Garland's business was so successful that in 1898 he was able to purchase the Howell Opera House.

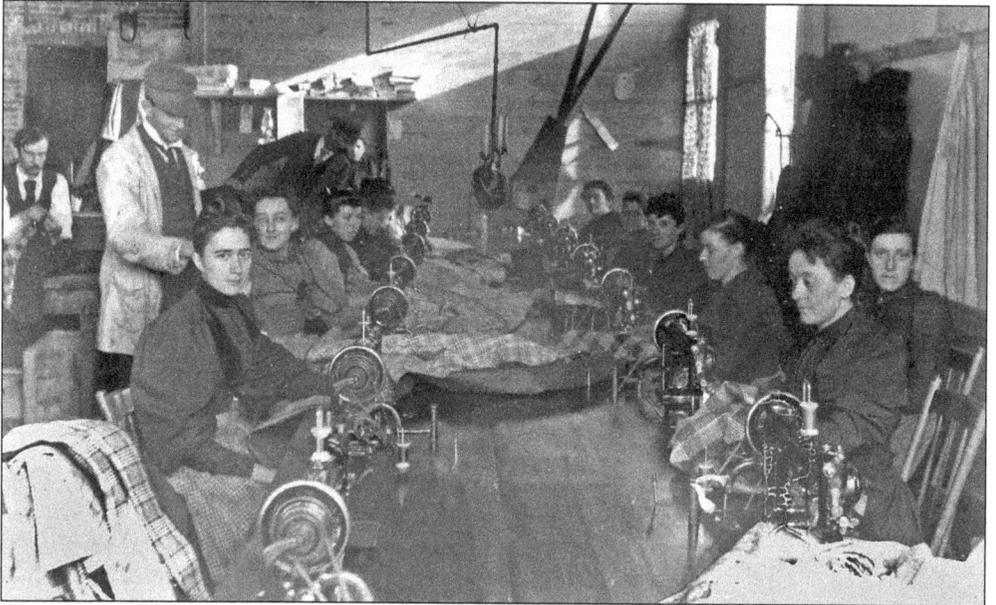

GARLAND'S TAILOR SHOP, 1896. A dozen women are working at sewing machines making men's clothing. A variety of fabrics are on the table and chairs. The finished suits, vests, trousers, and jackets were shipped to stores throughout Michigan and to people in states beyond the Mississippi River.

McPherson's Business Card. At one time, this family owned and operated three stores on the north side of Grand River Avenue. They sold boots and shoes in one store, gentlemen's clothing in another, and general merchandise and ladies clothing in the third.

WM. M°PHERSON & SONS,

WHOLESALE AND RETAIL

MERCHANTS,

GRAND RIVER STREET,

HOWELL, - - MICHIGAN.

Established 1843.

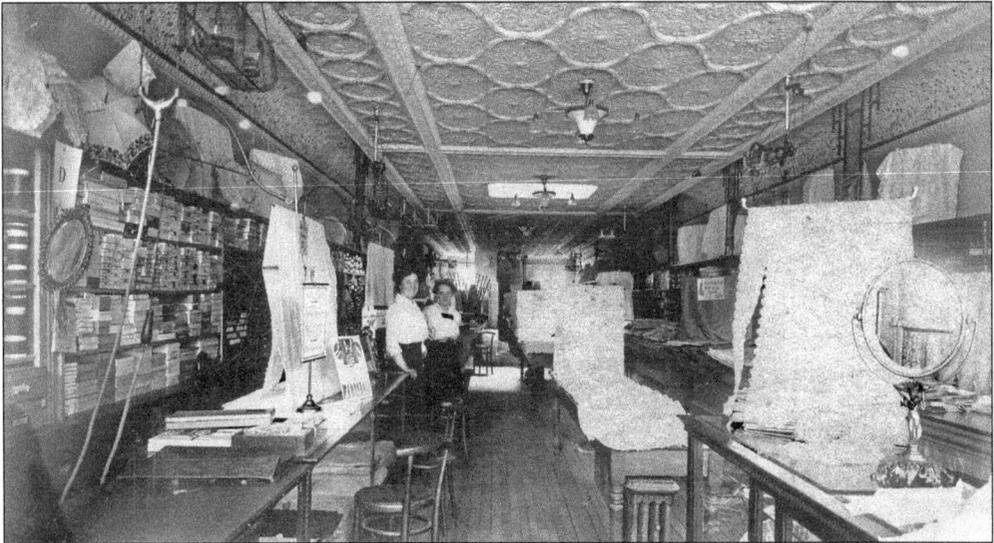

McPherson's Dry Goods Store. Sales clerks Georgia McPherson and Alva Hall welcomed customers as they entered this store at 108 West Grand River Avenue. McPherson's three stores were well stocked and boasted a huge variety of dry goods, including men's, women's, and children's ready-to-wear clothing, fabrics, curtains, footwear, carpets, and many miscellaneous items.

37

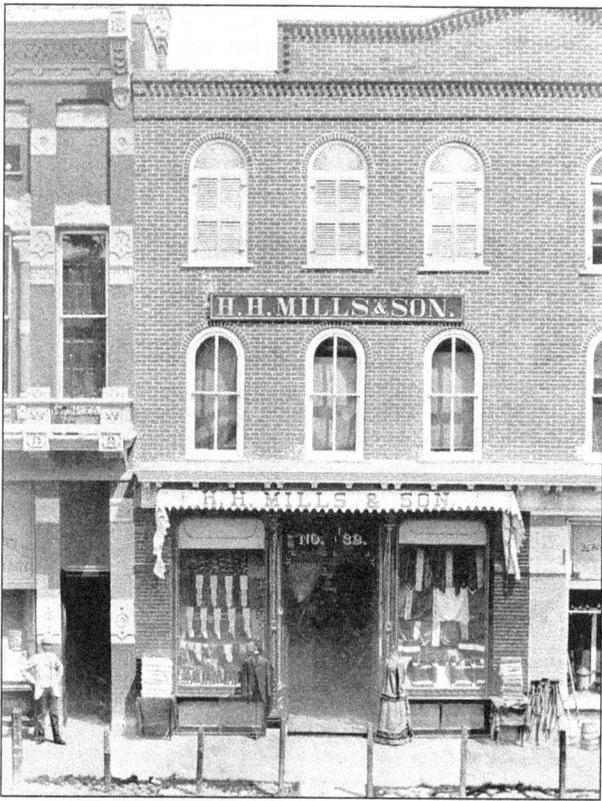

WOMEN'S READY-TO-WEAR CLOTHING. H.H. Mill's and Son owned this business located at 110 East Grand River Avenue. The great fire of 1892 destroyed this building and most of the stores on the block. The storefront windows exhibit a variety of clothing available in 1890.

IMPLEMENTS AND BUGGIES. E.F. Armstrong and R.E. Barron sold Columbus wagons, high-grade implements, plows, buggies, harnesses, and seed. Their establishment was located at the corner of Michigan Avenue and Sibley Streets. In this image, salesmen, prospective buyers, and their ladies are gathered for a 1910-era photograph. This building was destroyed by a fire that started on Saturday, November 28, 1931, at 6:30 p.m.

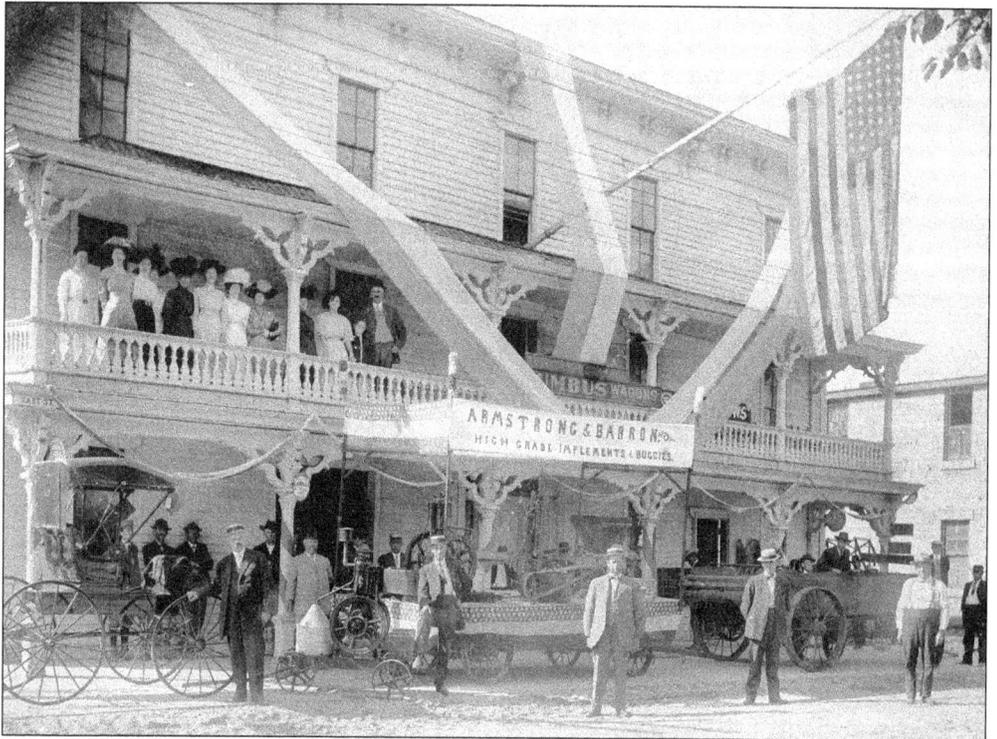

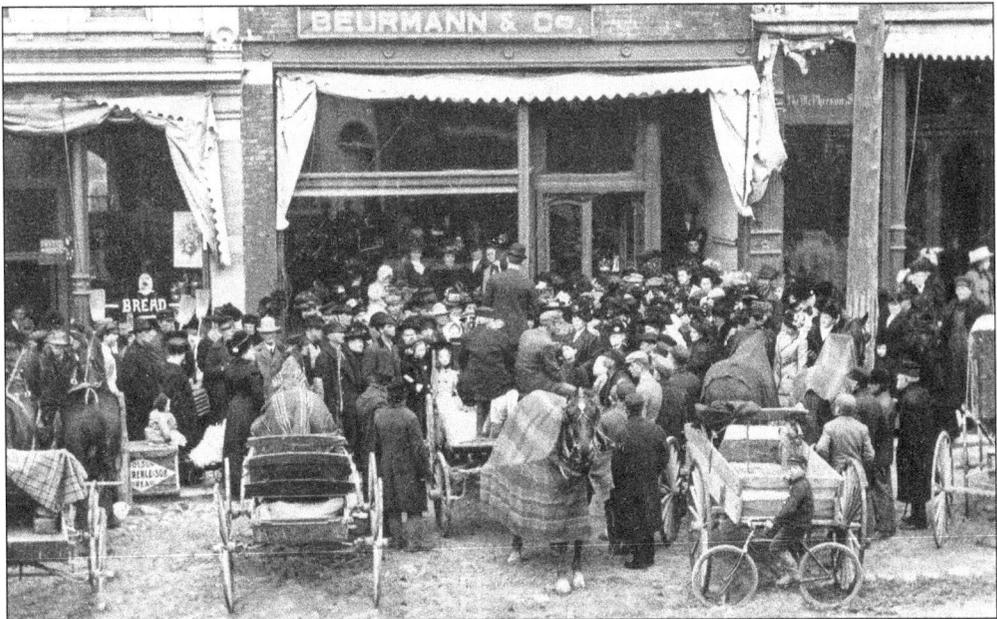

BEURMANN AND COMPANY. Established in 1907 by Glenn Beurmann and Kate O'Connor, who purchased the business from L.D. Browkow, Beurmann's Furniture store held a winter sale that year, which brought many customers to the store. This image shows horses covered with winter blankets and anxious buyers crowded about a salesman standing on the wagon. The Beurmann Company sold furniture, mirrors, crockery, and electric appliances.

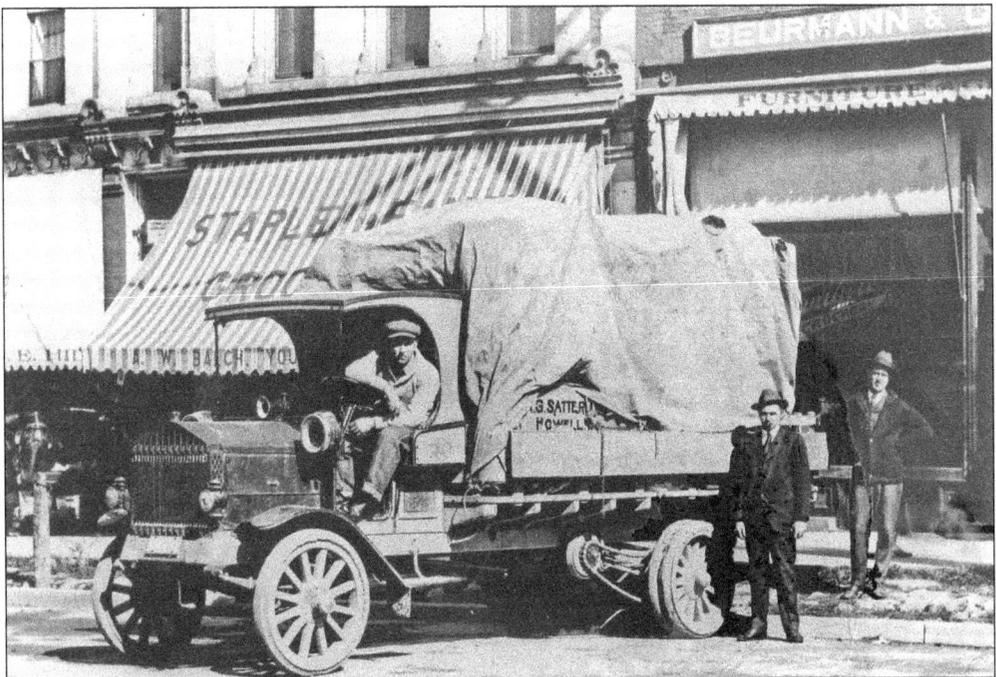

BEURMANN'S DELIVERY TRUCK. In 1916, Beurmann's purchased this vehicle to deliver furniture to customers. The canvas top on the truck protected products from inclement weather as well as dusty gravel roads.

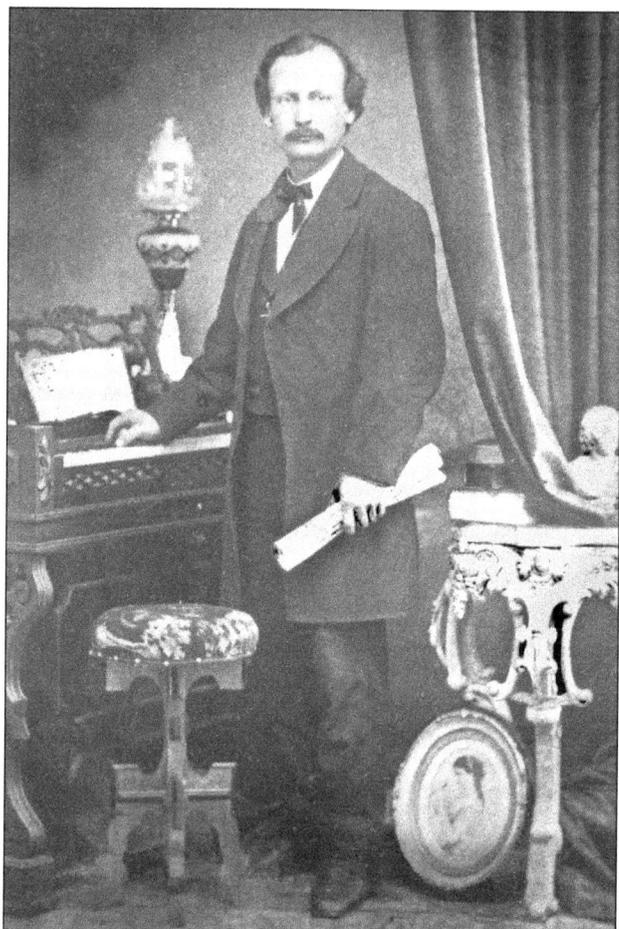

CLEAVE, A SELF-PORTRAIT. Walter E. Cleave opened his studio in Howell about 1868. The organ and framed oil painting in this image reflect his love of music and art. He married Emma Mason in June 1875 and built a family home on South Isbell Street. His passion for photography as an art form is evident in this portrait. Cleave was devoted to photographing Howell's history and people.

BEST-KNOWN PHOTOGRAPHER. This is Cleave's beautifully printed business card. He used typical artistic designs of the 1860s and 1870s and placed this on the back of cartes de visites.

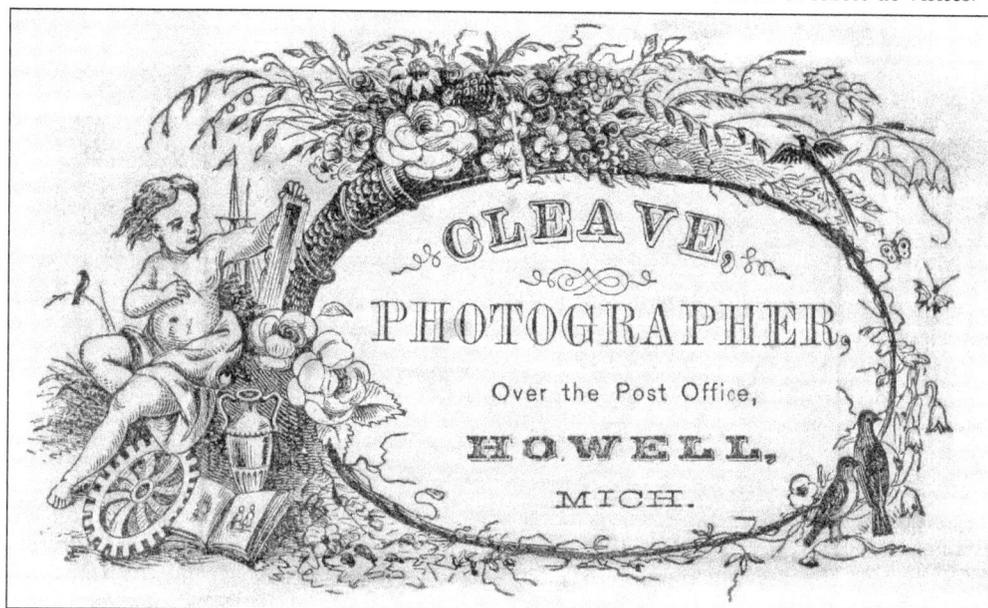

CLEAVE,
PHOTOGRAPHER,
Over the Post Office,
HOWELL,
MICH.

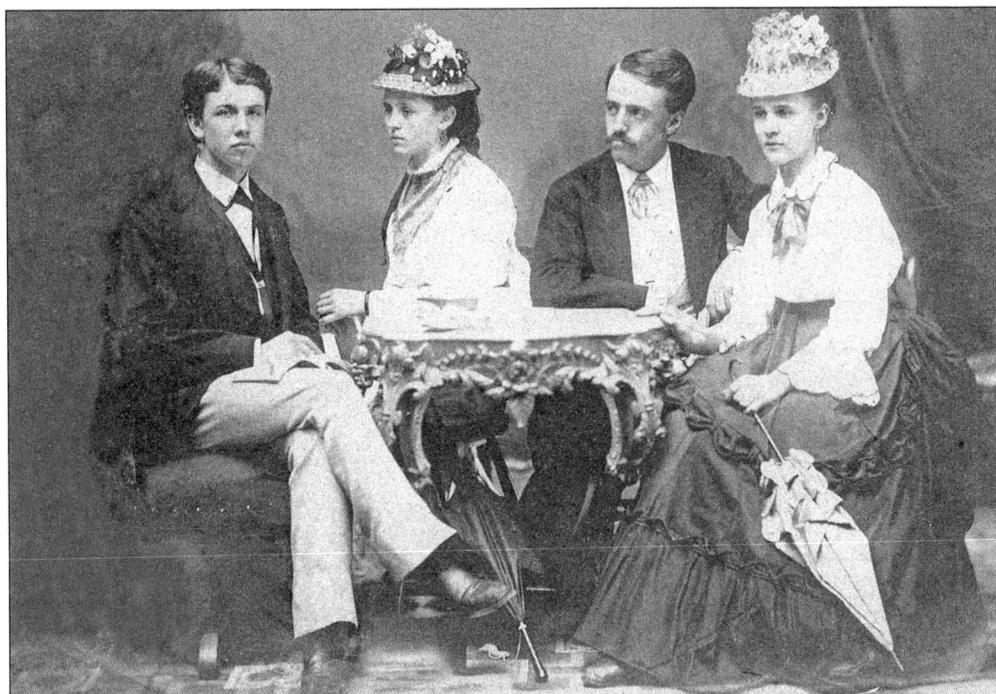

FASHION PHOTOGRAPHY. In this 1880s image, Cleave has posed Howell residents, from left to right, Henry Speicer, Carrie Bascom, Lyle Axtel, and Sarah Foster around a Victorian table in their fashionable clothing. The women's hats, dresses, and parasols reflect the latest fashions of the era.

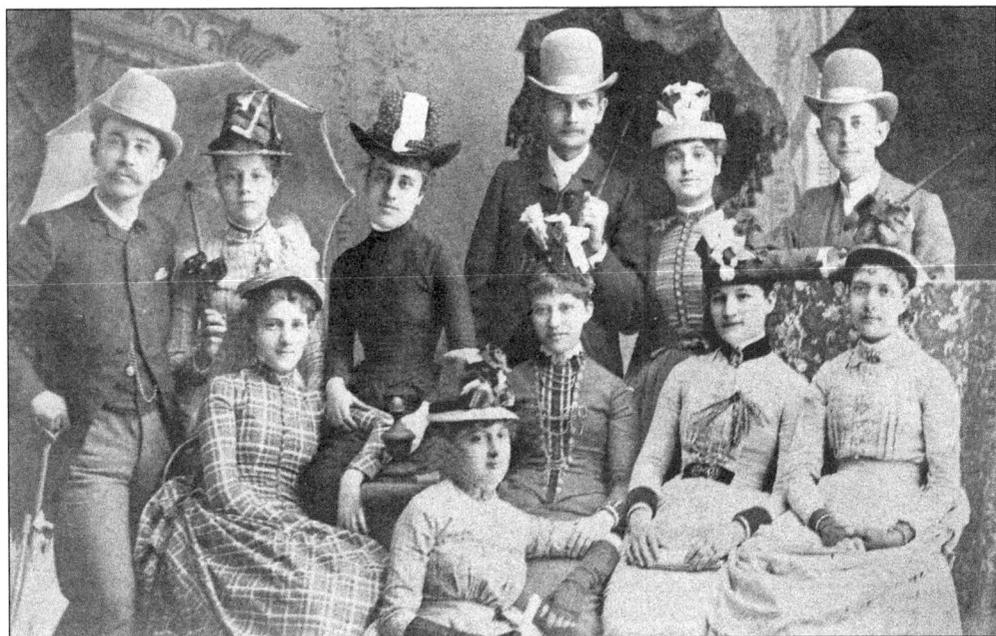

THE LAST WORD IN FASHION. This Cleave's photograph was taken around 1885. On the left is Edward Stair, who, when this image was taken, was owner and editor of the *Livingston Republican*. Stair later became editor of the *Detroit Free Press*. Others in the group include Mary McPherson, Alice and Belle Spencer, Dr. Will Spencer, and Allie McPherson.

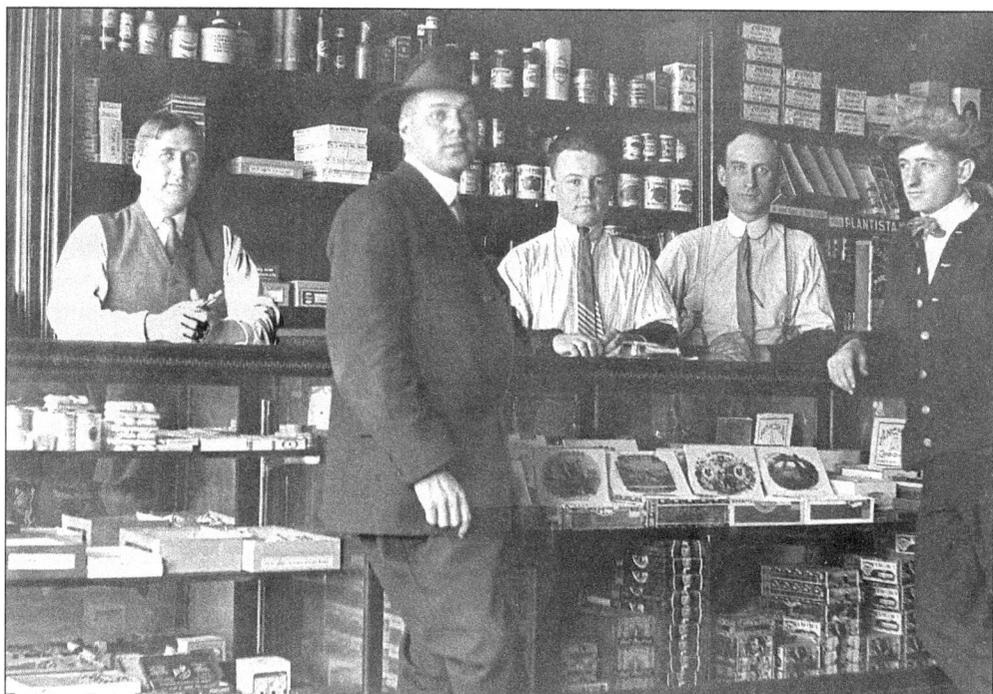

POOL HALL AND TOBACCO/CIGAR STORE. Bert Pate was born on June 12, 1875, and died on February 22, 1947. A lifelong resident of Howell, he married Lucena Pharis on July 24, 1900. He was a Methodist and was in business for 41 years in the same store on East Grand River Avenue. Pate served on the board of directors for the former First State and Savings Bank and later the First National Bank. He was active in Rotary, Red Cross, and War Chest.

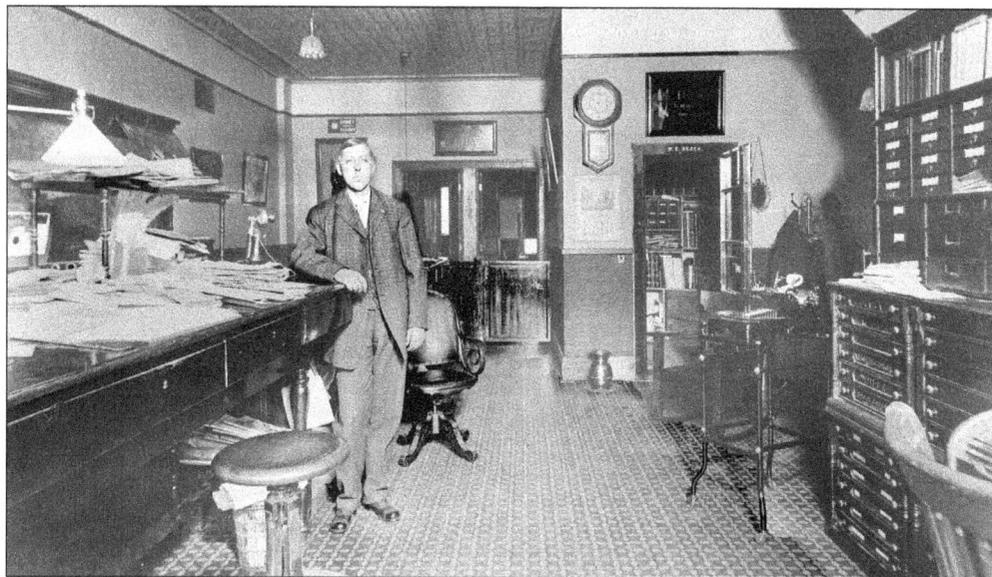

THE INSURANCE OFFICE OF ED BEACH. In June 1896, Beach purchased the insurance business of Thomas Gordon, located on West Grand River Avenue on the south side of the street. His secretary was Mable Wright, who graduated from Howell High School, the class of 1895, and later became Beach's wife. She died in 1971.

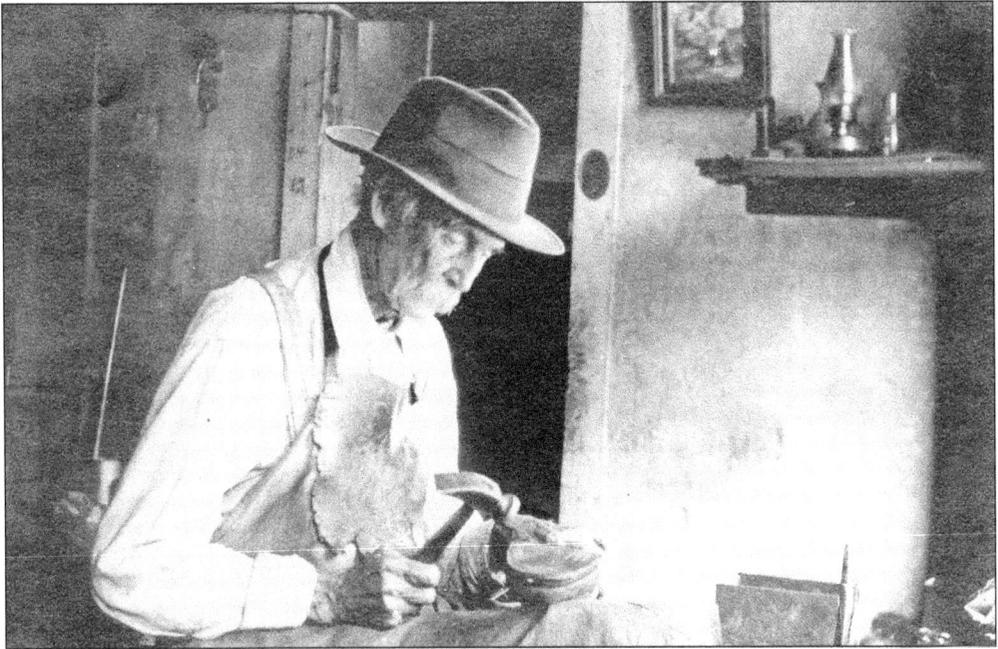

CHARLES H. DONLEY. Donley was born in Dryden, Thompkins County, New York, in 1832 and moved to Howell in 1856. He had learned the trade of cobbler from his father at age 13. Donley worked at the Griffith Building and resided at 222 North Almon Street. He worked at the shoemaker's trade in Howell for 76 years and died on November 22, 1921.

ABRAHAM LOSFORD. Howell's first barber was merely passing through town one day in 1854. Arriving by stagecoach with his barber's chair on top of the stage, he was coaxed by George Wilbur to set up his trade in Wilbur's barroom. He did so, and by genial ways, courtesy, and strict honesty, Losford made a host of friends in town. Affectionately known as "Uncle Abe," he became Howell's first African American resident. Losford was a member of the First Baptist Church of Howell. He resided in town until his death.

Schnackenberg's

PIANOS UNDERTAKING UPHOLSTERING

We have a Licensed Lady Embalmer
for Women and Children.

CALLS PROMPTLY ANSWERED
DAY OR NIGHT

Office Phone 48F2 Resident Phone 48F3

213 East Grand River St.

HOWELL - - MICHIGAN

SCHNACKENBERG'S BUSINESS CARD. Started in 1904 and located at 213 East Grand River Avenue, Schnackenberg's sold pianos and did upholstering and undertaking. Interestingly, the business employed a licensed female embalmer on staff to care for women and children. It operated at a downtown location until 1922, when the Schnackenbergs purchased a large residence at 312 South Michigan Avenue, the current location.

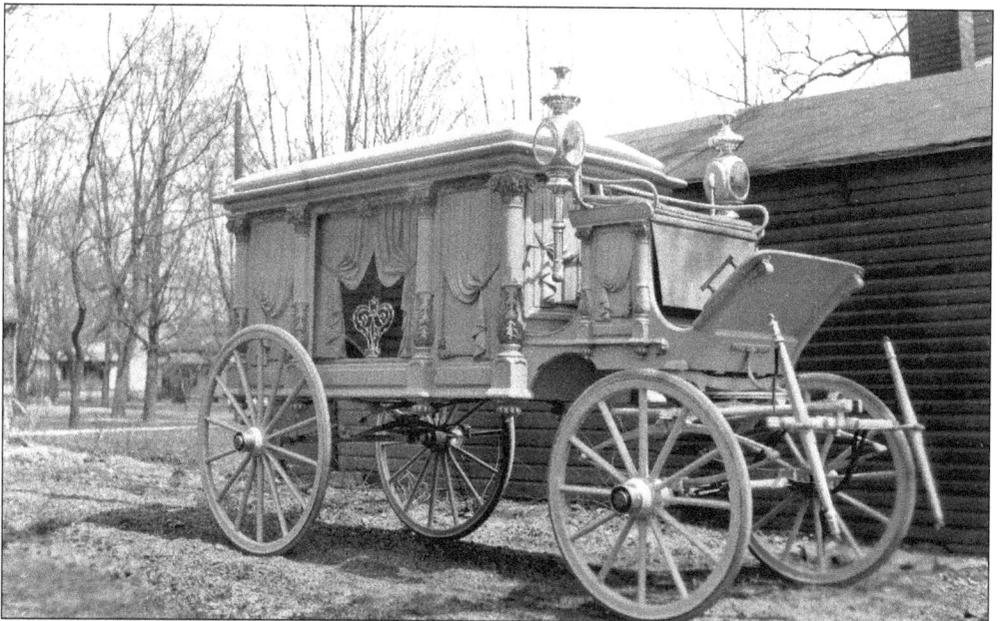

UNDERTAKER HARVEY GOODRICH'S HEARSE. Goodrich's ornate, horse-drawn hearse was all white, with windows and custom drapery treatments. Special glass enclosed the hearse and allowed final viewing of a loved one. The hearse was a familiar sight at Howell funerals from 1875 to 1915, and it was designed to symbolize respect and goodwill for those making a final journey from the church to the grave.

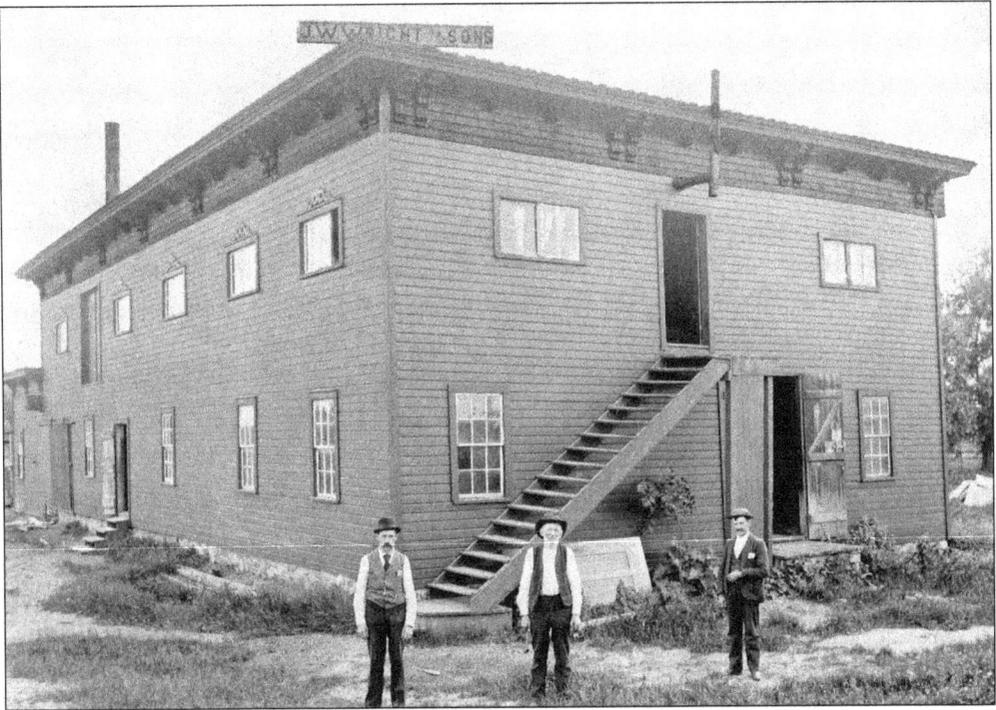

HOWELL PLANING MILL. John W. Wright built his first mill in 1869 on Clinton Street between Walnut and Centre Streets, which was destroyed by fire in 1875. With assistance from his sons, he constructed this factory on Michigan Avenue near the Pere Marquette Railroad tracks. Until his death, Wright and his sons operated this business and made sashes, doors, blinds, moldings, and dressing lumber for building purposes. Shown in this image are Lewis (left), John W. (center), and Frank E. Wright.

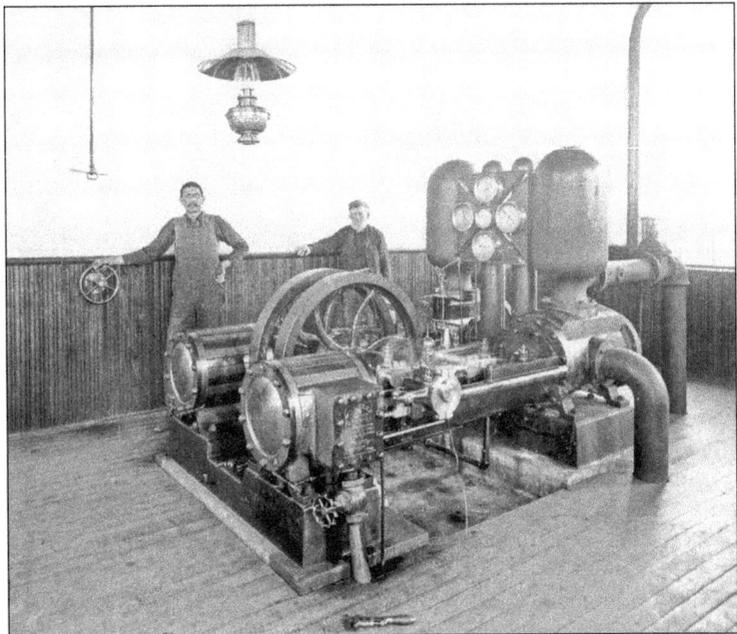

HOWELL PLANING MILL. George Greenaway (left) and John Wright pose for this July 1895 photograph at Wright's Planing Mill. A kerosene light fixture hangs from the ceiling, and power equipment with wheels and gauges operates the mill.

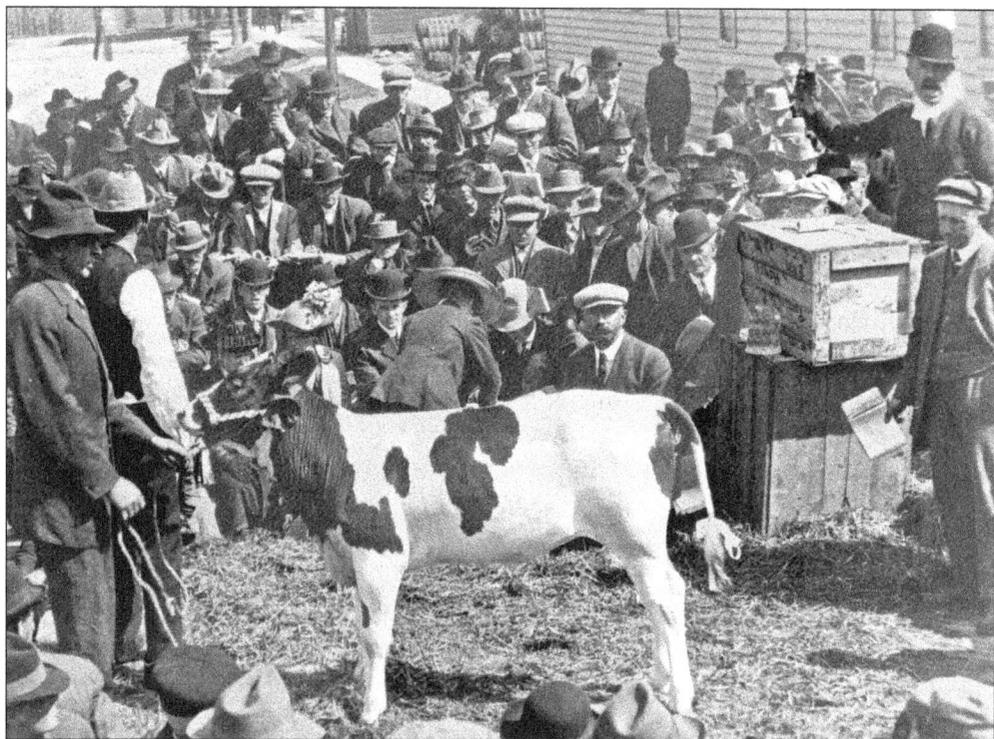

CALF AUCTION AT THE TEN-CENT BARN. Holstein-Friesian cattle were popular in Livingston County, especially with the arrival of the condensed milk factory. In the 1880s, W.K. Sexton brought Holsteins to the area, and buyers came to him from all over the country. His success motivated many local farmers to developed herds and become dairy farmers.

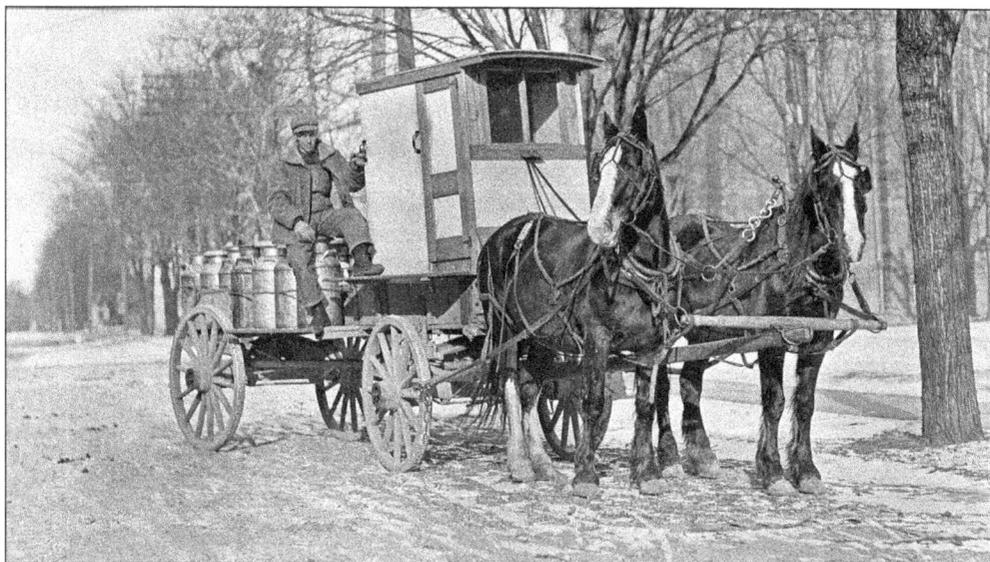

MILK WAGON. Each morning, the milk wagon would collect containers and take them to the condensed milk factory for processing. This milkman has stopped on State Street to have his picture taken on a wintery day. In the background is the First Baptist Church of Howell, and to the right is the county jail.

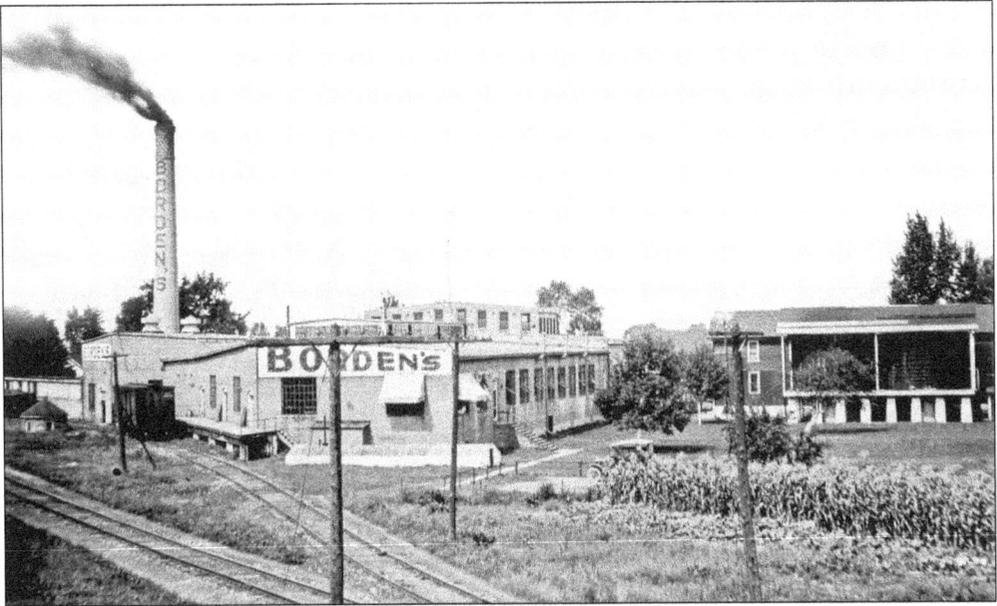

MICHIGAN CONDENSED MILK FACTORY. The factory opened in Howell on April 5, 1894. Prior to this, milk had to be shipped to Lansing for processing. The industry provided opportunities for local employment and established Howell as a regional center for dairy farming. Howell became a national center for the sales and breeding of Holstein cattle due to the Michigan Condensed Milk Factory. A devastating fire killed two workers and destroyed the factory on Friday, May 2, 1913.

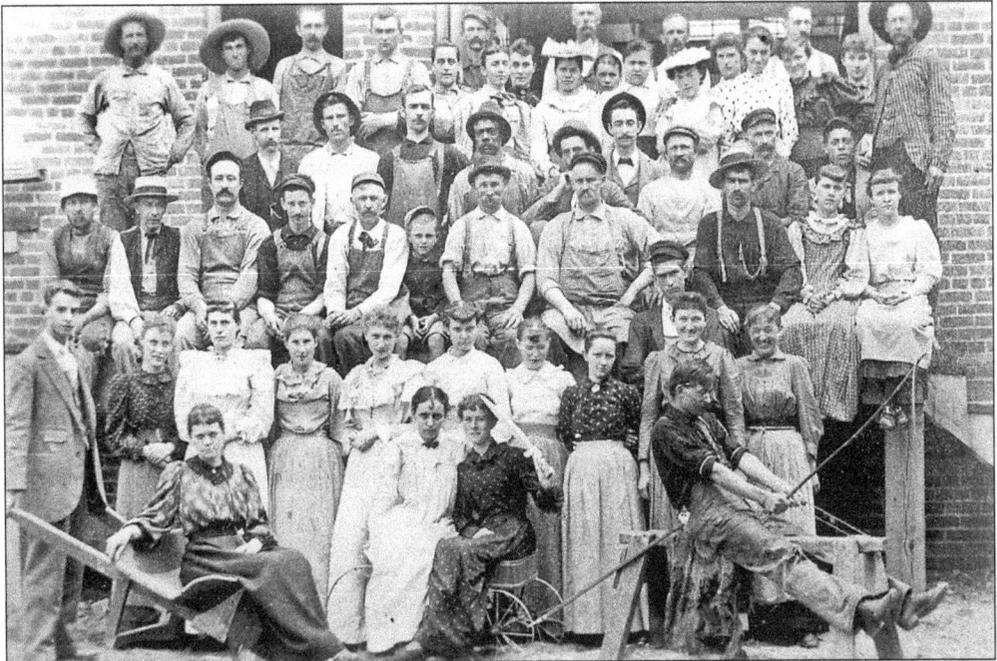

MILK FACTORY EMPLOYEES. Workers at the condensed milk factory, which was one of Howell's largest employers, take a break from their labors to have their photograph taken around 1900. Both young and old, and male and female, there are 53 people in the image.

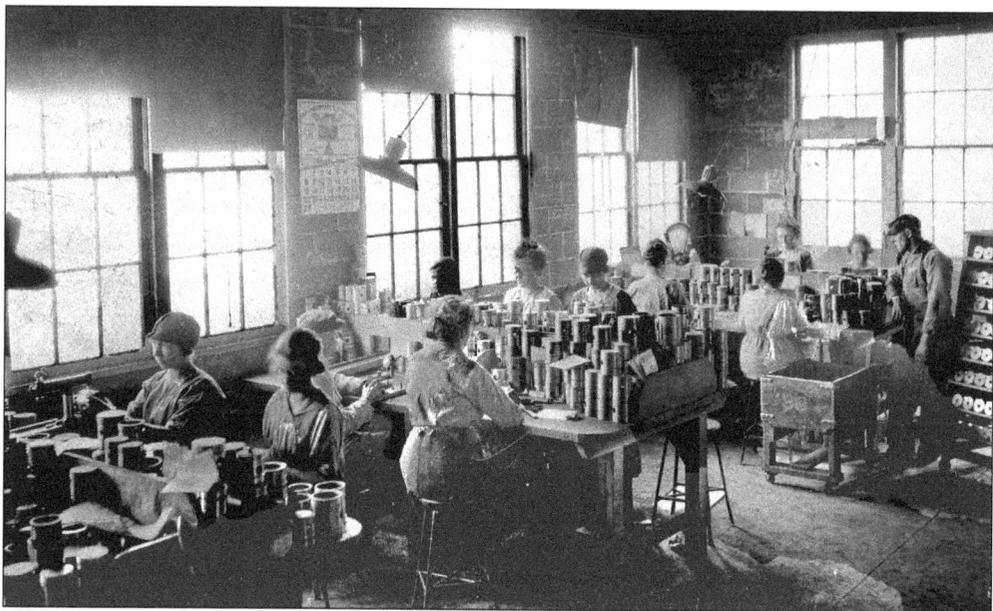

SPENCER-SMITH FACTORY. Female employees work with pistons at the factory on Roosevelt Street; a wall calendar is turned to February 1920. Founded in 1914, the company manufactured pistons for airplanes, trucks, cars, tractors, and jeeps. During World War II, its 210 workers made it the largest employer in Howell.

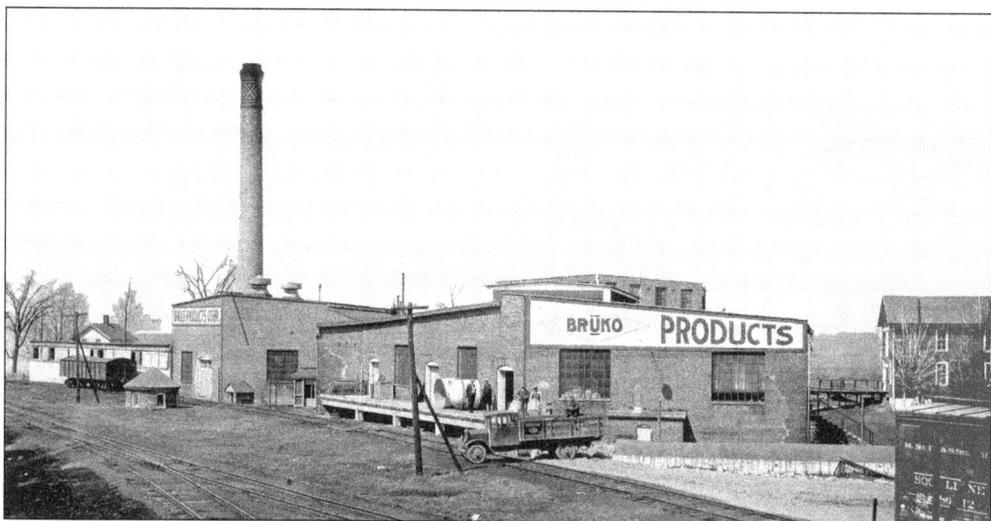

BRUKO PRODUCTS CORPORATION. In 1926, the old condensed milk factory, at the corner of West and Factory Streets, was sold to the Bruce Products Company. It produced finishing materials for industries working with metals, plastics, and lubricants for machining, polishing, stamping, drawing, and die-casting. It also produced a line of buffing and polishing wheels and compounds under the trade name Bruko.

Four

KEYSTONES

Throughout the years, the Livingston County Courthouse, Carnegie library, Howell Opera House, and local governmental institutions have provided Howell with a strong identity and foundation. These cultural, civic, and social keystones created the fabric of Howell's community and supported the needs of residents. To this day, each of these linchpins performs essential roles in maintaining a stable community and provides opportunities intended to enrich the lives of citizens.

For generations, annual, well-planned calendars of events and activities designed to appeal to residents were created by local leaders. These helped shape the cultural and social identity of Howell's people. Entertainment and political action have been abundant at the courthouse square since the 1840s. Built in 1881, the opera house has provided a variety of entertainments, including Shakespearean plays, musical concerts, lecture series, burlesque performances, minstrel shows, high school plays, and commencement exercises. From 1881 to 1924, high school diplomas were presented to 881 students who crossed the stage at the Howell Opera House.

With financial support from philanthropist Andrew Carnegie, Howell built a library that has had an immense and lasting impact on the community. Local government provided the infrastructure necessary for the community to expand and prosper. Since the mid-19th century, local political leadership has provided schools, parks, roads, street lighting, police and fire protection, water and sewers, snow removal, and many additional requests desired by residents.

This chapter includes a never-before-published photograph of the opera house and the earliest known image of Livingston County's first courthouse. A unique steel engraving of that courthouse and several early-20th-century photographs of the Carnegie library are also included. Additional images show Royal Hardy, Howell's police chief from 1921 to 1935, astride his motorcycle with his trusty dog riding in the sidecar, early fire engines, and a 1947 city-owned conveyor belt used to remove snow.

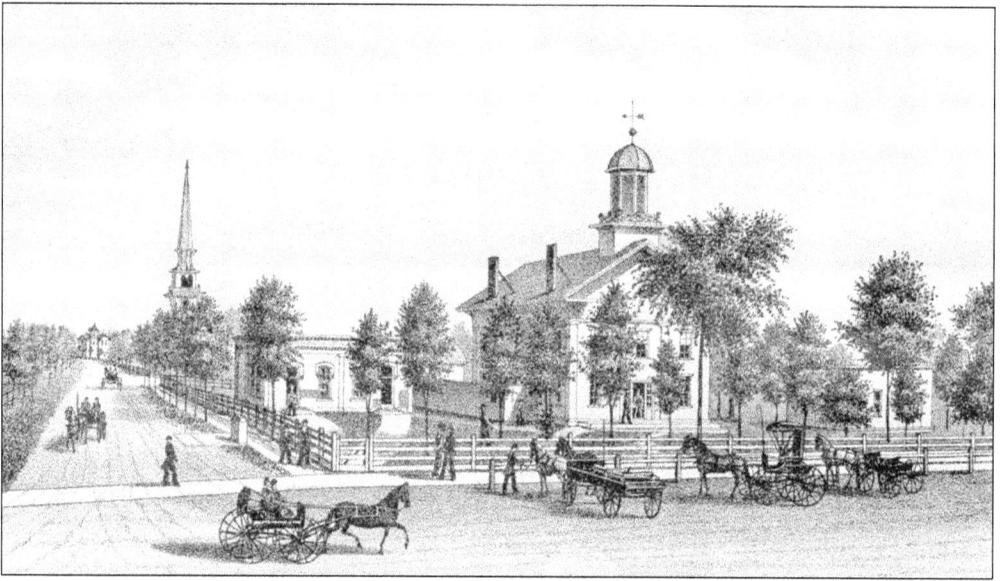

THE FIRST COURTHOUSE. This exquisite steel engraving of Livingston County's first courthouse was published in Franklin Ellis's 1880 *History of Livingston County, Michigan.* The structure was completed in the autumn of 1847 at a cost of $5,928. The first floor of the courthouse served as the sheriff's residence and jail. The second floor provided the courtrooms, judge's chambers, and the jury room.

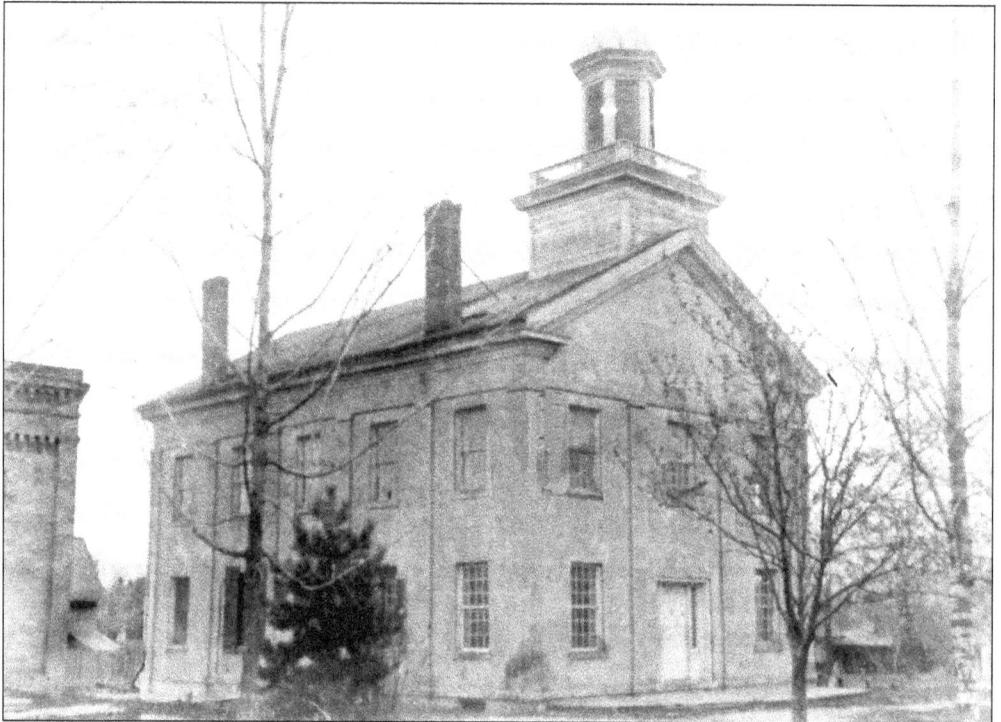

PHOTOGRAPH OF THE FIRST COURTHOUSE. This winter image of the Greek Revival courthouse was taken between 1849 and 1853. The west annex, built in 1849, is visible to the left. This courthouse served the citizens of Livingston County for 42 years and was razed in 1889.

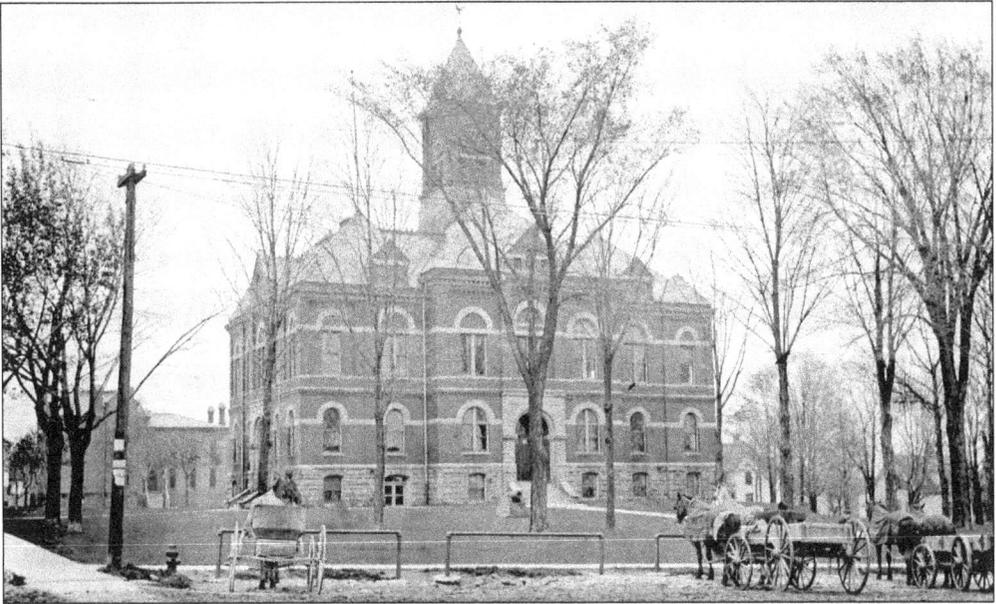

THE 1889 LIVINGSTON COUNTY COURTHOUSE. This three-story, brick-and-limestone Richardsonian Romanesque building was designed by architect Albert French. The structure has a signature architectural feature: the clock and bell tower denoting the center of Livingston County's political, social, and cultural heritage. A Civil War cannon and stacked cannonballs on the courthouse lawn are visible. Horses and wagons are tied to the hitching posts along Grand River Avenue in this c. 1900 image. The street is still unpaved, but telephone poles and water hydrants have been installed. Restoration of the 1889 courthouse was completed in 1978. Today, as in the past, the courthouse square remains a focus for political rallies, musical concerts, parades, festivals, and the popular farmers' market. The courthouse is listed in both the National Register of Historic Places and the Michigan State Register of Historic Sites.

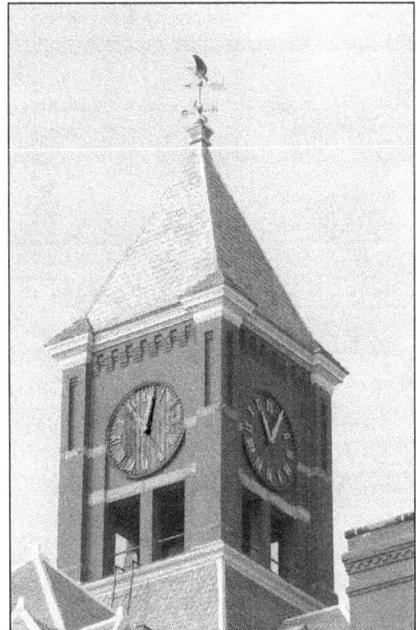

COURTHOUSE CLOCK TOWER. Installed on February 9, 1890, the courthouse clock weighs 1,300 pounds. Its dial is eight feet in diameter, the minute hand is three feet long, and the hour hand is two feet long; each numeral is nine inches high. Perched atop the steeple is a copper weather vane with a spread-winged eagle landing on a ball. (Courtesy of Judith McIntosh.)

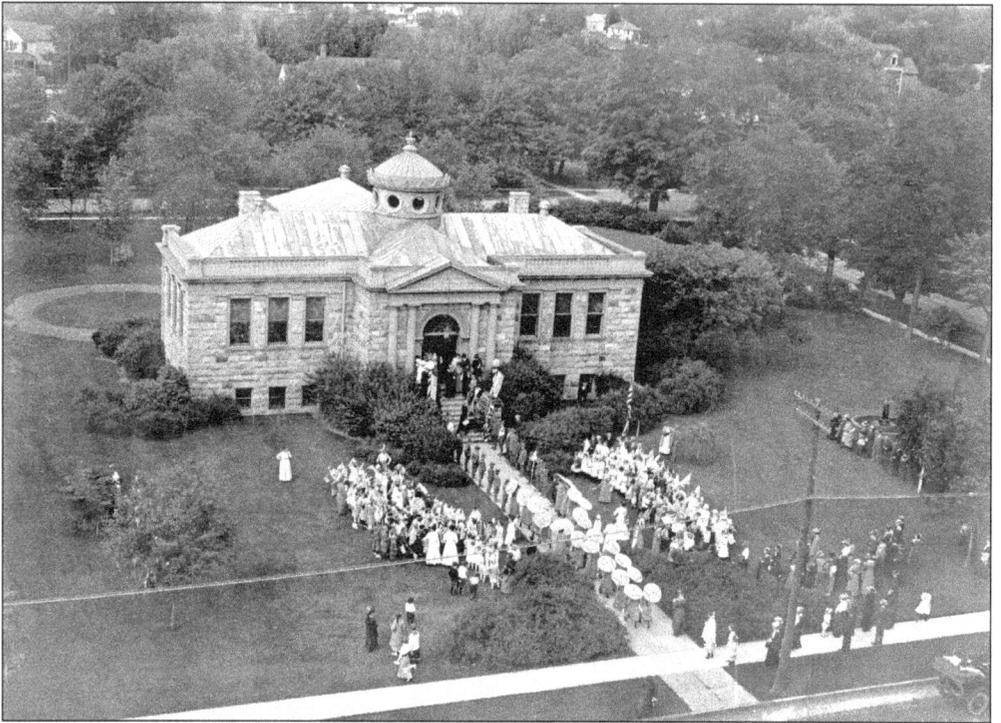

FLAG DAY. On June 14, 1915, Flag Day was celebrated at the Howell Carnegie Library Square. Boy Scouts and Camp Fire Girls led a parade of third-graders from the Livingston County Courthouse to the library. Camp Fire Girls carried parasols and Boy Scouts stood at attention along with teachers and schoolchildren waving American flags. They all joined together with local citizens and sang patriotic songs.

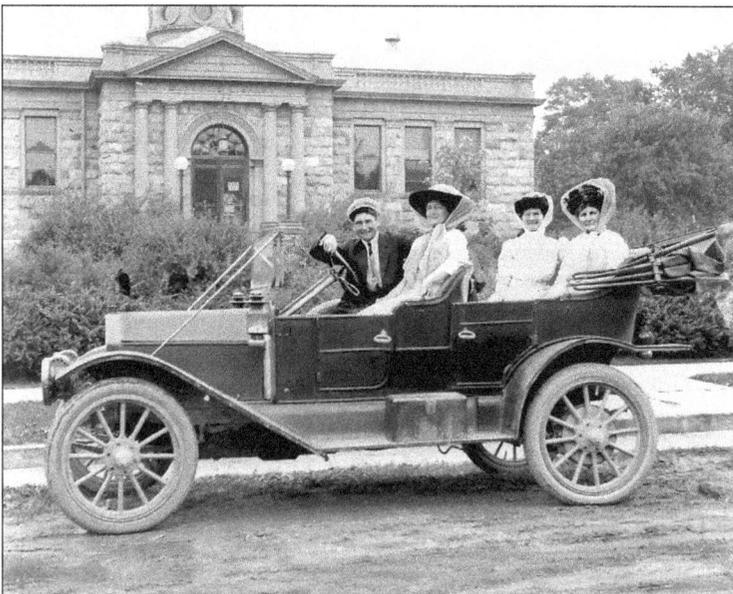

LADIES IN WHITE. On an August day in 1914, Elvin Trollman was driving his 1912 Buick on a Sunday outing with, from left to right, Marian, Johanna Trollman, and his Aunt Del. In this image, they are parked in front of the Carnegie library while preparing for an excursion through the county.

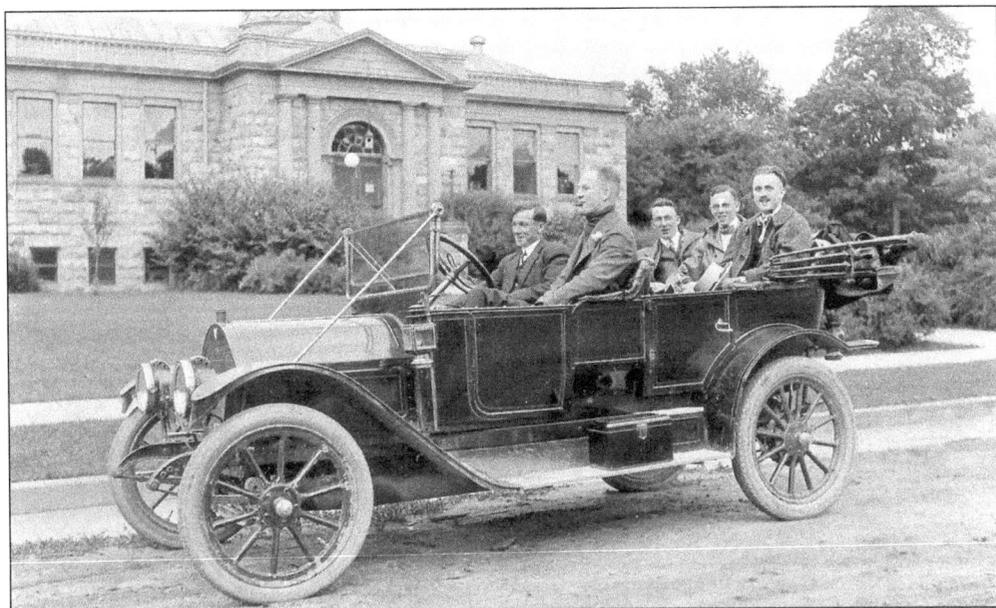

A 1915 HUDSON AT THE CARNEGIE. Spike Hennessey, Parker Tooley, George Mann, and two unidentified friends are ready for a Sunday cruise through Livingston County. The passenger in the front is smoking a cigar, and the steering wheel is on the right side of the car.

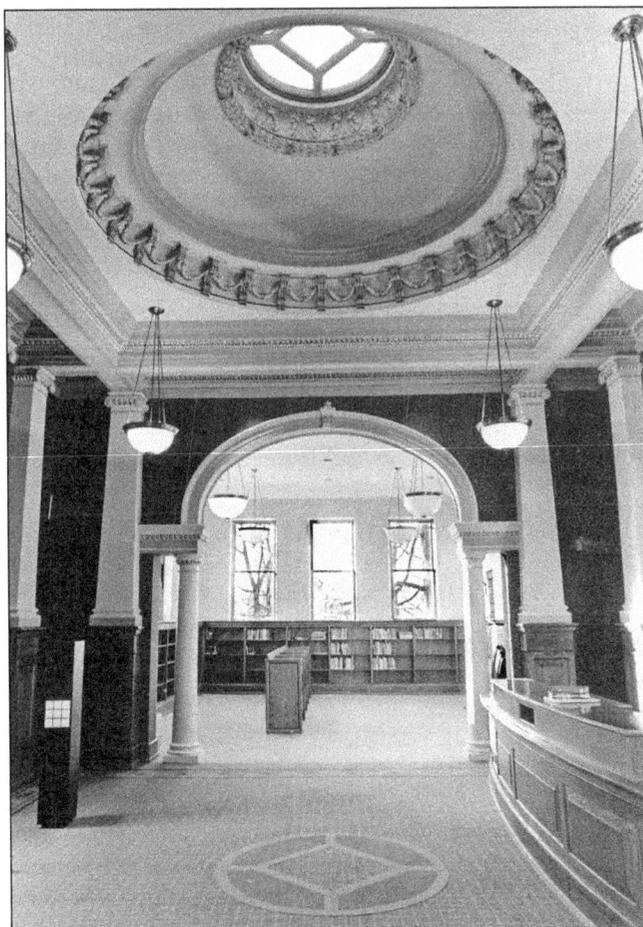

LIBRARY INTERIOR. Andrew Carnegie provided funding for the construction of the library. E.E. Meyers, the architect for Michigan's state capitol, was selected to design the Neoclassical building, which was dedicated in November 1906. In this photograph, Doric and Ionic columns, an arch, dome, mosaic tiles, and the circulation desk are visible. The library continues today to be a vibrant cultural keystone of Livingston County's community.

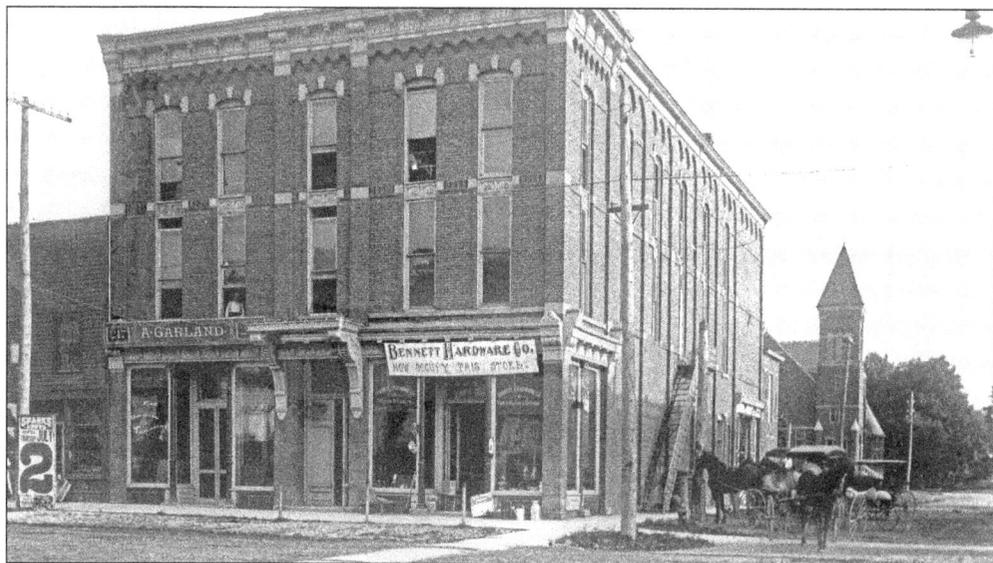

OPERA HOUSE AT GRAND RIVER AVENUE AND WALNUT STREET. Hundreds of performances were presented at the Howell Opera House in the 42 years it operated. The Fisk University Jubilee Singers from Nashville, Tennessee, the Lever Lecture Series, *Dr. Jekyll and Mr. Hyde*, the *Santley Burlesque*, and *Uncle Tom's Cabin* were all seen on stage. Howell High School commencement ceremonies were held at this location from June 1882 through June 1923. Plays and events were sponsored and performed by the Sons of Union Veterans of the Civil War, Masonic Lodge, Order of the Knights of Pythias, Knights of the Maccabees, Howell High School drama club, and numerous other organizations. Visible in the background is the First United Methodist Church of Howell.

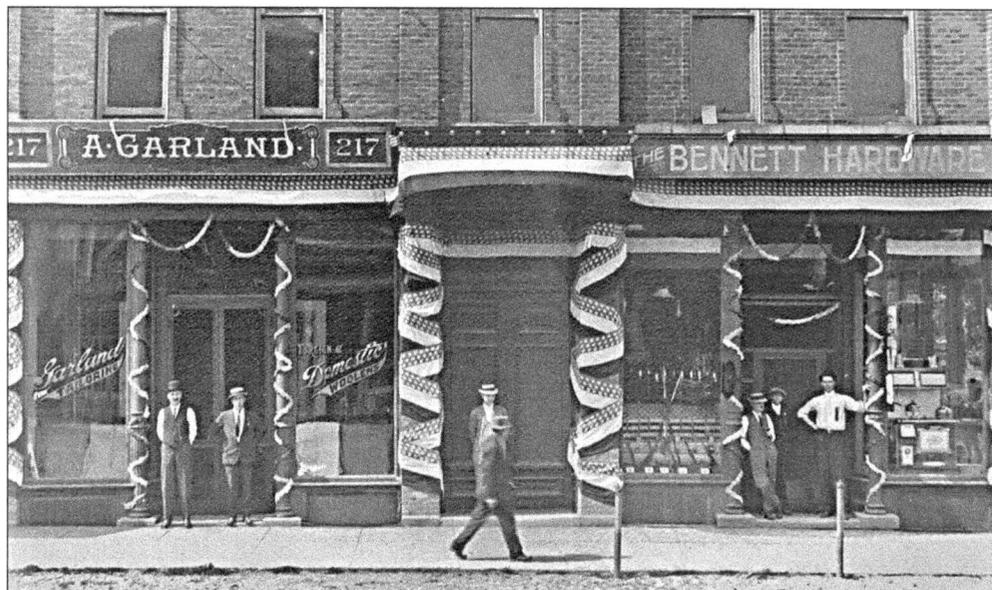

THE OPERA HOUSE. Retail space on the street level of the opera house was leased to various businesses. In this 1913 image, Arthur Garland stands at the entrance to his clothing store. On the right, several employees stand in the doorway of Bennett's hardware store. A center staircase provided entrance to the theater on the second floor, which housed the stage with a balcony on the third level. In this photograph, the opera house entrance is decorated with patriotic bunting.

54

OPERA HOUSE PROGRAM, 1903. This October 16, 1903, playbill headlines the well-known vaudeville entertainer Porter J. White and co-star Olga Verne in George Boker's six-act tragedy *Francesca da Rimini*. The play is about a woman forced into a political marriage with a brutal older man who falls in love with her brother-in-law. Eventually, the husband catches the two in the midst of passion and murders them both. (Courtesy of the Howell Opera House.)

OPERA HOUSE. A.C. Varney, a Detroit architect, designed the Howell Opera House, which was built in 1881 on the site of the old Eagle Tavern. The inaugural performance at the opera house was given by famous actor Joseph Jefferson, who played the lead role in Bentley Campbell's *Galley Slave* on December 30, 1881. Never before published, this image was taken from the roof of the Howell Cigar factory building located at the northwest corner of Grand River Avenue and Walnut Street. Close inspection of the photograph reveals plank sidewalks, an oil streetlamp, signage for the Howell Opera House Bakery (the bakery was at the rear of the building facing Walnut Street), and a billiards parlor. (Courtesy of the Howell Opera House.)

Howell Opera House.

OCTOBER 16, 1903.

B. C. WHITNEY PRESENTS

PORTER J. WHITE and OLGA VERNE,

SUPPORTED BY JOHN STURGEON,

—— IN ——

Francesca da Rimini

A Tragedy in Six Acts by George H. Boker.

DRAMATIS PERSONÆ.

LANCIOTTO } Malatesta's Sons	{ PORTER J. WHITE
PAOLO }	{ OLIVER J. WHITE
Malatesta, Lord of Rimini	ALBERT JARVIS
Guido da Polenta. Lord of Ravenna	WALTER J. PARLE
Pepe, Malatesta's Jester	JOHN STURGEON
Cardinal, friend to Guido	EDWARD GOODWIN
Rene, a Troubador	JOHN R. WORDEN
Lucentio } Friends to Paolo	{ ELAINE CAREW
Torelli }	{ ROBERT BICKLE
Retardo	FRANK E. SCOTT
Captain	DORRANCE GRIFFIN
Lady in Waiting	LULA MAE VROMAN
Rita	LEONA BLISS
FRANCESCA	OLGA VERNE

SYNOPSIS OF SCENES.

ACT I.—Garden of Palace of Rimini
ACT II.—Courtyard at Ravenna.
ACT III—Garden of Palace of Rimini.
ACT IV—Scene I. Hall of the Palace of Rimini. Scene 2, Interior of the Cathedral at Rimini.
ACT V—Scene I, Garden of Love. Scene 2, The Camp of Lanciotto.
ACT VI—Boudoir of Francesca

NEXT ATTRACTION:

Missouri Girl, Wednesday Eve., Oct. 28.

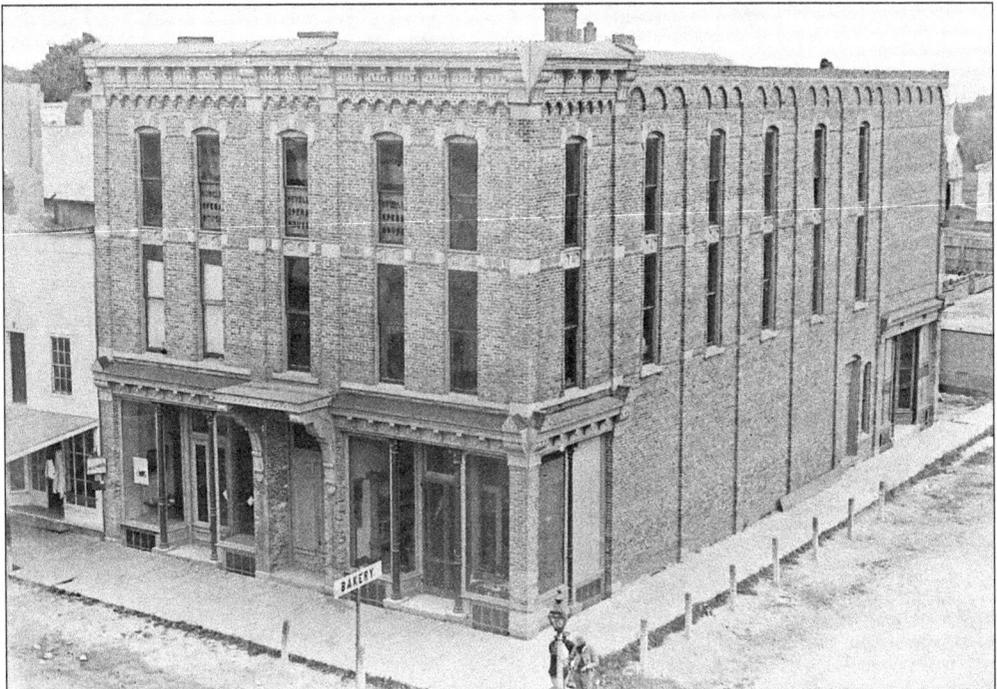

Howell High School

Twenty-eighth
Annual

Commencement

Thursday Evening, June 24, '97

PROGRAM.

Invocation, - - - - Rev. Fr. Ryan
Class Song, - - - *Idelia A. Gifford*
By Class.
Presentation of Diplomas.
Salutatory, - - - - - Jennie M. Topping
Solo, (Asthore) - - - *H. Thorere*
Reginald E. Gilbert.
Poem, - - - - Culture for Service
Hiram A. Boylan.
Solo, (Lestasi) - - - - *Ardite*
Alice E. Garland.
Oration, - - - - - Progress
Seymour H. Person
Solo, (Nocturne) - - *Tauzweisse Und Turerurzz*
Erik Meyer Helmund.
M. Agnes Gorton.
Class History, - - - - Marie I. Lyon
Valedictory, - - - Gertrude E. Palmer

COMMENCEMENT EXERCISE, 1897. The 28th Howell High School commencement was held at the Howell Opera House on Thursday evening, June 24, 1897. Commencement and graduation ceremonies continued to be held at this location until 1923–1924, when it was determined that the facility was too old and unsafe. (Courtesy of the Howell Opera House.)

"THE MIND IS ITS OWN PALACE." The opera house is set for commencement dinner in the 1890s. A banner draped above the stage displays the graduating class's motto, "The Mind is Its Own Palace."

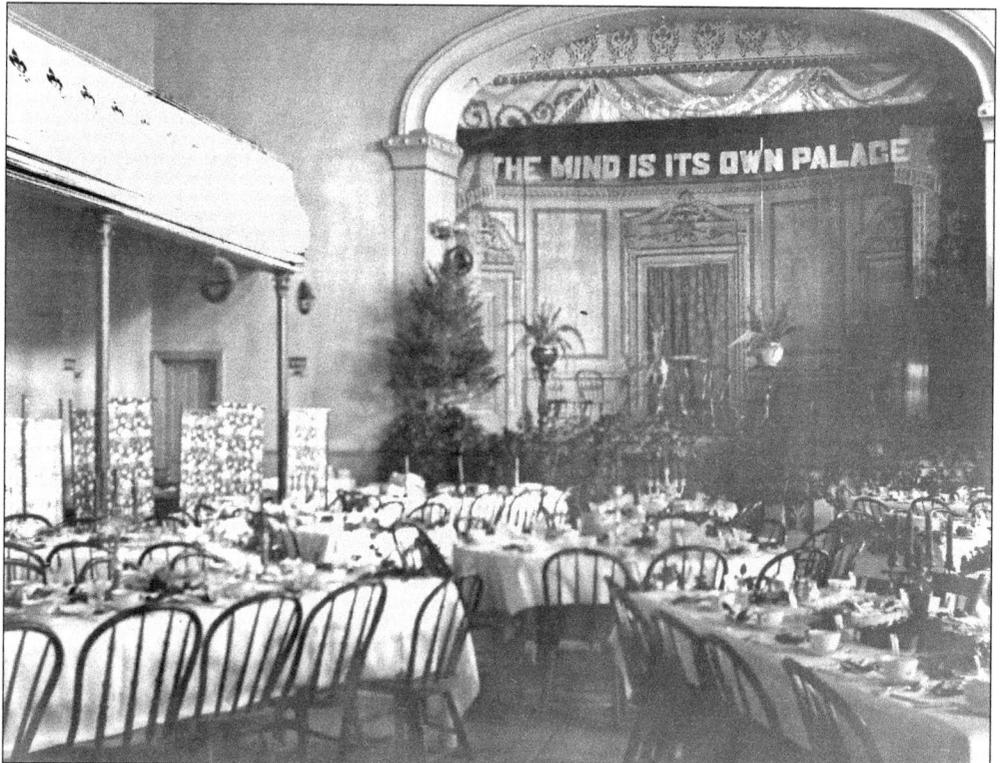

STAGE AND BALCONY. A beautiful hand-painted curtain with a Venetian theme provides a colorful backdrop for one of the many plays performed on stage. Gracefully curving above the main theater floor is the balcony, where ticket holders could get a bird's-eye view of the performance. On this stage in 1900, John B. Gordon, a former Confederate general, governor, and US senator from Georgia, gave a lecture. On September 26, 1932, an audience heard World War I hero and Medal of Honor recipient Sgt. Alvin C. York speak on "Why I Am for Prohibition."

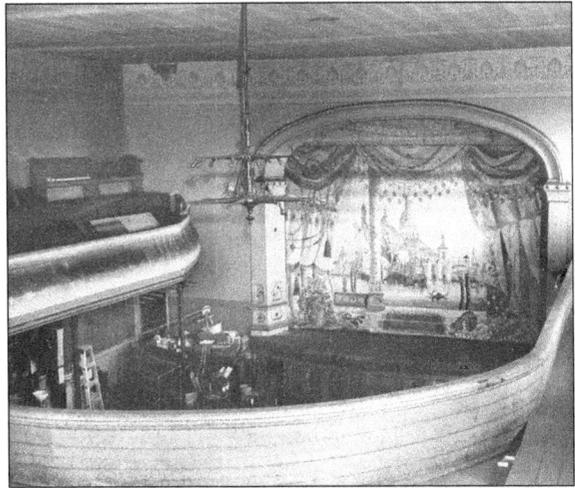

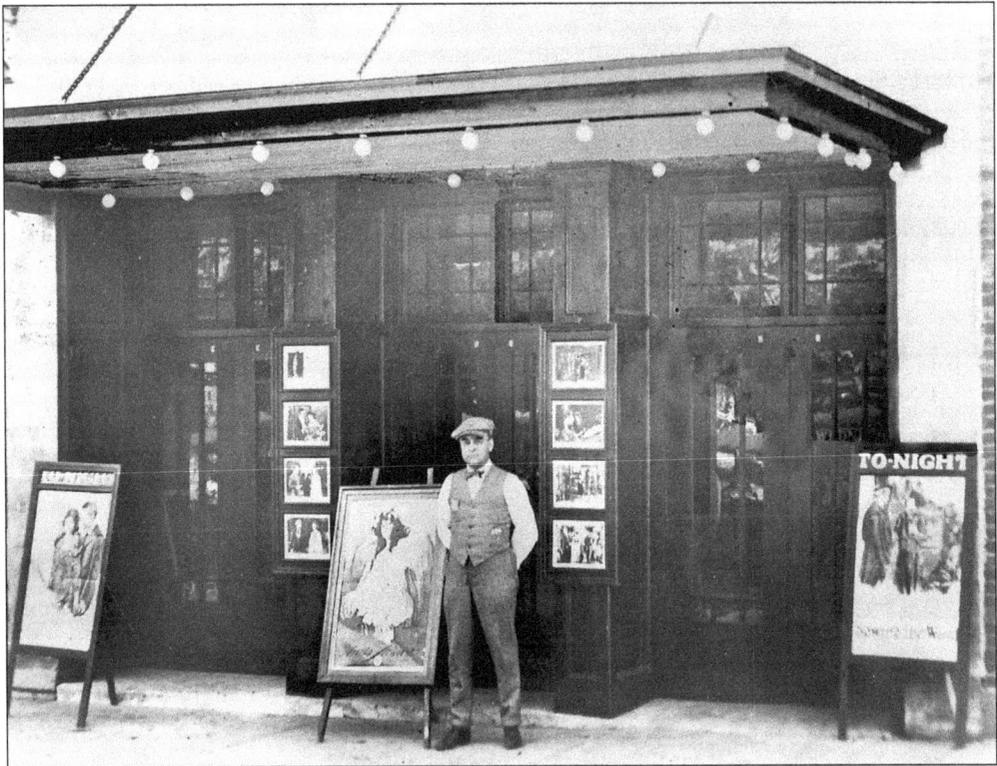

TEMPLE MOVIE THEATER. Bert Moeller from Detroit purchased this theater in 1913, and his sister-in-law Ella Moeller was given the responsibility to remodel it. She changed the entertainment format from Magic Lantern shows to silent movies with piano accompaniment. She also added electric lights to produce dramatic effects and placed fans on the walls. In the summer of 1921, the movie *Sowing the Wind*, starring Anita Stewart, played at the Temple Theater on Grand River Avenue. The theater closed in 1927.

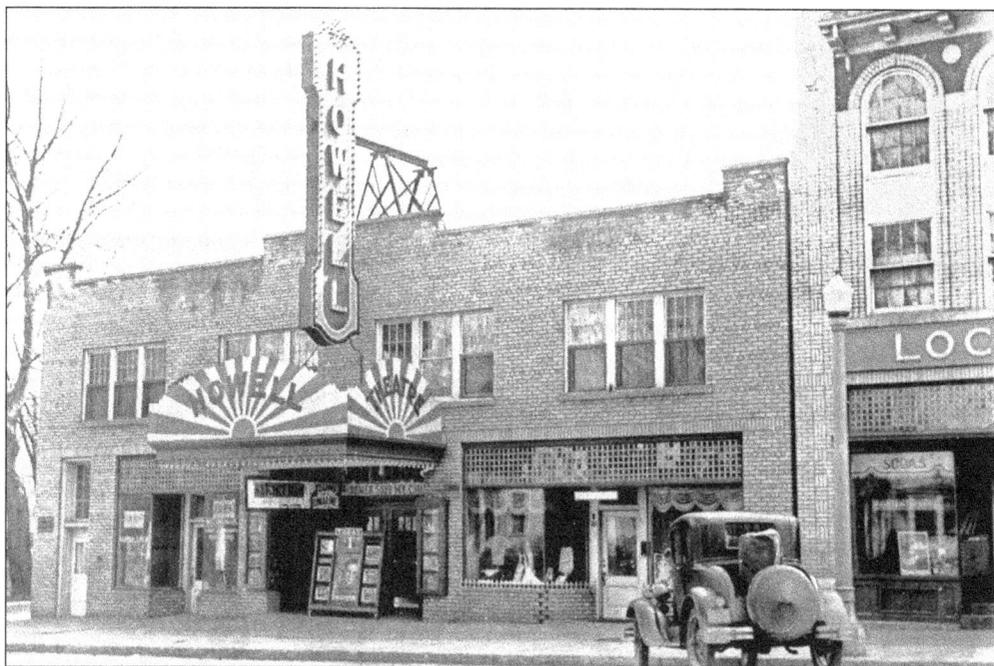

HOWELL'S SUNBURST MARQUEE. This Howell movie theater opened on December 11, 1928. The owners advertised a bowl-style seating arrangement, sloping floor, modern heating system, and the most advanced type of projectors of the time. The first movie at this theater was *Show People*, which starred Marion Davies and William Haines. In 1931, during the height of the Depression, triple features were often shown. The marquee advertises the movies *The Hatchet Man* (about the Chinese tong wars in San Francisco), starring Edward G. Robinson; *Fireman, Save My Child*, a 1932 film featuring Joe E. Brown; and *Trapped in a Submarine*.

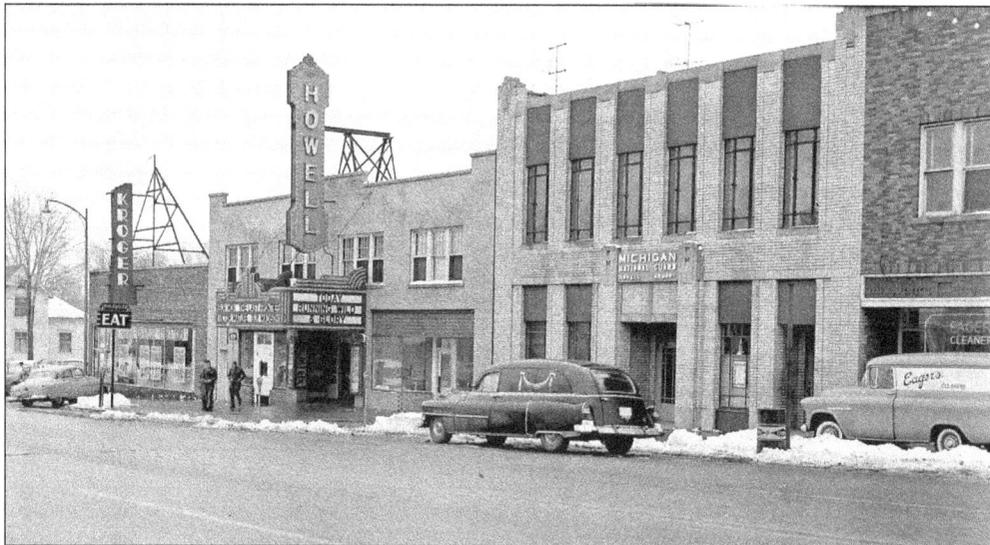

THE LAST FRONTIER. In the winter of 1955, sandwiched between the Michigan National Guard Armory and Kroger grocery, Howell's movie theater is showing *The Last Frontier*, starring Victor Mature, Guy Madison, Anne Bancroft, and James Whitmore. This western was set during the Civil War at an isolated Army fort in the far reaches of the American frontier.

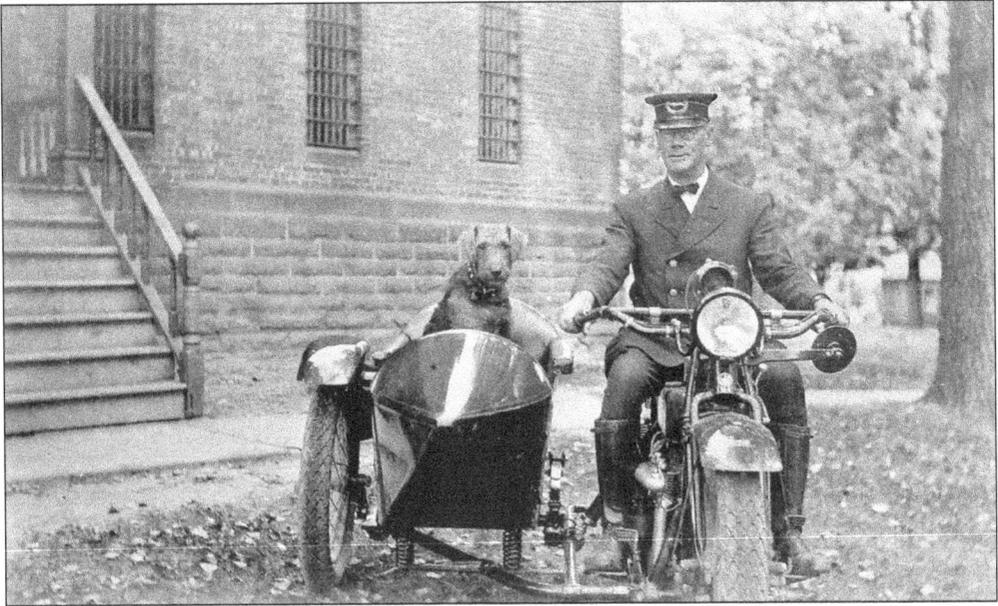

CHIEF ROYAL HARDY (1871–1954). Serving as the city of Howell's police chief from 1921 to 1935, Royal Hardy sits astride the police motorcycle with his faithful dog in the sidecar. This photograph was taken next to the jail, which was located behind the courthouse. Check out the bars on the windows.

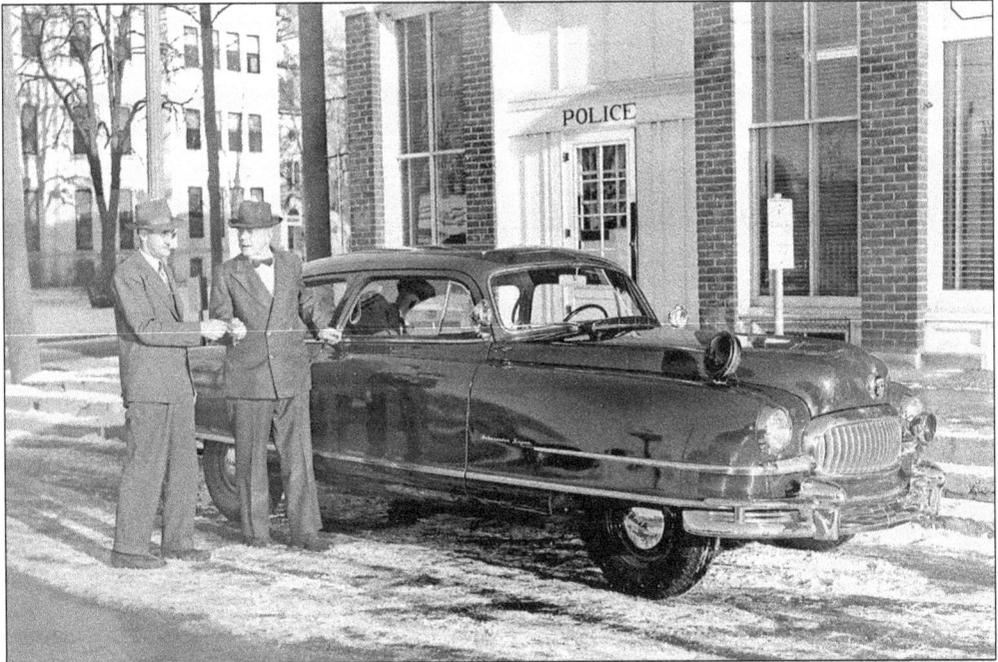

NASH AMBASSADOR SUPER. In the winter of 1951, police chief Fred K. Cronenwett (right) received the keys to a new Nash Ambassador Super patrol car. The Nash Ambassador Airflytes were considered the "cars of the future." Its distinctive and futuristic styling had a new vertical-bar grill, enclosed wheels, guardrail front bumpers, sloping fastback, and one-piece windshield. In 1951, the Howell Police Department was located at the corner of Michigan Avenue and Clinton Street.

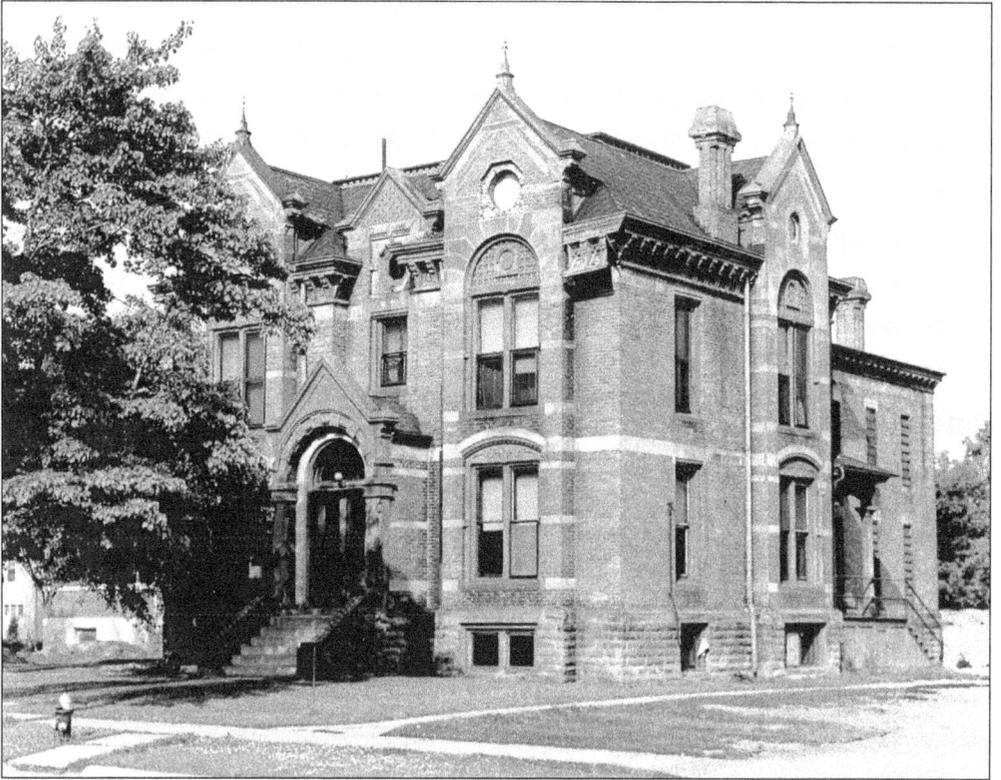

LIVINGSTON COUNTY JAIL. Constructed for a cost of $8,000 in 1888, the jailhouse was located at the corner of State and Clinton Streets, directly behind the courthouse. This photograph was taken February 28, 1932. The sheriff's residence is in the front, and the jail is in the rear area.

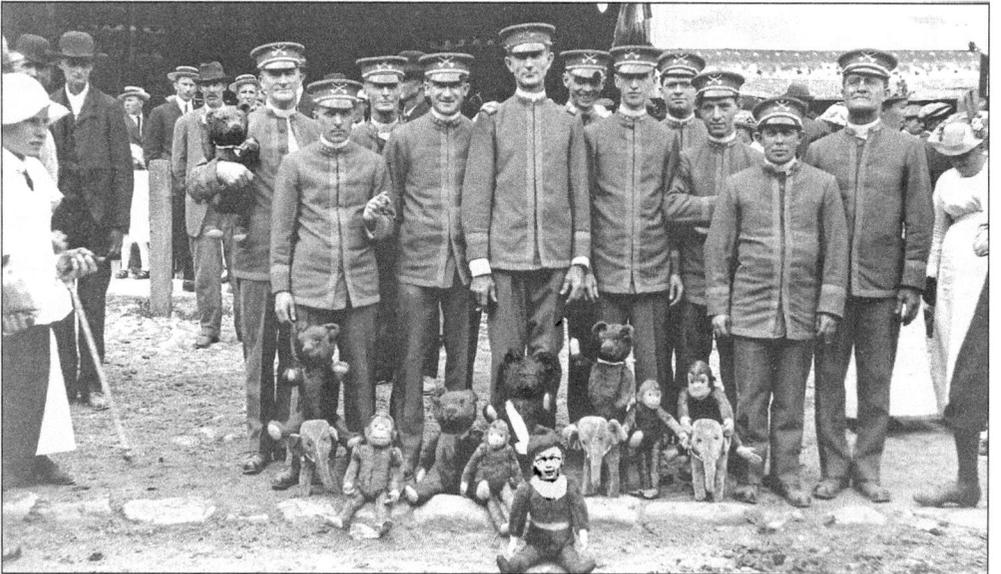

FIREMEN POSE WITH TOYS. From September 1 to 4, 1914, volunteer firemen sold teddy bears, stuffed monkeys and elephants, and other toys to raise funds to purchase new uniforms and fire equipment. Standing in the center of this image is fire chief Earl Sharpe.

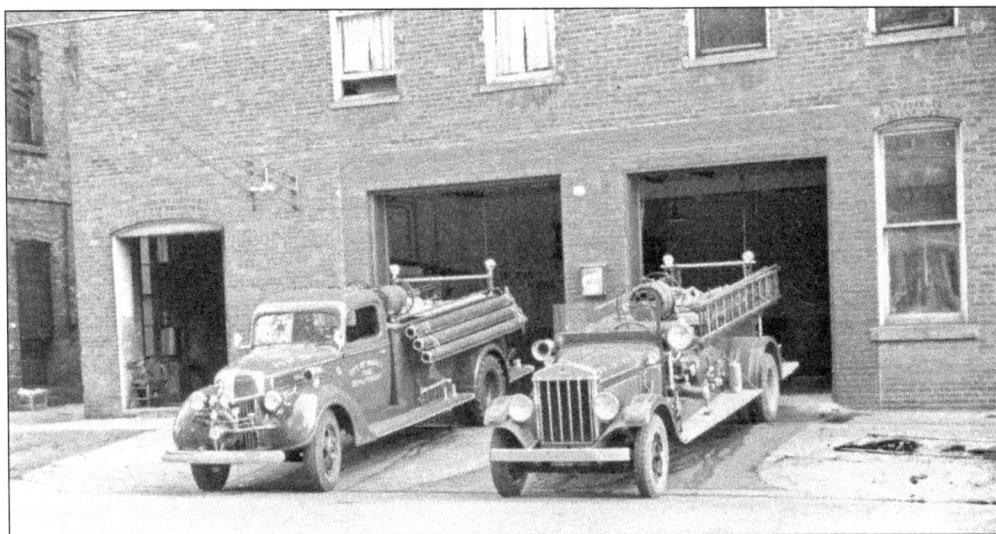

FIRE ENGINES. On the right is a 1931 REO Obenchain-Boyer fire truck. Parked on the left is a 1941 Ford truck equipped with an American Fire Apparatus chassis; this vehicle replaced a 1924 REO fire truck.

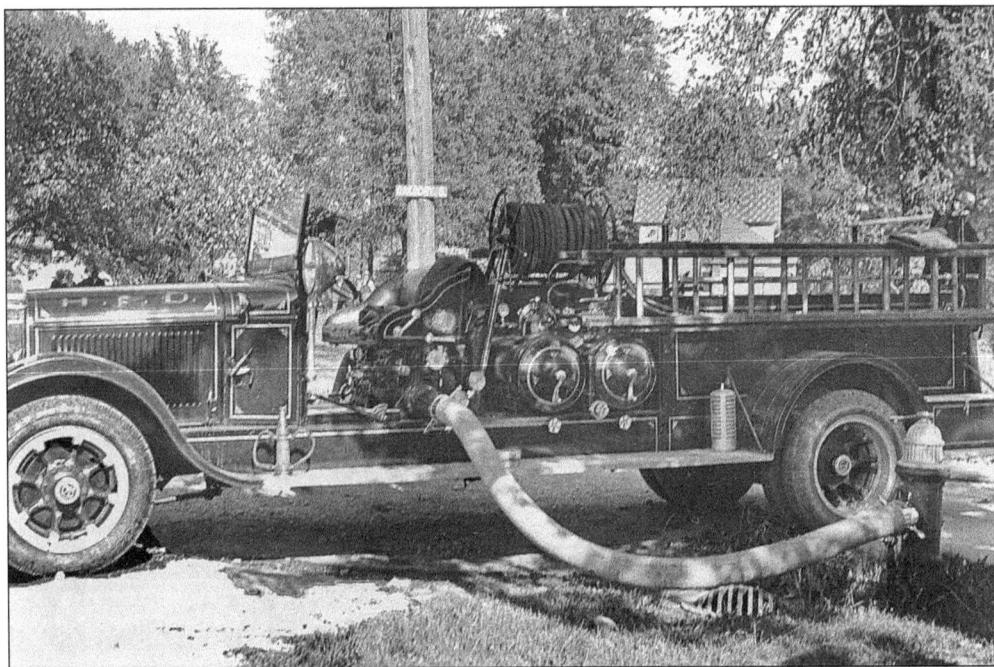

1931 REO. This May 28, 1932, photograph shows a Howell Fire Department truck outfitted with Obenchain-Boyer fire apparatus and two lead-lined, 40-gallon chemical tanks. This fire engine could pump 500 gallons a minute from a hydrant or draft source. R.J. Hall was selected as the caretaker for this vehicle during its use by the city. When decommissioned, it was purchased by Father Quinn, a Catholic priest in Detroit. Eventually, it was obtained by L&L Salvage in Paw Paw, Michigan, where it is currently on exhibit and retains the Howell Fire Department lettering.

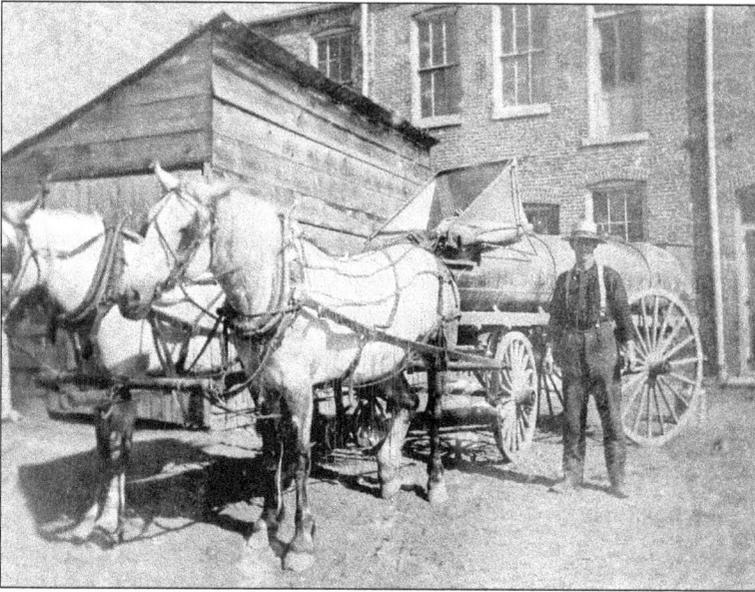

WATER WAGON. In 1892, the village provided this water wagon to spray the streets to keep the dust suppressed and wash horse and oxen droppings from the main crossings.

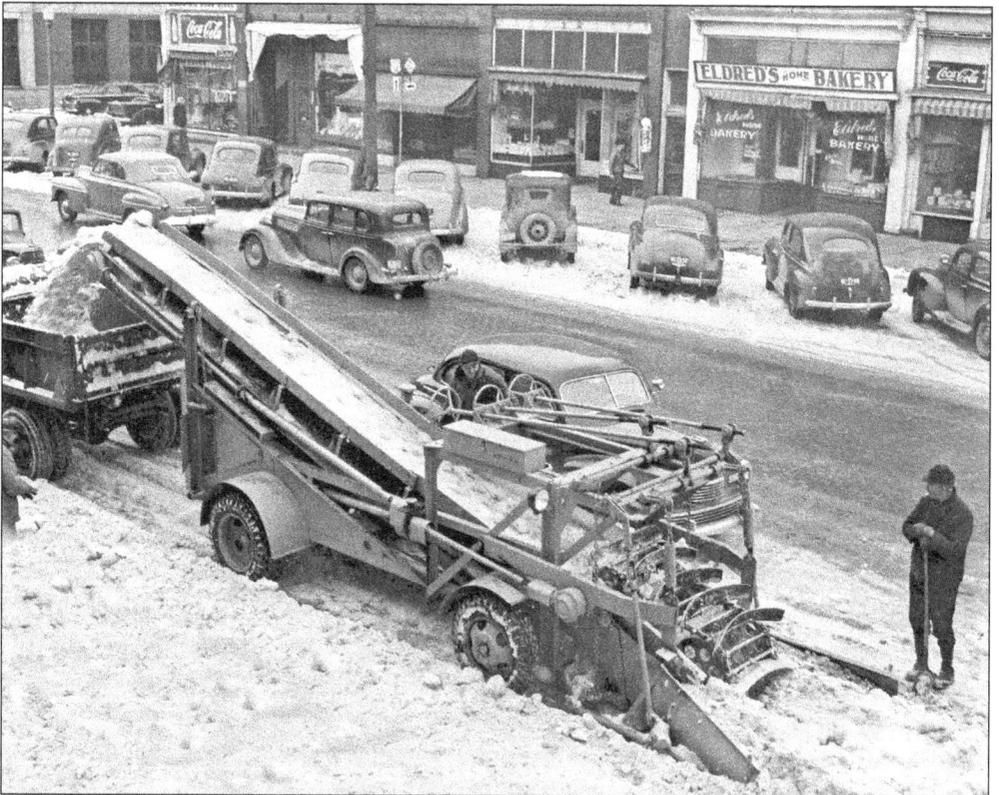

SNOW REMOVAL. Howell's city council approved the purchase of this conveyor belt snow-removal machine in the fall of 1947. In the background are Baldwin's Drug Store, Yax Jewelers, a barber pole, Eldred's Home Bakery, and signs designating highways Michigan 155 and US 16.

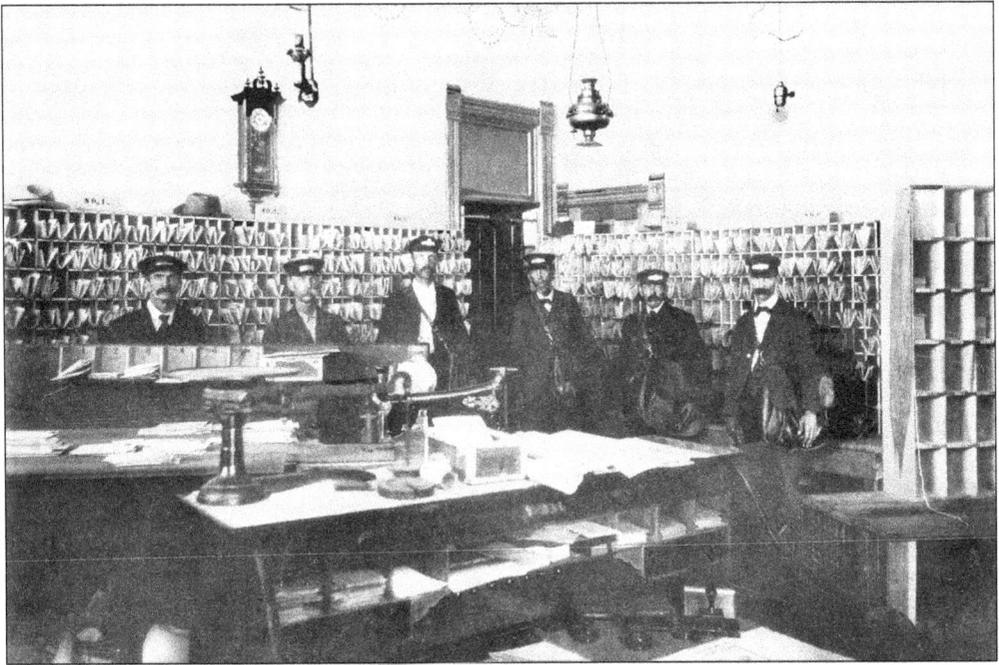

POST OFFICE ON NORTH MICHIGAN AVENUE. The six postmen in this image are unidentified. Note the leather mailbags hanging from their shoulders and the scales and cancellation stamps on the tables. Suspended from the ceiling are three different light sources: gas, kerosene, and electric lights.

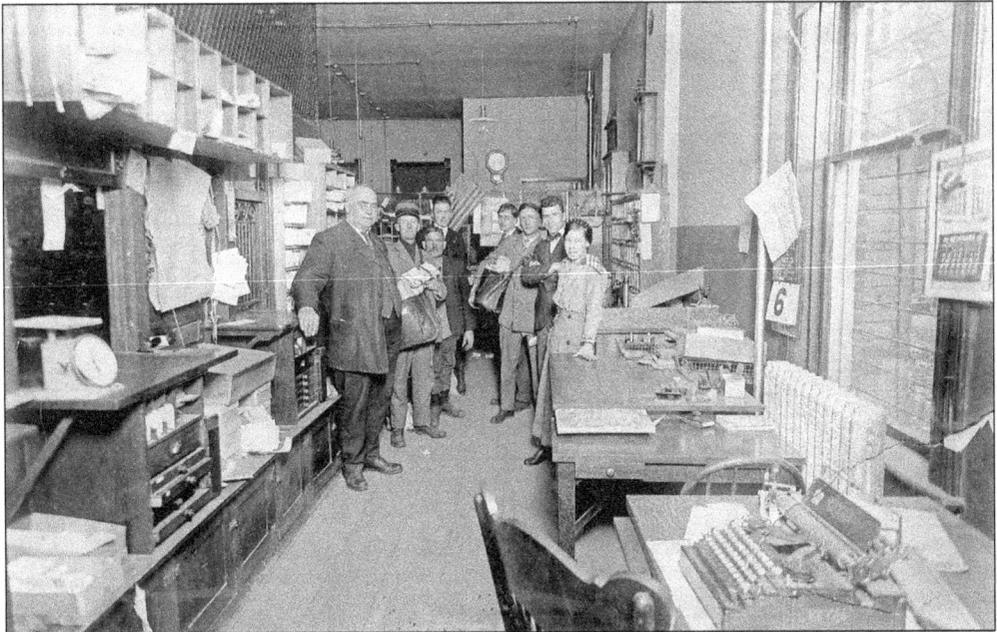

POSTAL STAFF. America was engaged in World War I and Christmas was less than three weeks away when the workers of the Howell Post Office on North Michigan Avenue posed for this photograph on Thursday, December 6, 1917. The staff includes, from left to right, W.H.S. Wood, Ross Hildebrandt, Fred Dean, Kenneth Granger, Arthur Willard, unknown, Bird Hight, and Sarah Cooper.

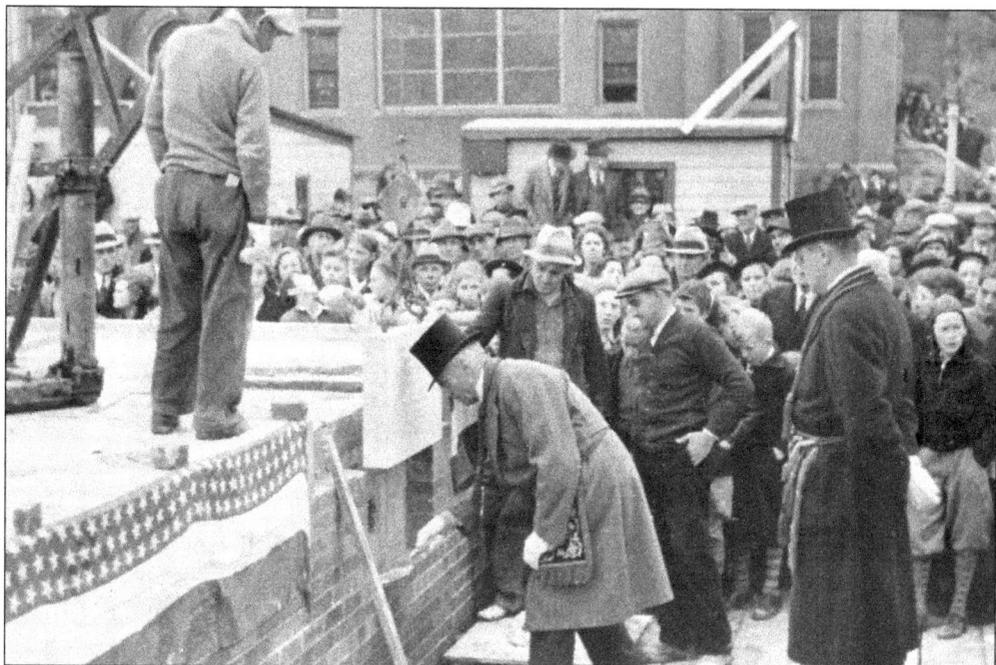

POST OFFICE CORNERSTONE CEREMONY. The post office, which had been at the corner of Michigan Avenue and Sibley Street since 1926, relocated to Walnut Street in 1936. On October 22, 1936, postmaster Al Pfau arranged a dedication ceremony for the facility. The grand master of Michigan's Masons, Neil E. Reid, was invited to lay the cornerstone for the new building. Howell's high school band, Knights Templar, and members of Howell Masonic Lodge No. 38, F&AM (Free & Accepted Masons), were participants in this event.

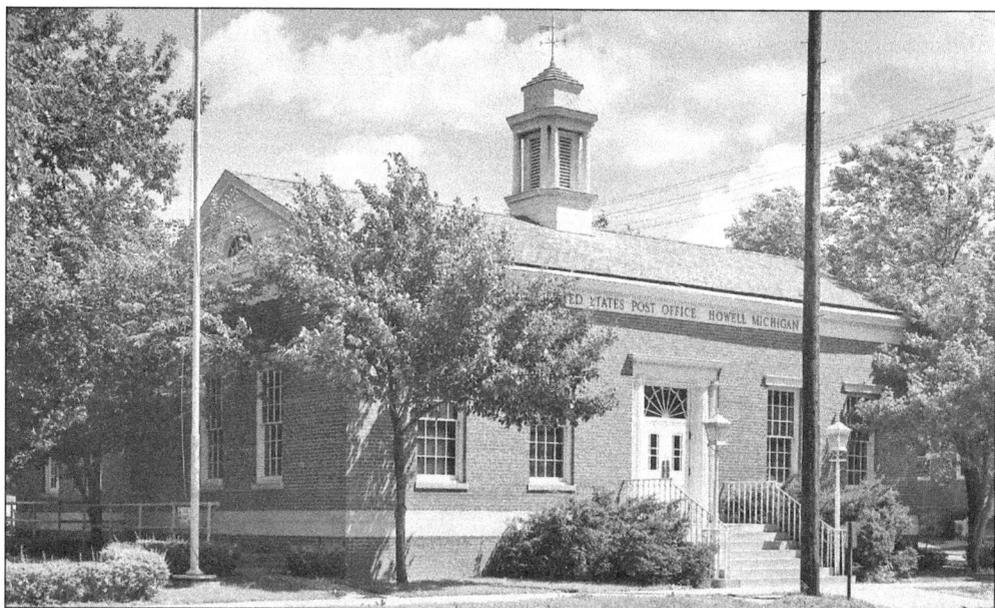

POST OFFICE. For more than 50 years, the post office on Walnut Street served the needs of the community. When a new building was constructed on Michigan Avenue, the old post office was purchased by the Ann Arbor Railroad and is currently used as its headquarters.

Five

ALL ROADS LEAD TO HOWELL

Numerous settlers arriving in Michigan during the 1830s and 1840s migrated across Lower Michigan from Detroit by following the old Grand River Trail. Originally a footpath, the trail evolved as more people followed it, and the road was widened, straightened, and somewhat improved. In the 1850s, two plank roads were constructed linking Detroit to Michigan's capital city, Lansing. The Detroit-Howell Plank Road, coupled with the Howell-Lansing Plank Road, allowed travelers to make the Detroit-to-Lansing trip through Howell. Plank road companies charged fees to use the roads, and tollgates were generally erected every five miles.

The plank roads (sometimes called turnpikes) did, on average, only mediocre business. With the development of the railroads in the later decades of the 19th century, most plank roads went out of business, and the old plank toll roads reverted to public use, usually in a deteriorated state. This was certainly true for Grand River Road, as it had come to be called in the late 1800s.

In the second decade of the 1900s, improvements were again to be made to the "Grand River route." About 1909, the Michigan State Highway Department began designating primary roads through the state as state trunk lines. One obvious choice was the Grand River Road connecting Detroit, through Howell, to Lansing.

Railroads played an essential role in the development of Howell and the surrounding countryside. Steel rails brought a new energy, enterprise, and progress to the community while connecting Howell to cities and towns throughout Michigan. Progress seemed to follow the rails. Railroads provided stimulus to the livestock industry, especially to sheep and Holstein diary farming. The Pere Marquette and Toledo, Ann Arbor, and Northern Michigan Railroads gave rise to Howell's prosperity and growth of farms and industry, providing movement of agricultural and industrial goods, and passenger traffic.

The haunting noise of the whistle and the clanging of the bell as a train approached town would catch everyone's attention. A traveling salesman's sample cases, trunks, suitcases, cardboard-bound parcels, boxes, packages, newspaper reporters, and carriages from local hotels could be found near the depot platform. Some men and boys who had nothing to do often sauntered over to watch the trains arrive.

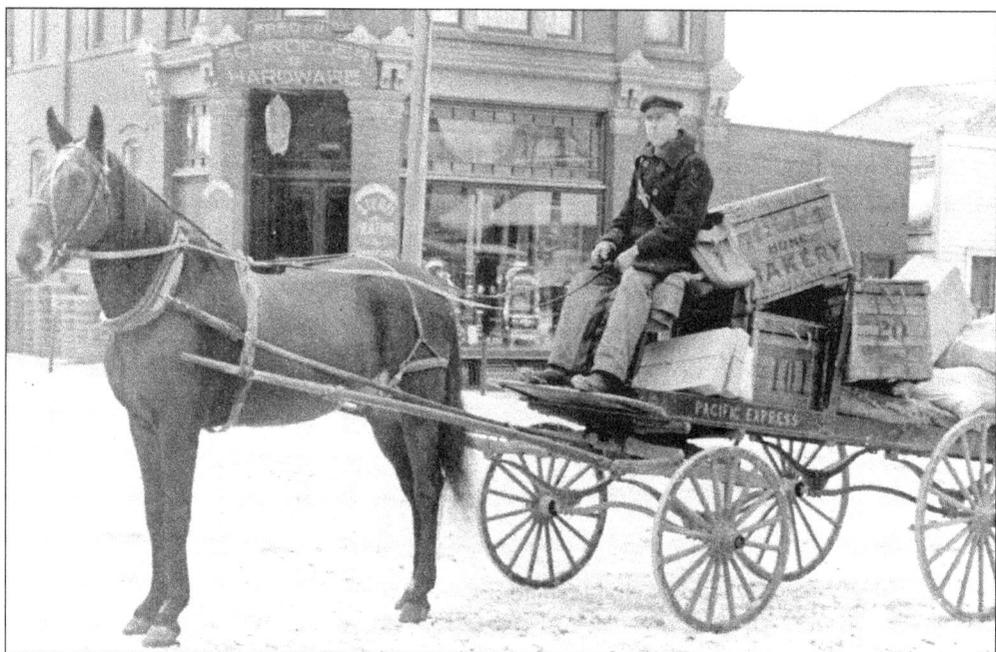

ED BEACH AND HIS PACIFIC EXPRESS WAGON. Beach was a familiar sight in the 1890s as he picked up and delivered packages at both the Pere Marquette and Ann Arbor Railroads' freight depots and then delivered them to local businesses and residents. Here, Beach is at the corner of Grand River Avenue and Walnut Street in front of Schroeder Hardware store. In the window of the hardware store are wood- and coal-burning stoves. The boxes on his wagon are labeled "Home Bakery"; over his shoulder hangs a leather satchel that stores his invoices, receipts, and additional records.

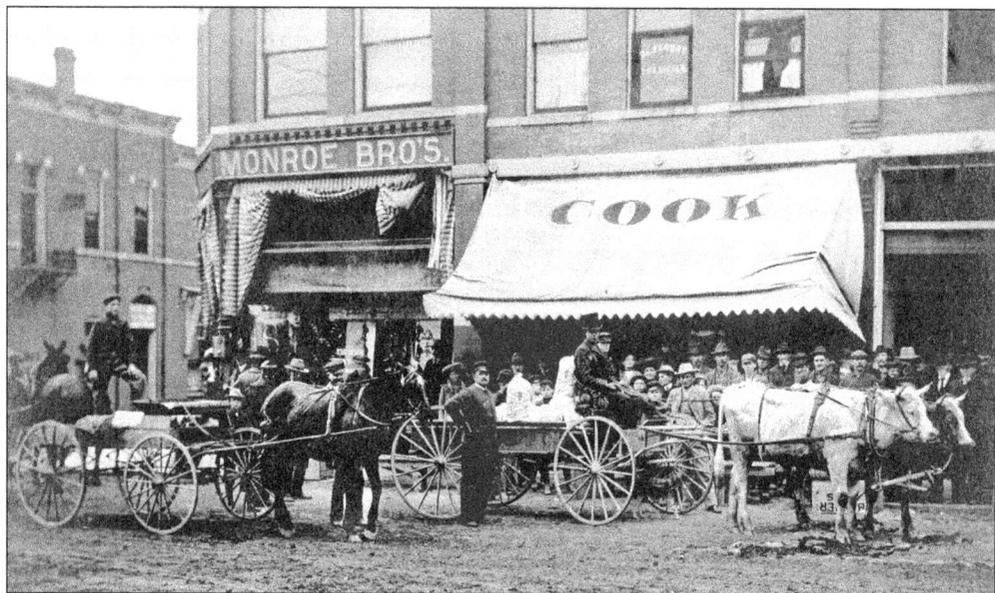

DELIVERING BAGS OF FLOUR. A yoke of oxen has arrived at Cook's Grocery to deliver large sacks of flour, and many local folks have gathered to have their image taken, probably in the 1890s, by a local photographer. Dr. Egbert, a local physician, had his office above the grocery store, and the Monroe Brother's store is seen on the corner of Grand River and Michigan Avenues.

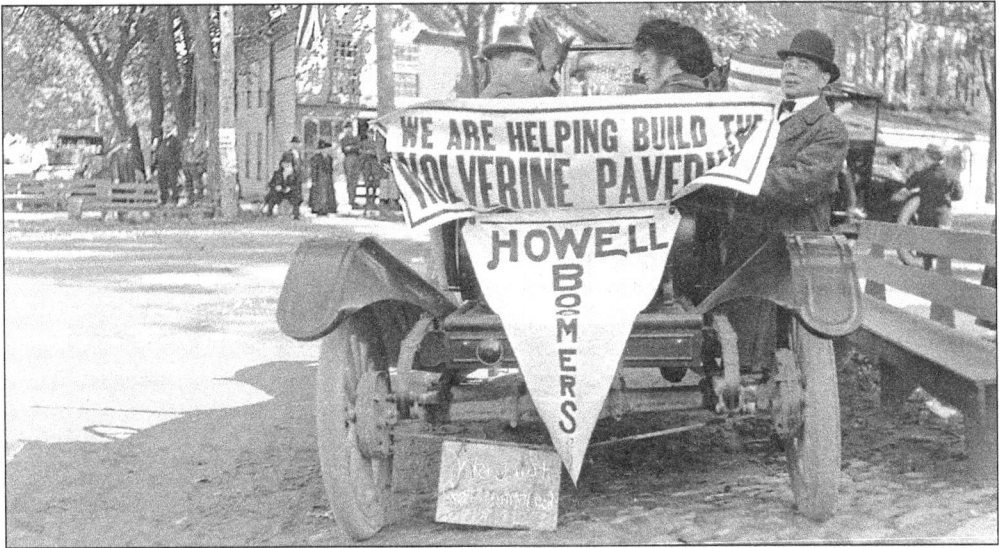

THE HOWELL BOOMERS CLUB. The Howell Commercial Club was started in 1910. Its president was R.B. McPherson, and the secretary was Riley Crittenden. From 1914 to 1919, it was known as the Howell Boomers Club. Members August Schmitt, William McPherson, Mac Smith, and Paul Uber were instrumental in getting Grand River Avenue paved and obtaining streetlights. From 1919 to 1948, this club became the Howell Board of Commerce. In 1949, it was reorganized as the Howell Chamber of Commerce.

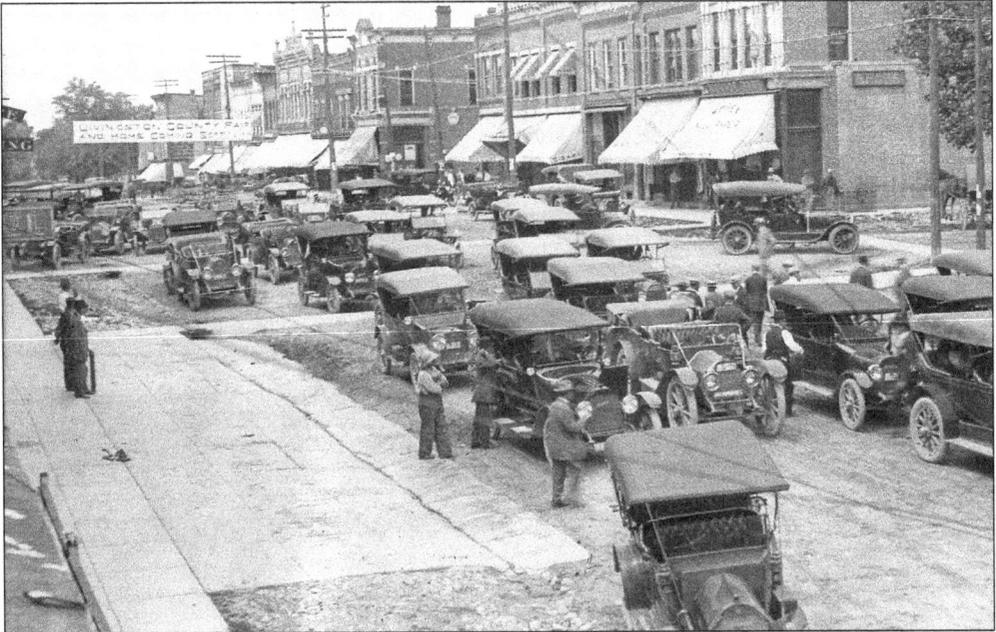

THE GREAT WOLVERINE PAVED WAY. In 1915, "The Great Wolverine Paved Way," known as Grand River Road, was nearing completion. This brick road connected Detroit to Lansing, passing through Howell. Looking west along Grand River Avenue, this image reveals an automobile rally that began in Lansing. Many people drove cars to Howell to participate in the celebration of paving Grand River. Notice many of the vehicles are right-hand drive. The banner in the background welcomes travelers to the Livingston County Fair and Home Coming in September.

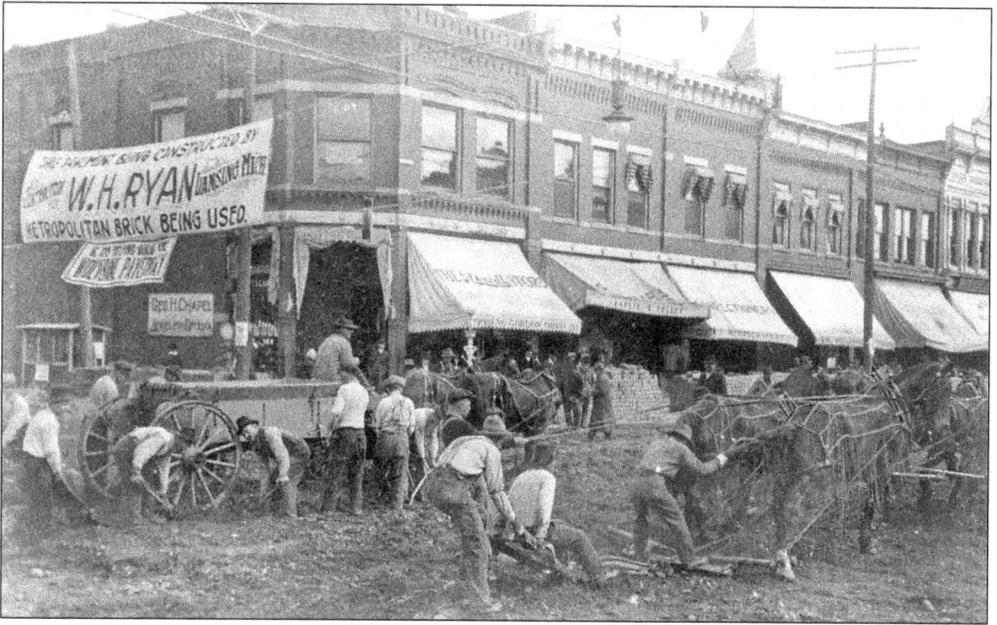

MICHIGAN AND GRAND RIVER AVENUES. The initial step in paving was plowing and grading the street. Bricks are stacked in front of buildings as horses, wagons, and laborers plow up Grand River. Businesses in the background include the corner Rexall Drug store, Fred W. Gordon's Drug Company, Larkin & Kruger's Grocery, and a confectionery. The banner reads, "This pavement being constructed by W.H. Ryan, Lansing, Michigan—Metropolitan Brick Being Used."

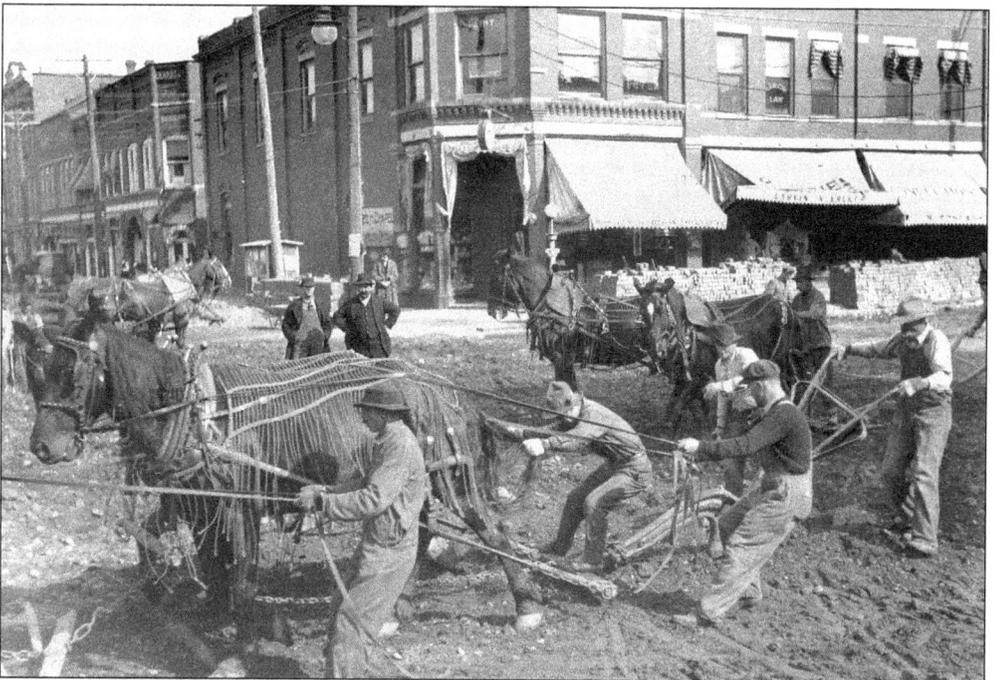

THE MAIN INTERSECTION. The boss stands in the middle of the intersection watching horses and men labor as they plow up the street. Straining against their hames, horses pull while a laborer provides added weight by standing on the plow; he holds onto the horses' tails for balance.

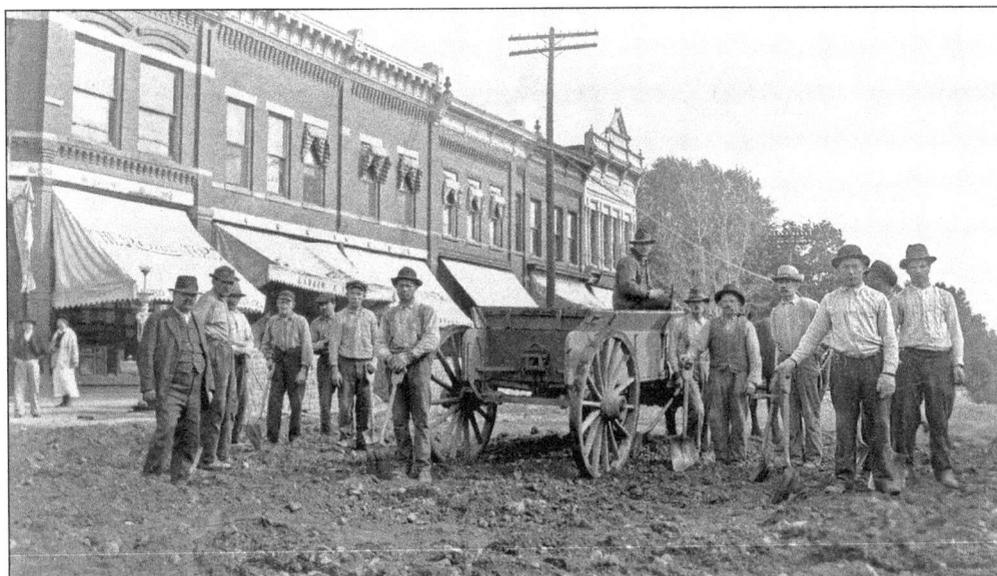

WORK GANG POSING ON GRAND RIVER AVENUE. It was rumored that most of the road-gang laborers were work-release prisoners from Jackson State Penitentiary. This image shows the crew in the middle of the street and buildings on the north side of Grand River east of Michigan Avenue in the background.

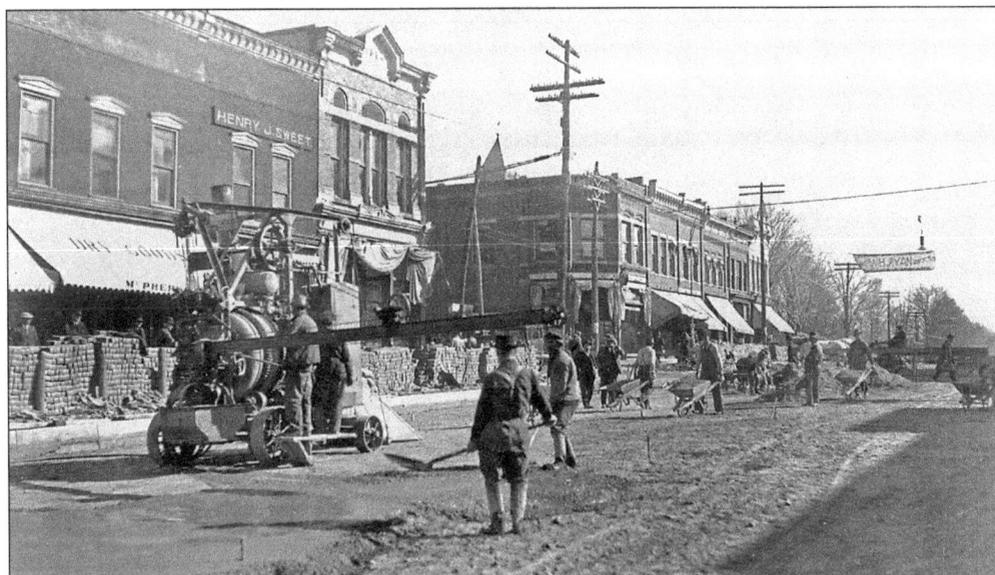

PAVING OF GRAND RIVER AVENUE. This Smith Steam-Powered concrete "paver" mixed cement on-site and moved as the work progressed. Stacks of bricks line the sidewalk. Two workers in the foreground are wearing rubber boots and spreading cement. After an eight-inch layer of cement was poured onto the road's surface, laborers laid bricks, and a steamroller pressed them into the cement. Finally, a layer of sand was swept into the cracks.

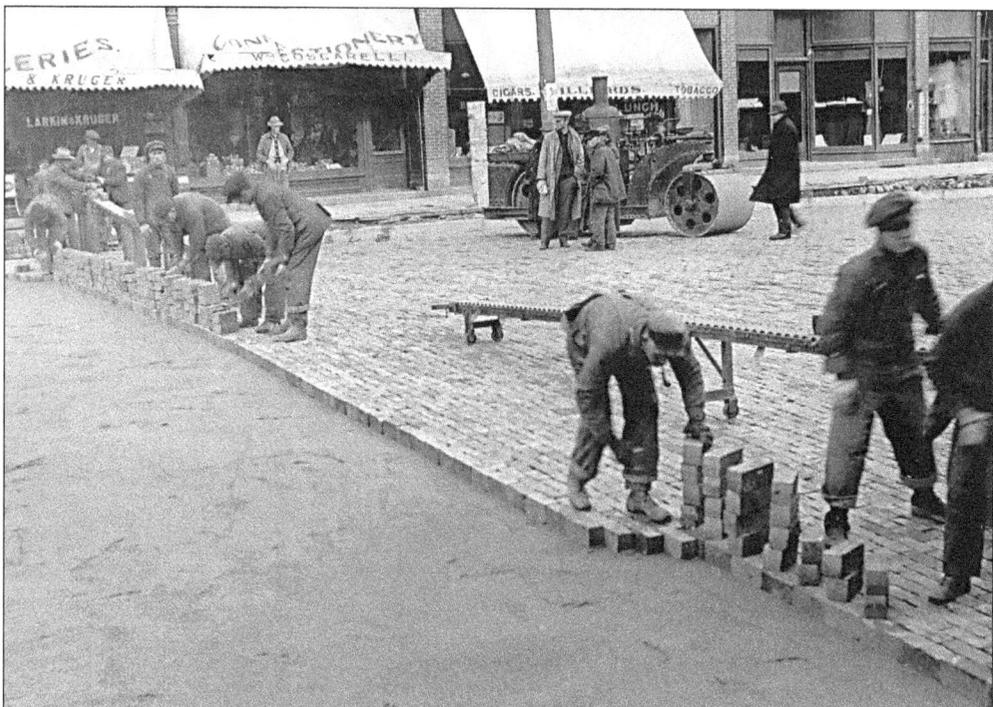

LAYING BRICKS. This road gang lays bricks in what was described as a backbreaking process. The view shows a steamroller in the background and a conveyor sending bricks to the workers. Buildings in the background include Larkin and Kruger's Grocery, William Coscarelli's Confectionery, and stores offering cigars, billiards, and tobacco.

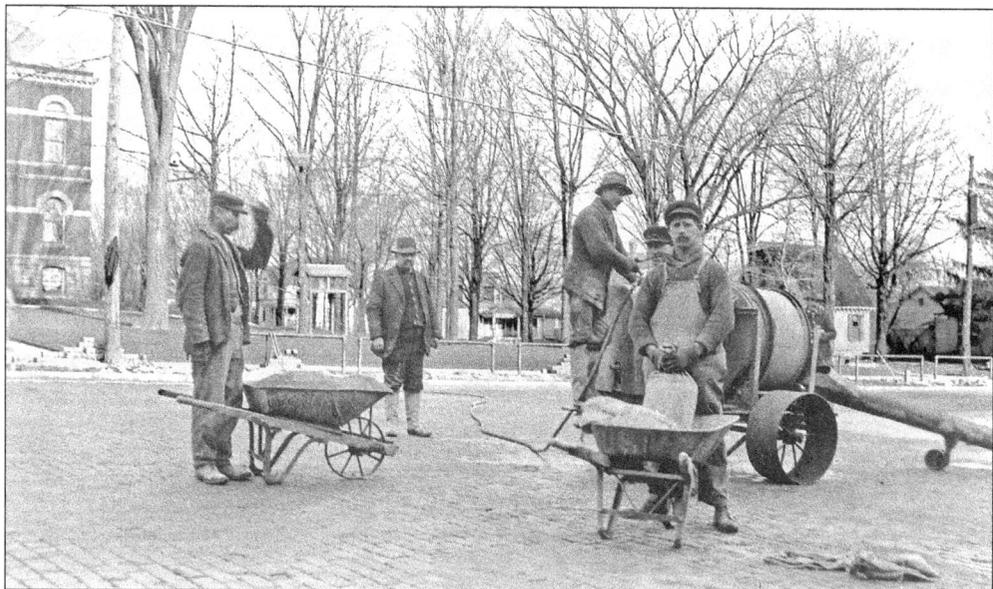

FINAL TOUCHES. By December 15, 1915, the final touches were being applied to Grand River Avenue. This crew is filling in the cracks between bricks in front of the courthouse. Note the water hose and smaller cement mixer, the workman with a bag of concrete mix in his hands, and two wheelbarrows. The hitching posts in the background are located in front of the courthouse.

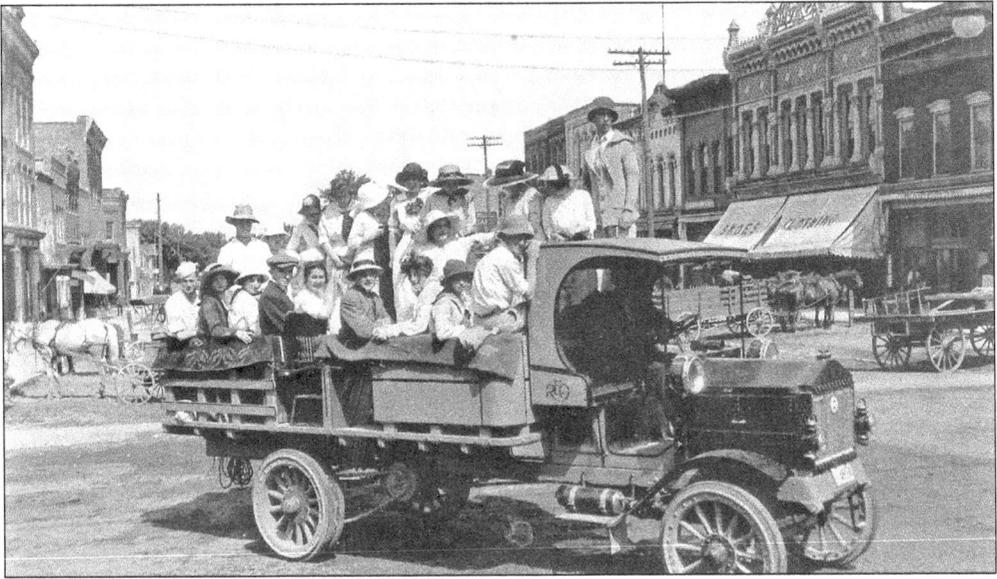

FIRST TRUCK IN HOWELL. Excitement spread through Howell in the summer of 1915 when a new two-ton REO truck drove into town. Many citizens were given a free ride through the streets of the city. As seen in this image, folks brought chairs and blankets to cushion their rides, while some people chose to stand. Visible is the truck's chain drive, hard rubber tires, and acetylene lamps, as well as horses, wagons, and buggy in the background. This REO truck was photographed at Howell's main intersection, Grand River and Michigan Avenues.

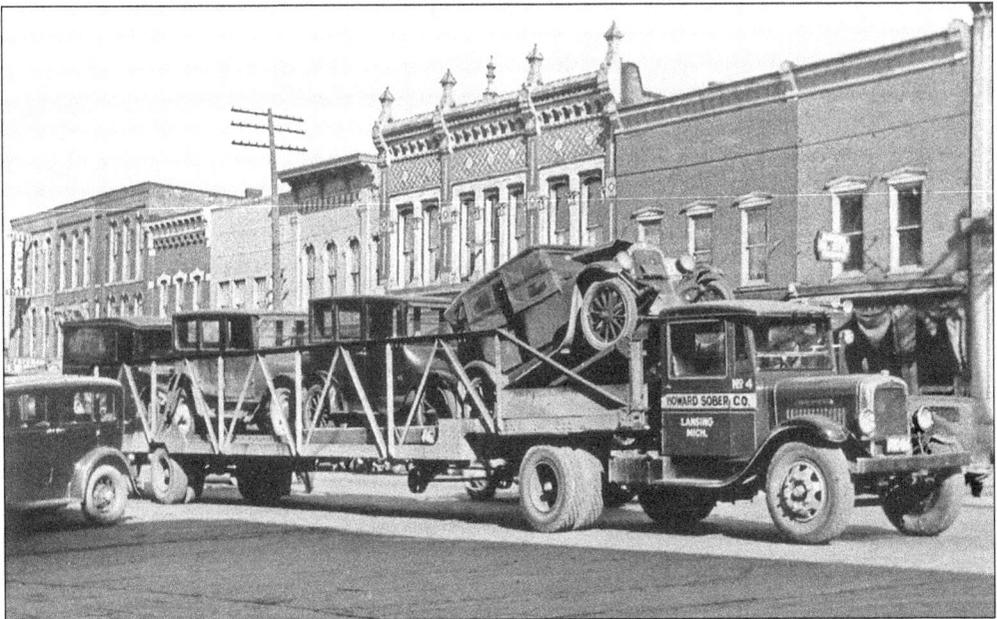

TO THE JUNKYARD. A 1930s flatbed truck on Grand River Avenue hauls vintage cars to the Howard Sober Company's junkyard in Lansing.

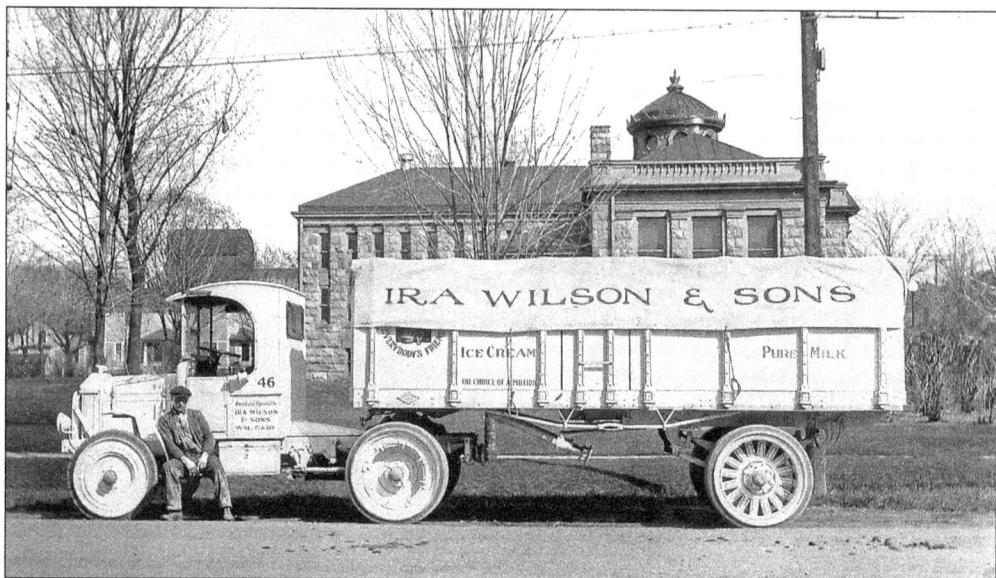

IRA WILSON AND SONS. Painted brilliant white, Wilson's fleet of dairy trucks advertises milk and ice cream. The company slogan was "Everybody's Friendly Diary and the Choice of a Million People." This milk truck is parked on the west side of the Carnegie library.

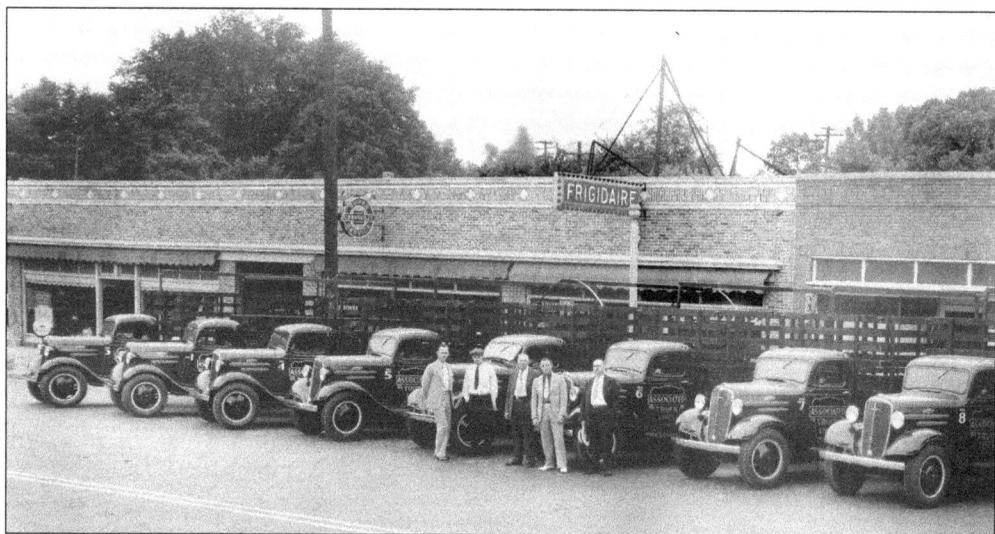

CHEVROLET TRUCK FLEET. W. Ford Johnson, president of Associated Truck Lines, purchased a fleet of ten 1935 Chevrolet trucks from Glenn Slayton. In this photograph are, from left to right, Jess Spalding, Glenn Slayton, Fred Slayton, W. Ford Johnson, and unidentified. (Courtesy of Mary Lou Hilton.)

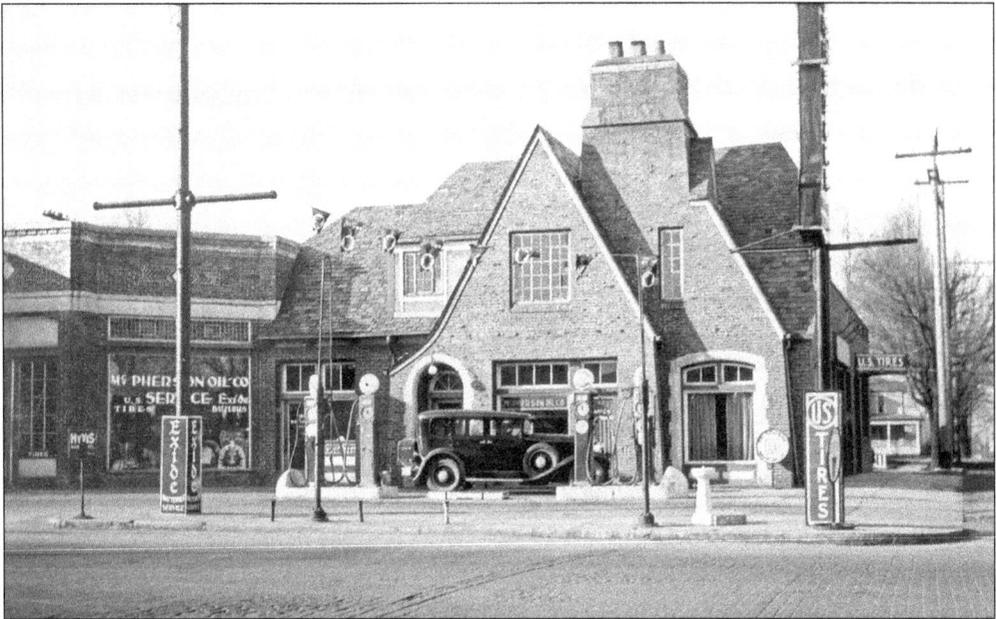

MCPHERSON OIL COMPANY. At the corner of Grand River Avenue and Center Street was McPherson's service station, built in 1928. Customers could purchase gasoline at their pumps, as well as oil, batteries, and tires. This photograph, taken on April 23, 1932, captures a wonderful image of the gas station and a public drinking fountain located on the sidewalk.

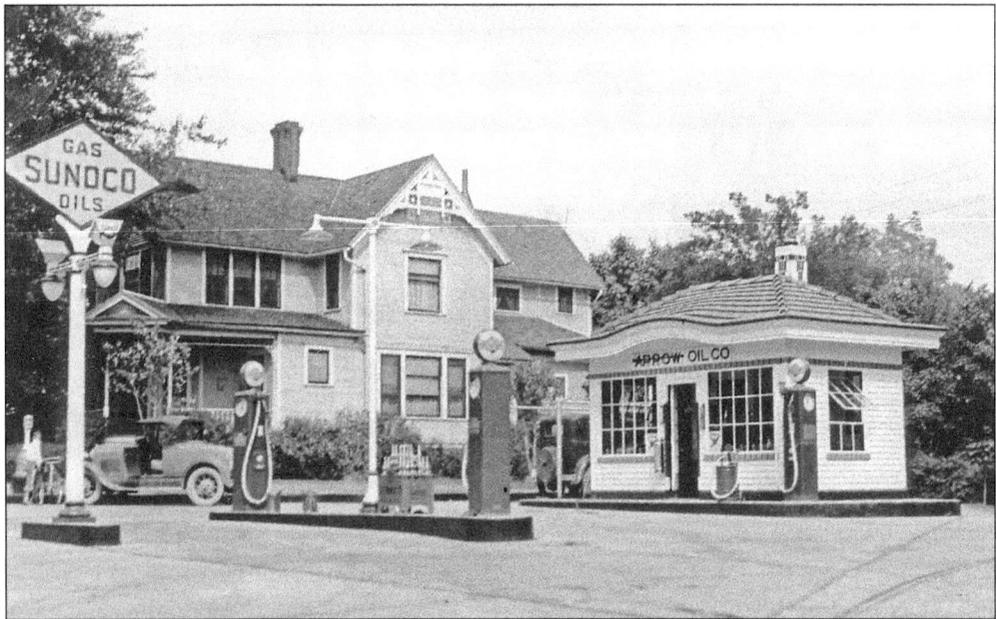

ARROW OIL COMPANY, 1920s. Located at the northeast corner of Grand River Avenue and Byron Road was a Sunoco gas station owned by the Arrow Oil Company. Currently, this site is a parking lot for Citizens Insurance.

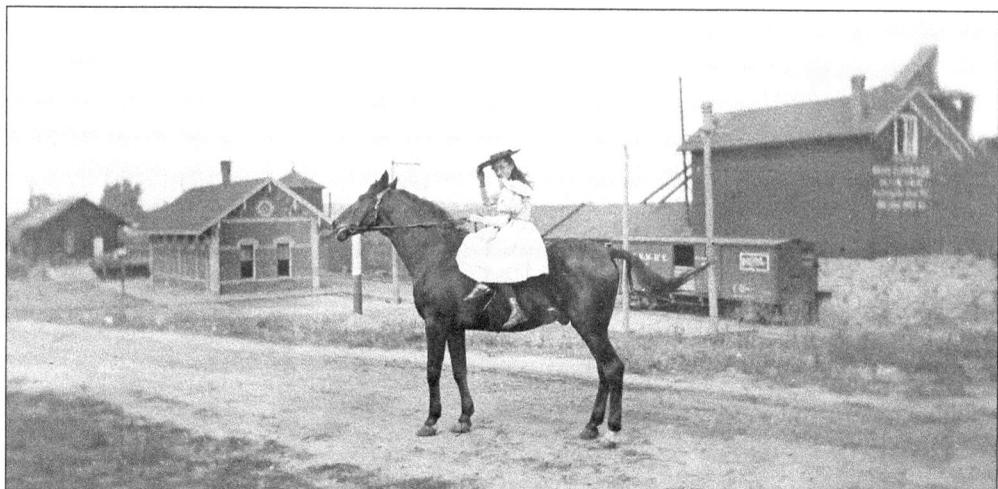

YOUNG GIRL ON HORSE. This unidentified girl is riding sidesaddle at the Ann Arbor Railroad depot. The depot is to the left, and one of Howell's mills is to the right.

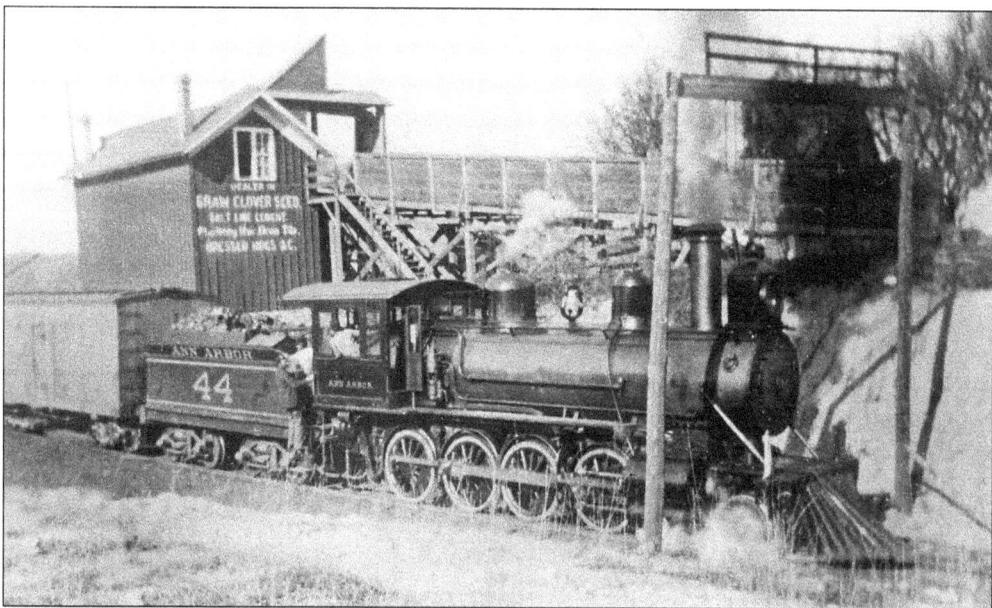

ENGINE NO. 44 IN 1893. Photographed near the Ann Arbor Railroad depot, the engine has two guide wheels, eight drive wheels, and a cowcatcher in front. The advertisement on the grain elevator reads, "Dealer in Grain, Clover, Seed, Salt, Lime, Cement, Plastering, Drain Tiles and Dressed Hogs, Etc."

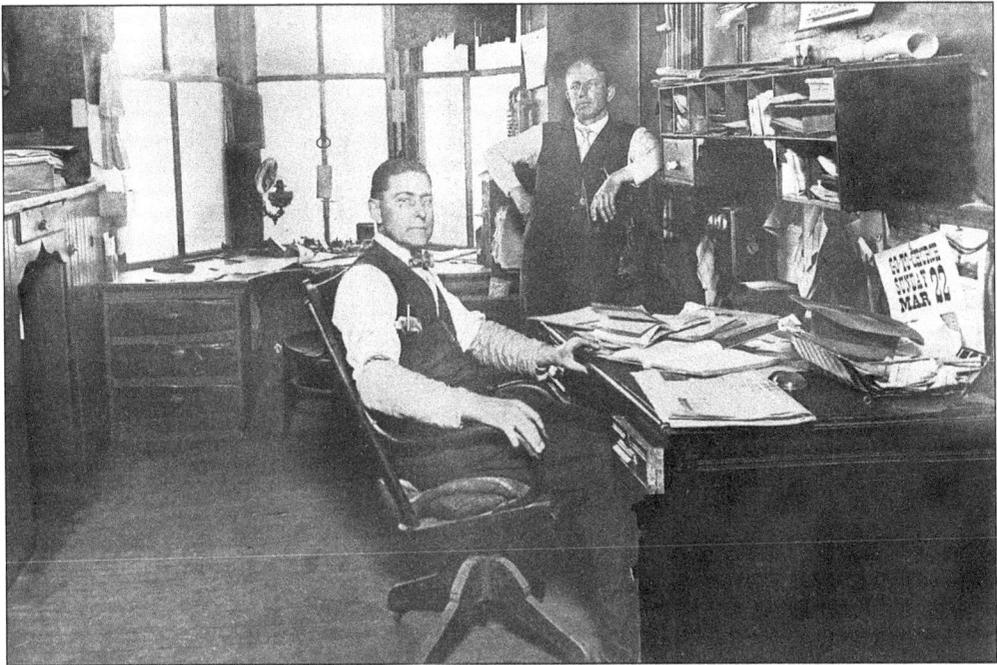

THE STATIONMASTER. John D. Hamilton, seated at his desk, worked as stationmaster at Howell's Ann Arbor Railroad depot for many years. His assistant, in the background, is a Mr. Wright. In this January 1914 photograph, the sign on Hamilton's desk reads, "Go to Church, Sunday, March 22." An oil lamp attached to the wall illuminates the back desk where the telegrapher's key is located. Readers can presume that train schedules are piled on the stationmaster's desk.

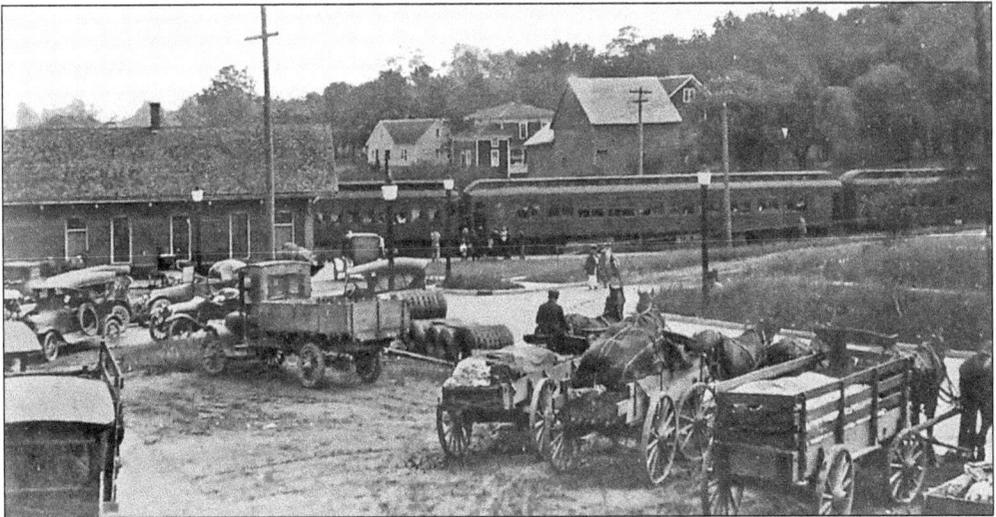

PASSENGER TRAIN AT THE DEPOT. When the train arrived, the depot became a hub of activity. Passengers exited the railroad cars, wagons were loaded, and horses pulled loads to various businesses. Trucks and cars were ready to motor people to their destinations. As the passengers left, workers loaded manufactured items, barrels, boxes, and suitcases into the baggage and freight cars. Soon, the conductor called out, "All abo-o-o-a-r-d!" Passengers climbed into the cars, the mighty engine's bell began to ring, and the haunting whistle blew, signifying the train would soon be rolling down the tracks to the next town.

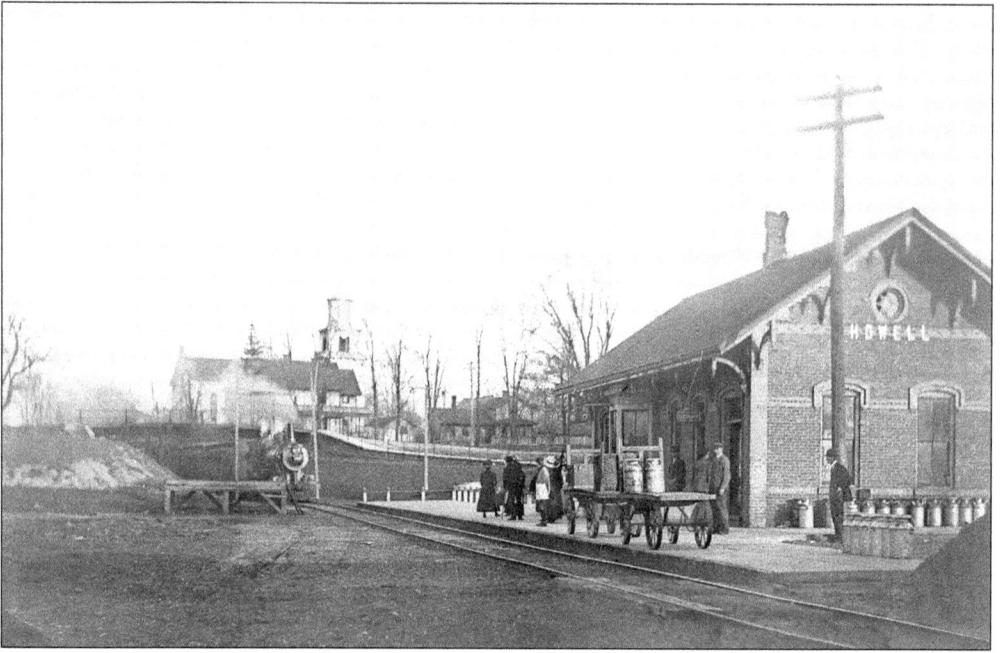

HOWELL DEPOT. The Toledo-Ann Arbor Railroad passenger and freight depot was located at the foot of North Walnut Street at 128 Wetmore Street. In this image, the engine is approaching the depot platform, where several passengers are waiting to board the train. In the background is the steeple of the First Baptist Church of Howell.

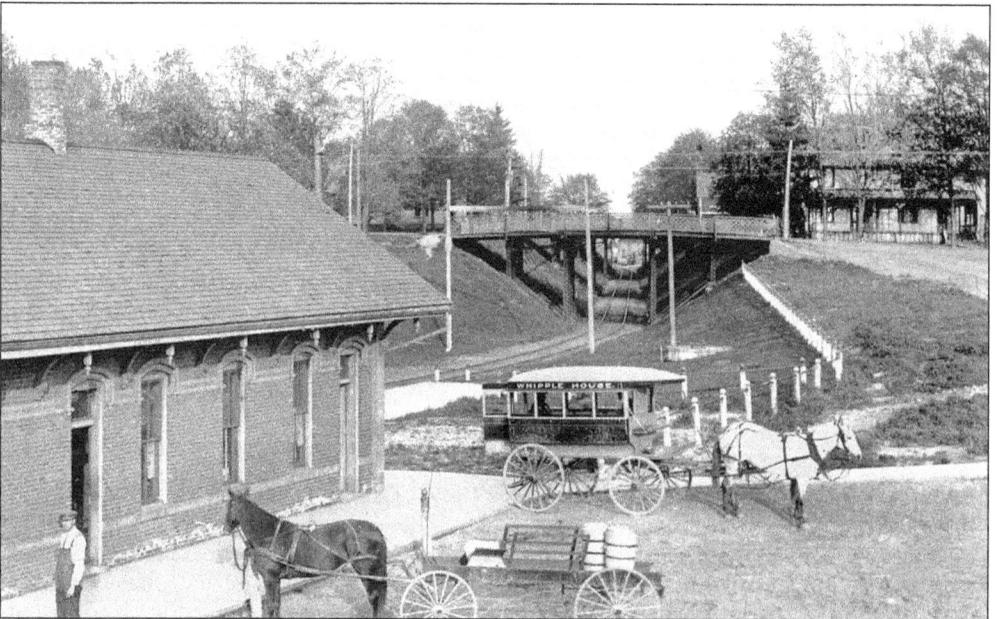

TOLEDO-ANN ARBOR RAILROAD DEPOT. An attractive brick depot was constructed on the north side of Howell by the Ann Arbor Railroad in 1885–1886. In this image, an omnibus from the Whipple House (owned by Henry Whipple), at the northwest corner of South Michigan Avenue and Sibley Street, is awaiting the arrival of the train. In the background is the Michigan Avenue Bridge.

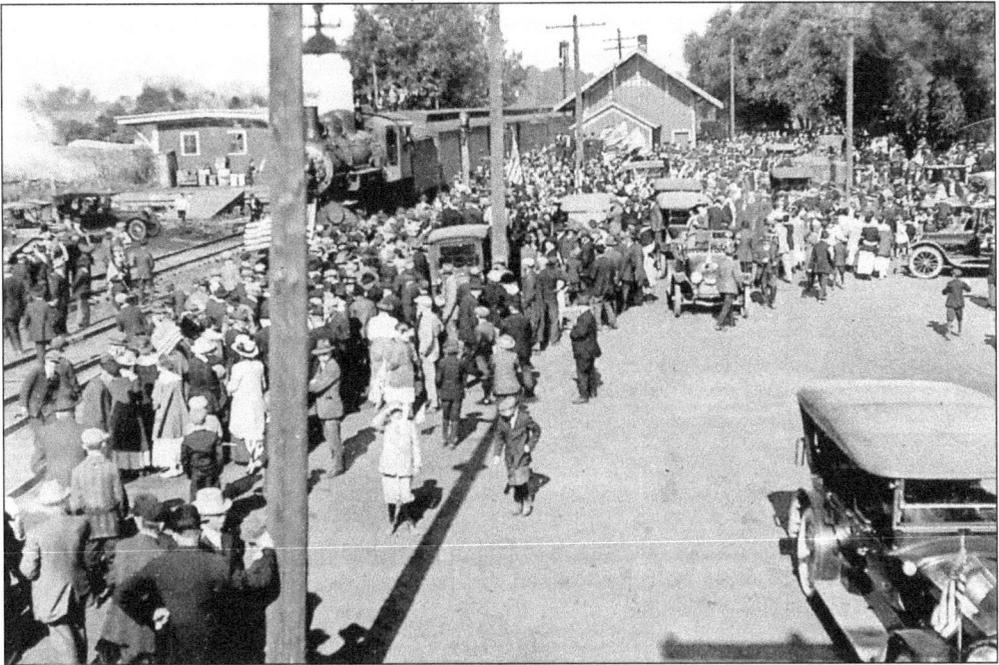

LEAVING FOR WAR. In 1917, the first group of local recruits waits to board the train at the Pere Marquette Railroad depot on the south side of Howell. The train took them to Camp Custer, near Battle Creek, where they received initial military training for service in World War I.

WAITING FOR THE TRAIN. The first day the Ann Arbor Railroad's new gasoline powered train, known as a "doodlebug," arrived in Howell, the community was quite excited. Anxiously awaiting the arrival of the train, people look for the distant wisps of smoke and steam. In this image, members of the business community have arrived. Pictured from left to right are Esther Newcomb, T.O. Newcomb, D.W. Griffith (chamber of commerce), O.J. Parker (druggist), Art Garland (tailor), D.D. Monroe (shoe salesman), V.E. Hill, a Mr. Bennett (hardware store), and Tom Gordon.

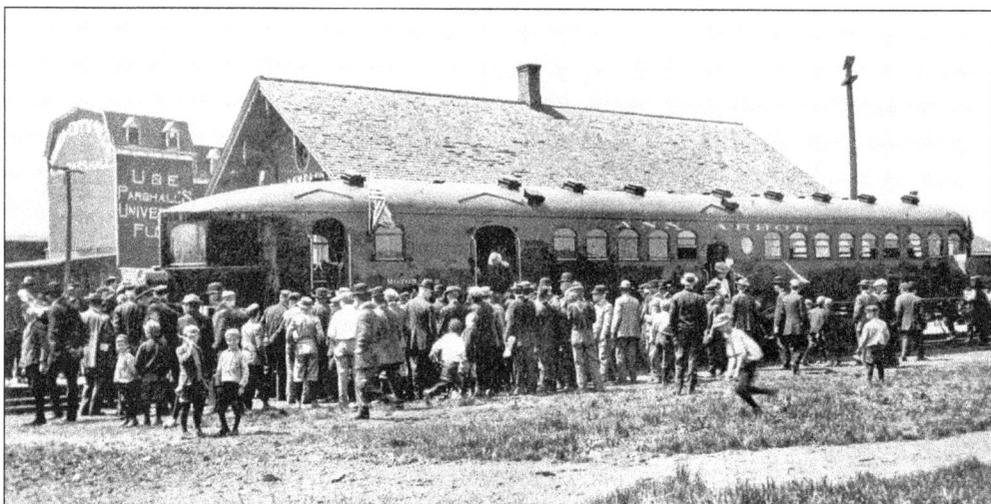

MCKEEN MOTOR CAR. The Ann Arbor Railroad owned five of these cars, which were gasoline-mechanical drive. Known as "doodlebugs" and sometimes called "potato bugs," they were popular from 1915 to about 1930. Most of the McKeen cars had the distinctive "wind-splitter" pointed, aerodynamic front end and rounded tail.

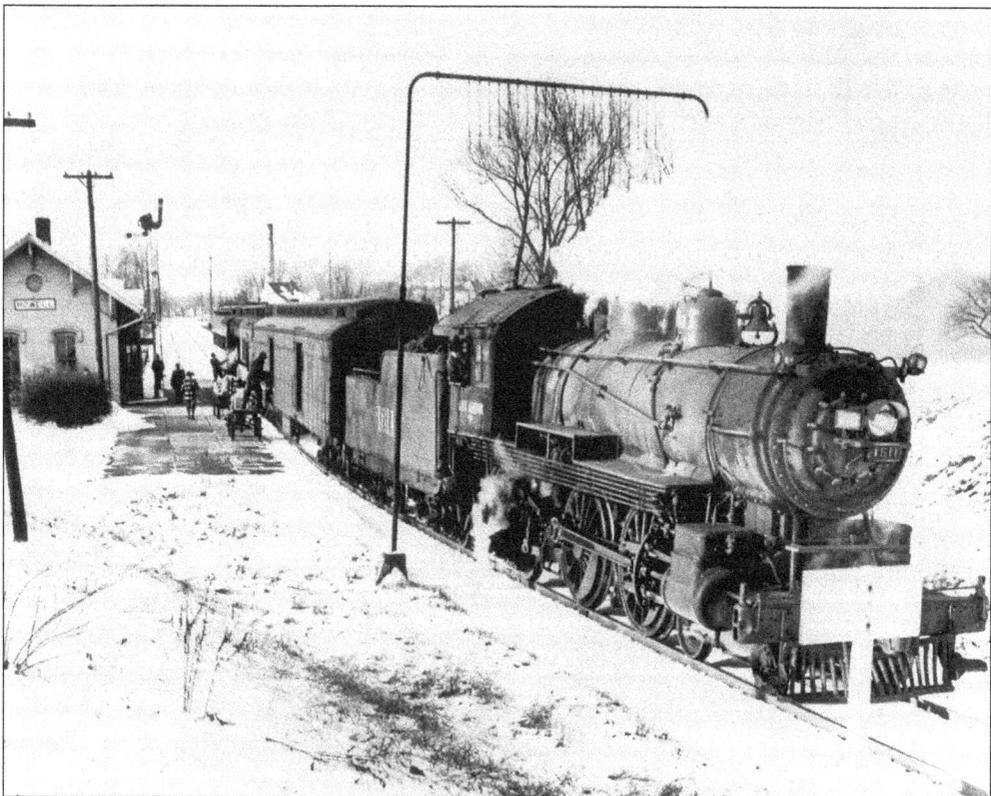

THE LAST PASSENGER TRAIN. In the winter of 1951, Ann Arbor Railroad's Engine No. 1611 pulled the final passenger train to stop at Howell's depot. Boxes, crates, and packages filled with local manufactured products continued to be shipped and received by freight trains passing through the city, but the era of the passenger train had come to an end locally.

Six

ACADEMICS AND
AMAZING GRACE

The value and need of intellectual development and spiritual growth were immediately recognized by early settlers of the Howell area. Local residents in the 1830s and 1840s invested time and money to provide education for their children and support to religious organizations that reflected their beliefs. As Howell grew, the deliverance of education and religion expanded.

School District No. 1 was created on May 21, 1836, and the first schoolhouse built in the spring of 1837 cost $350. The first teacher of the school was Abigail Adams, the daughter of Amos Adams, the owner of the Eagle Tavern. In March 1847, a new school was built to accommodate an expanding student population. This brick school was 30 feet by 40 feet and one story high with sidewalls that were 12 feet high and one foot thick, had two doors in front, and was crowned in the center of the roof with a small belfry. Additions and renovations were made to it in 1856. The building was used for 19 years as a school as well as for community meetings and religious services. In 1869, Central School was constructed on the same site. When it became overcrowded in the 1880s, East and West Ward Elementary Schools were built. In 1922, a high school was constructed on the site currently occupied by the post office. From its earliest beginnings, residents of Howell have been committed to providing education to its youth.

Early circuit-riding ministers and priests met for fellowship, preached, and offered spiritual guidance in homes of pioneers and settlers. They spread their theology and brought people together to create congregations. Permanent clergies were assigned by different denominations as Howell's places of worship grew. Methodists organized the first church and were soon followed by Baptists, Presbyterians, Lutherans, Congregationalists, Episcopalians, and Catholics. This chapter contains photographs and information regarding the local origins of several churches.

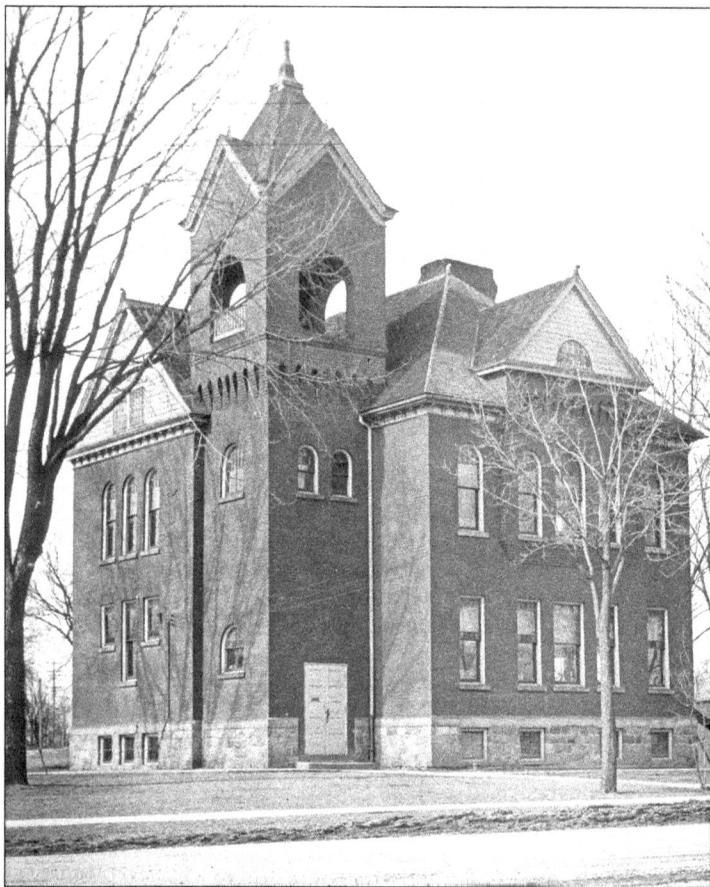

WEST WARD SCHOOL. An expanding student population required construction of several new buildings in the late 1880s. The West Ward School, also called the Byron Road School House, opened in 1891.

SIXTH GRADE. Zada Fleming, a teacher at West Ward School, has her sixth-grade class sitting properly and smiling for the camera in this class photograph. Written inside the wreath on the blackboard is "Xmas 1915." Two brothers, Francis and Winfield Lines, are seen here.

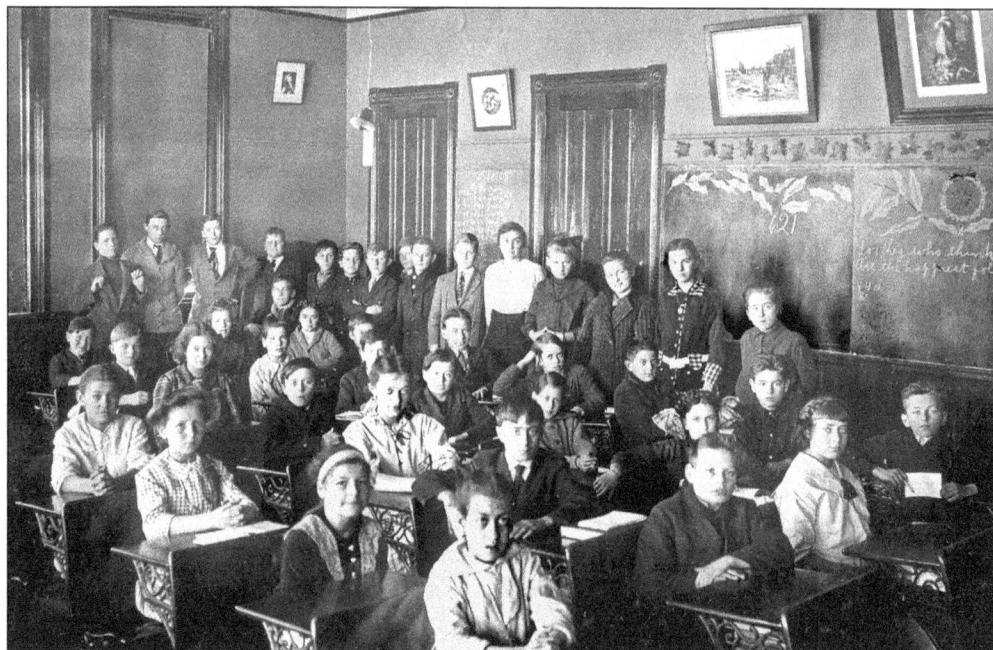

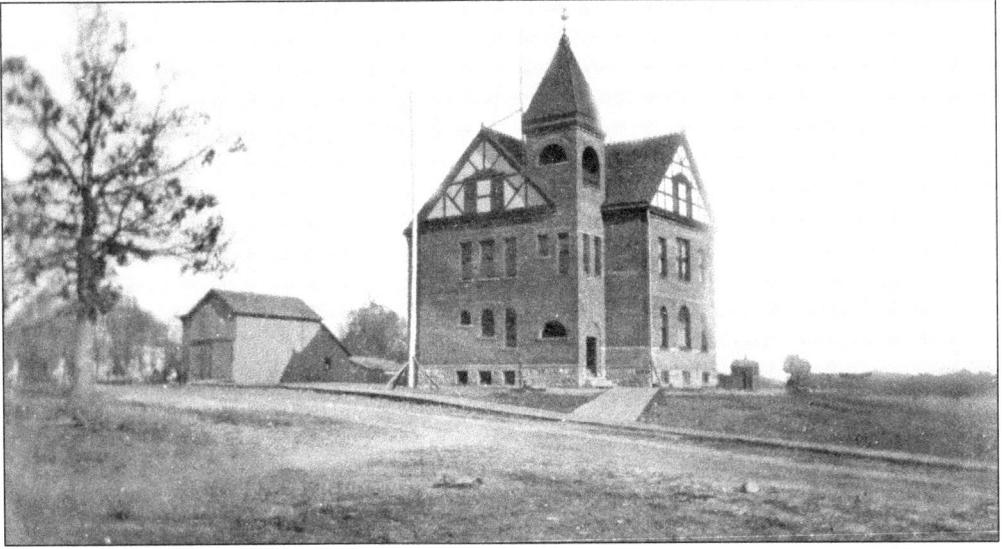

EAST WARD SCHOOL. In order to alleviate crowded conditions at Central School, where some classes were required to meet in the basement, the school board voted to construct two new schools on the east and west sides of Howell. East Ward School, built on Barnard Street near Thompson Lake, was completed in 1888.

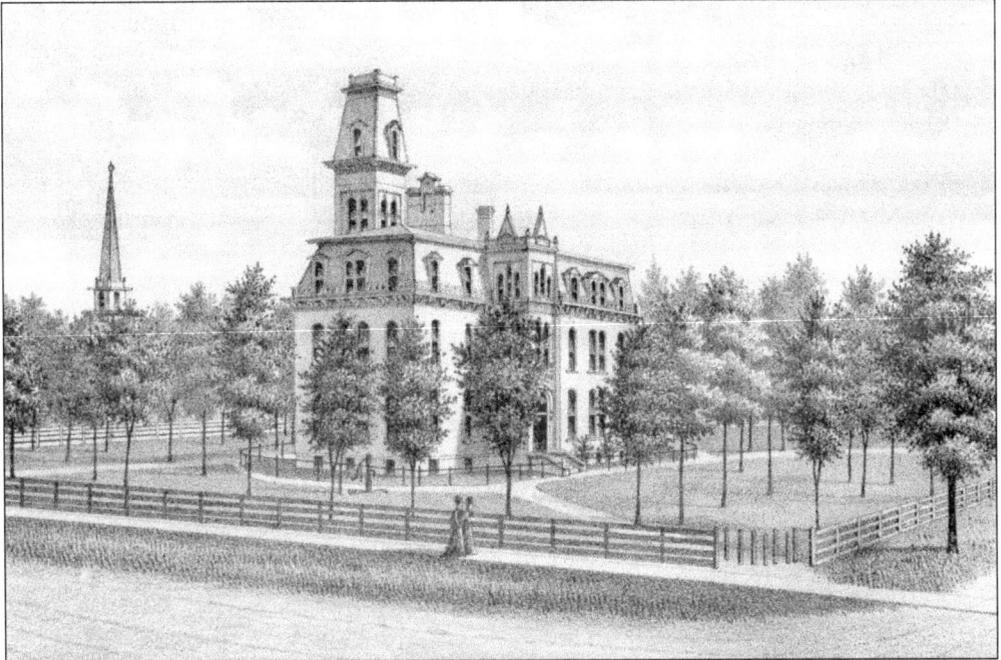

UNION OR CENTRAL HIGH SCHOOL (STEEL ENGRAVING). The school, located on South Michigan Avenue, was completed for the winter term in 1869. The building was made of brick, was three stories high above the basement, and had a French roof and a tower 100 feet in height. It contained 33 classrooms, each one 25 feet by 35 feet in size. The contractor was B.B. Rice of Detroit. The total cost of the school was just over $31,000. (Livingston County History.)

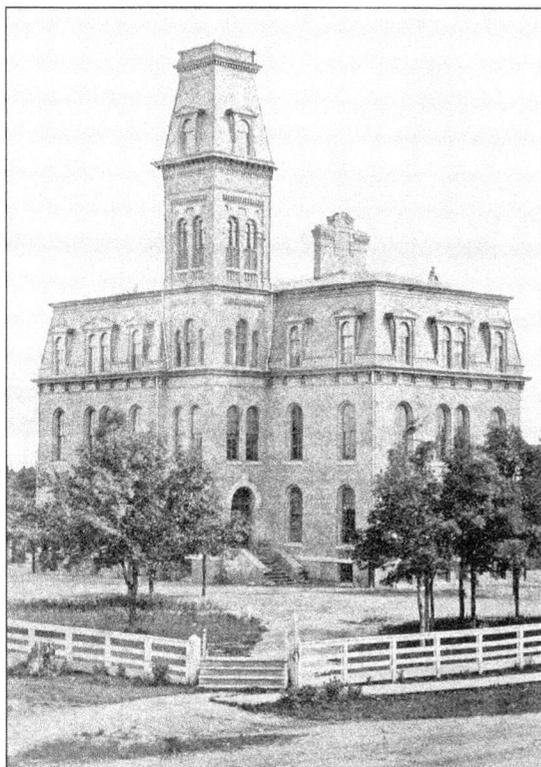

HOWELL'S CENTRAL SCHOOL. This 1870s carte de visite image of the school shows the main entrance to the building and unique architectural features, especially the tower from which photographer Walter E. Cleaves took many pictures of Howell.

CLASS OF 1916. This class chose the yellow rose as its flower and blue and gold as class colors. The class cheer was "Razzle! Razzle! Hobble! Scobble! Zip! Boom! Bah! Sixteen! Sixteen! Rah! Rah! Rah!"

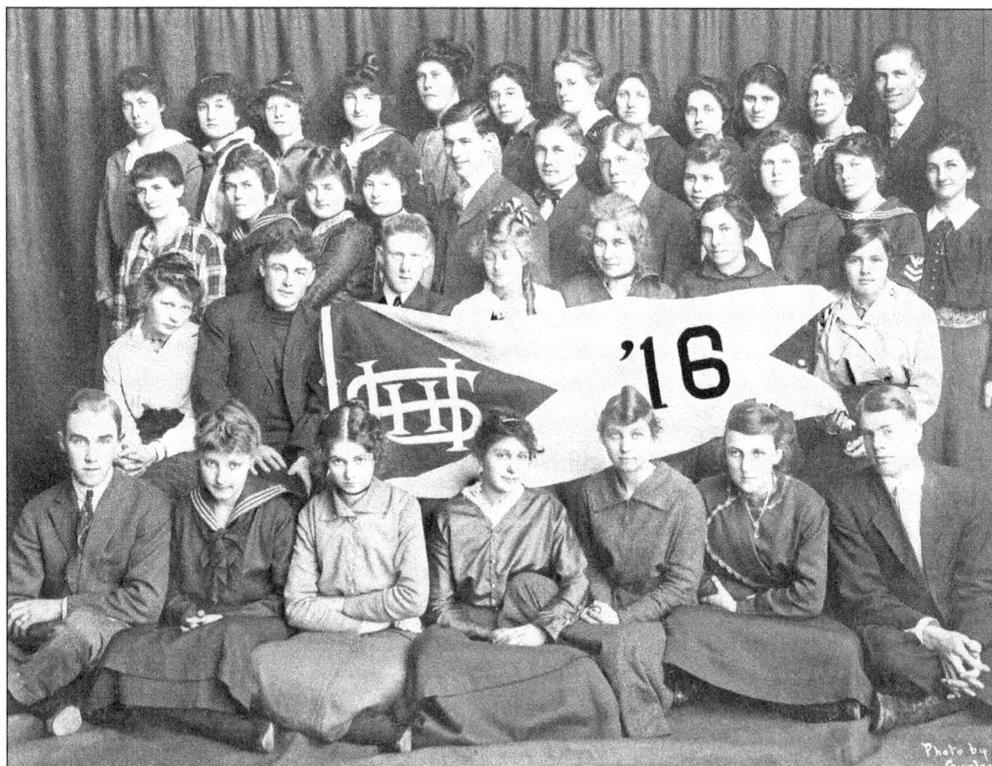

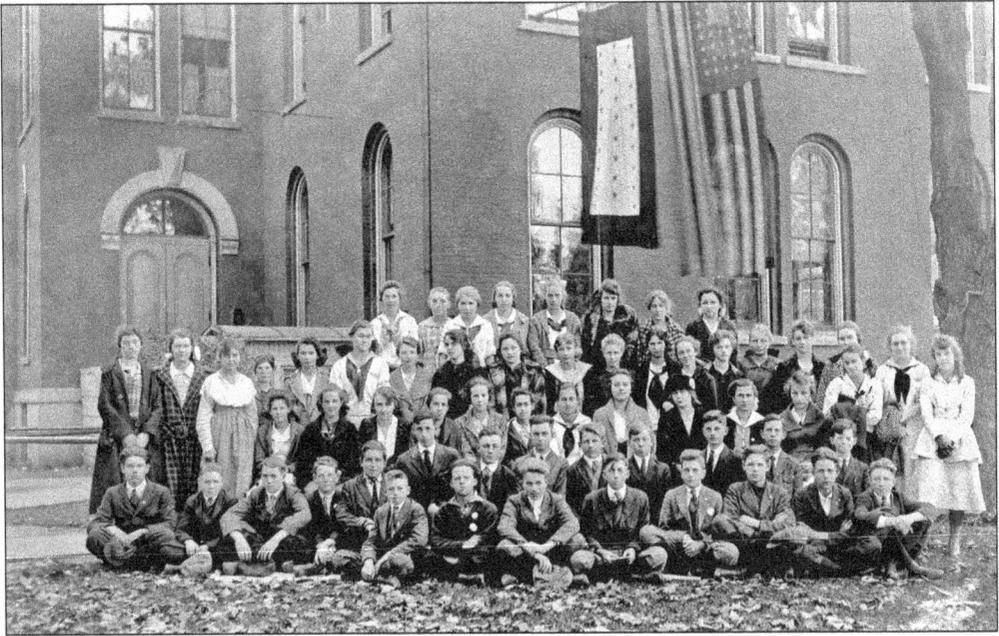

CLASS OF **1919.** Members of the class of 1919 pose in front of Central School. The American flag waves above the students, and the other flag represents the number of local men who were killed while serving in the military during World War I. Including the teachers, there are 59 people gathered for this photograph.

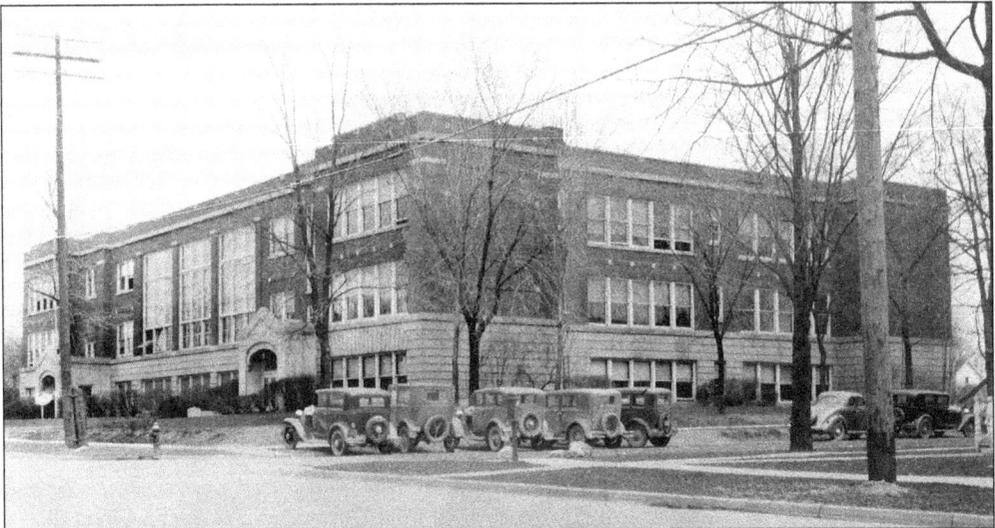

HOWELL HIGH SCHOOL. A new high school was opened in 1922 to accommodate an ever-expanding student body. After the old Central School was razed, the new school was constructed on the site where the post office is now located on South Michigan Avenue.

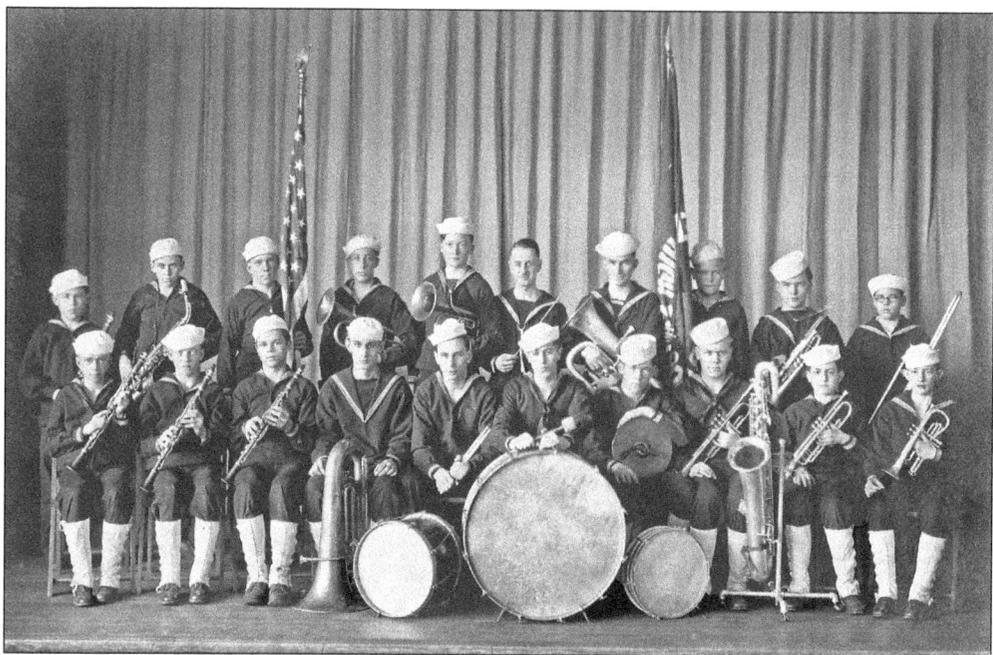

JACKIE BAND, 1925. It was founded as the High School Band in 1921. In this 1925 Ludwig Studio photograph, band members, wearing their unique uniforms, proudly display their musical instruments. Extremely popular during the 1920s, this all-boy band performed in parades and at athletic events, local concerts, and frequent conclaves attended by Howell's Commandery No. 28.

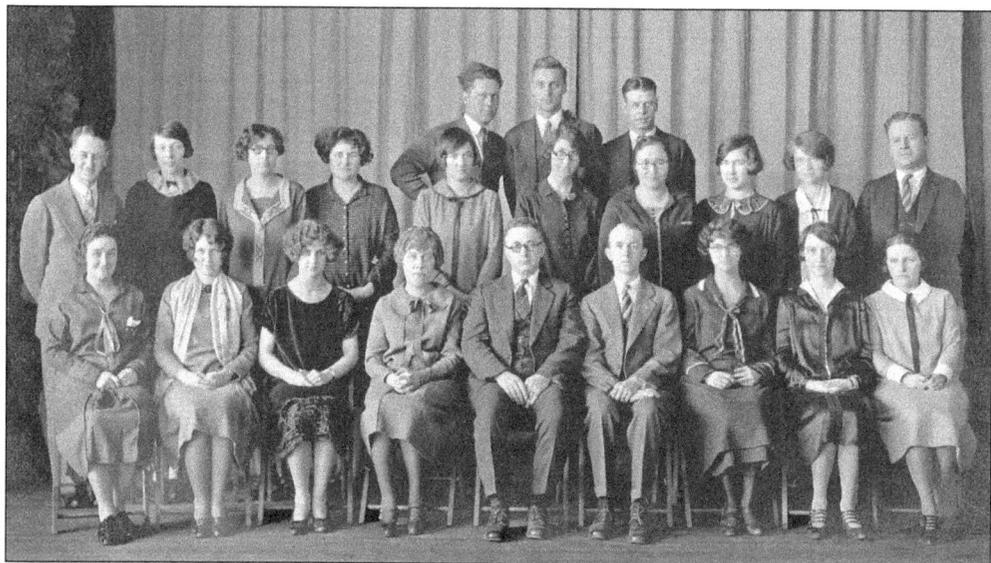

ADMINISTRATION AND FACULTY. Looking like a group of very stern and proper educators, Howell High School's administrators and teachers pose for a 1925 photograph taken by a photographer from the local Ludwig Studio.

METHODISTS. When they met at the home of Stephen Lee on December 31, 1836, Methodists organized the first religious congregation in Howell. Sunday services were initially held in a schoolhouse and later at the first Livingston County Courthouse. Methodists built their first church, which was completed and dedicated in March 1855, at the corner of Sibley and Walnut Streets. This is the earliest image of the church, taken from the top of the Union School about 1869.

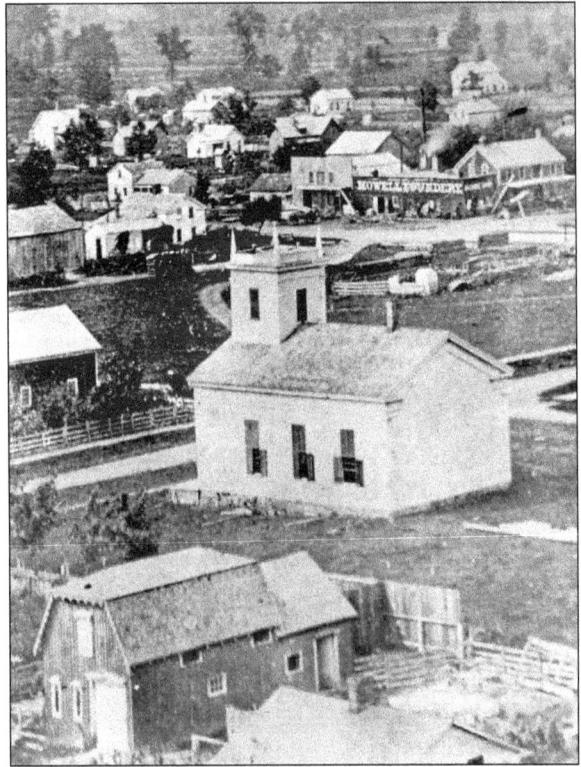

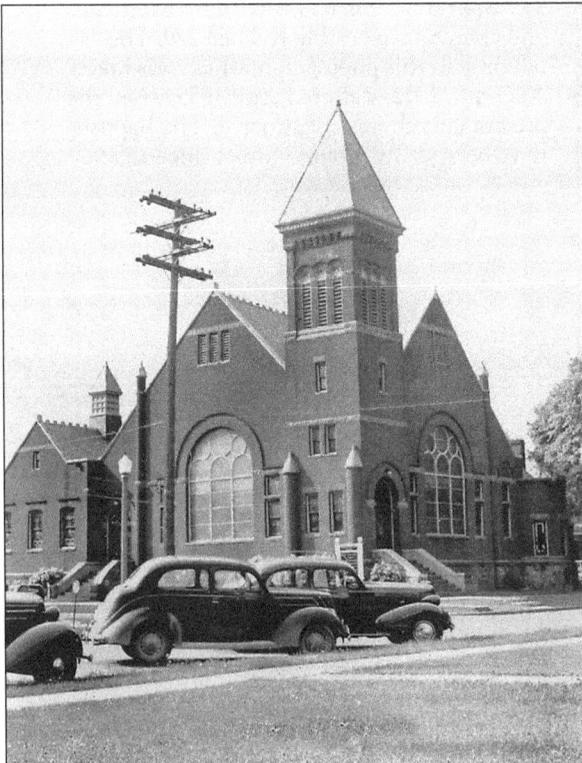

FIRST UNITED METHODIST CHURCH OF HOWELL. The congregation decided to erect a new church in 1890 at a cost of $18,000. Services were conducted in this building until 1970, when it was demolished and a new church built at 1230 Bower Street. The location in this image is currently a parking lot.

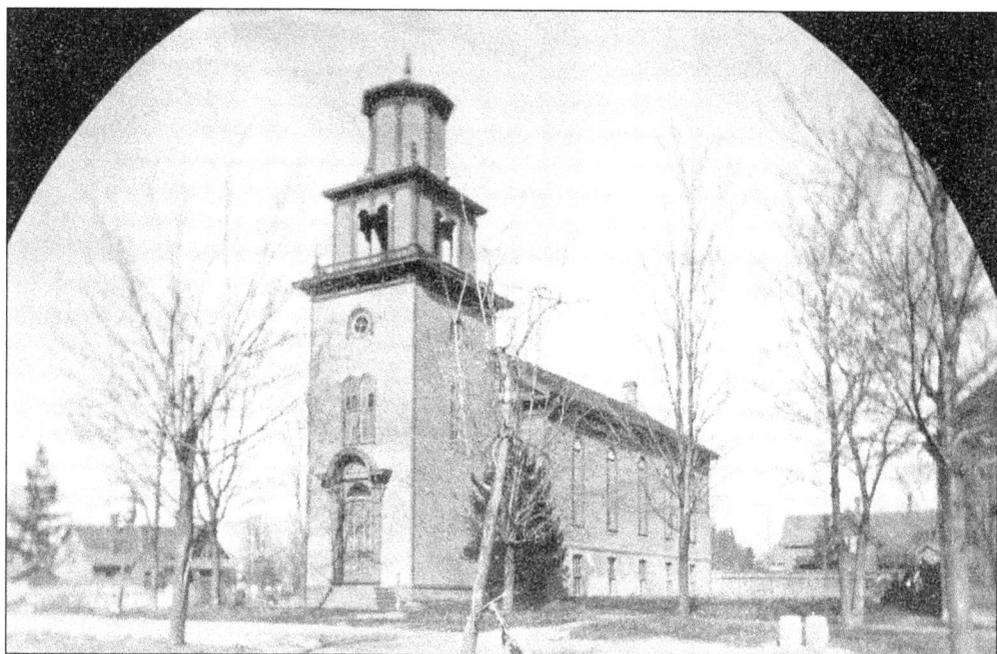

BAPTISTS. In 1846, members of the congregation voted to build a church, which was completed in 1850. Their first church was replaced with a new structure in 1873 and dedicated on October 25, 1874. That year, 63 people were baptized, and church membership reached 229. The building in this photograph, which was taken August 8, 1932, was used until 1955, when the present church was constructed. The Baptists have been at 210 Church Street since 1850.

BAPTIST FAIR. There is no date on this flyer advertising lunch and a grand supper following the evening's lecture. The menu indicates turn-of-the-century prices for a good meal at the First Baptist Church of Howell.

PRESBYTERIAN CHURCH.
Rev. Henry Root formed the
First Presbyterian Church
in Howell on June 17, 1838.
Edward Gay, Josiah Jewett, and
Philester Jessup were selected
as the first church elders.
In 1855, a brick church was
constructed on the southeast
corner of Sibley and McCarthy
Streets. This photograph
of the 1855 Presbyterian
church was taken in 1906.

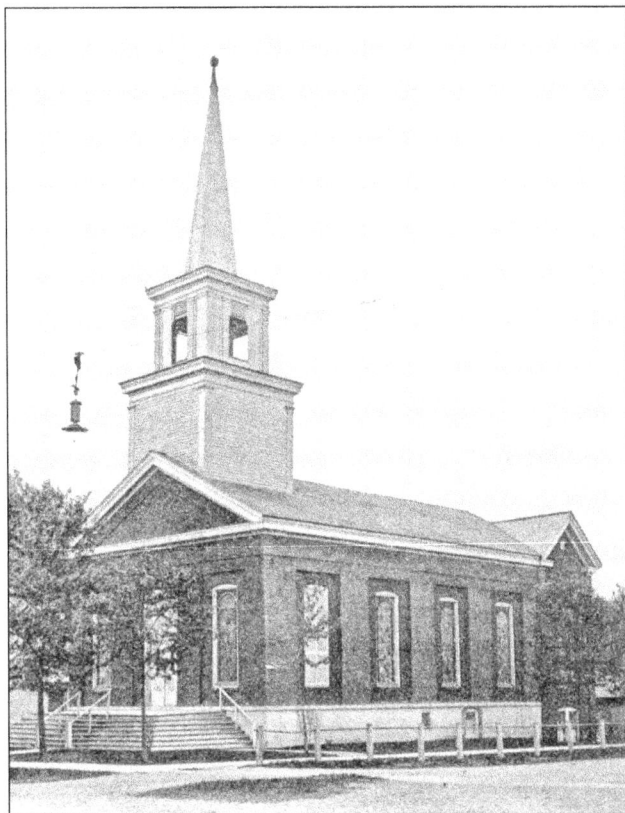

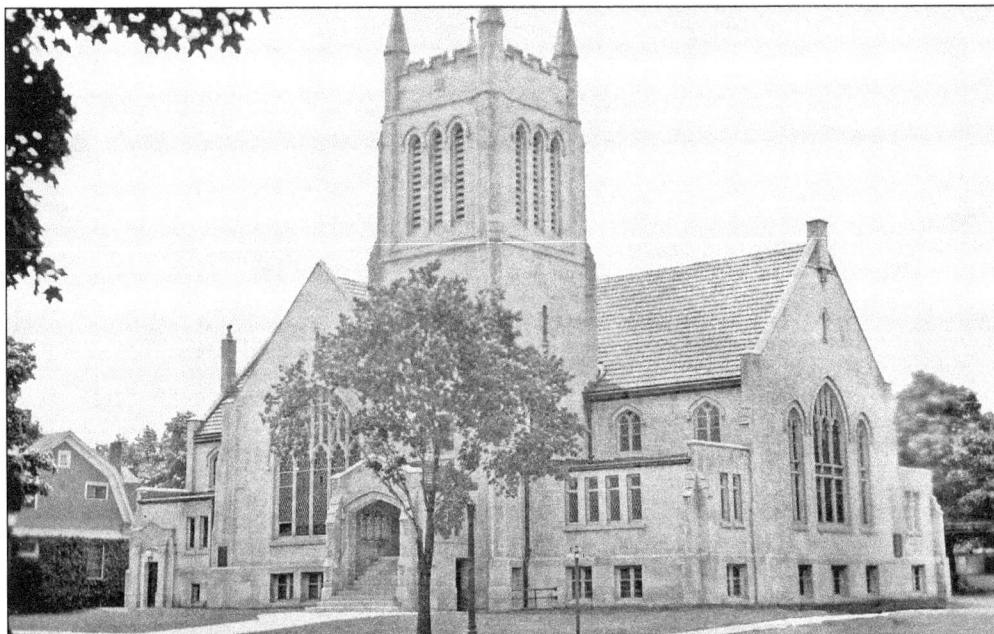

FIRST PRESBYTERIAN CHURCH. In 1915, the Presbyterians voted to construct a new church on property located across the street from the Carnegie library. This impressive Gothic Revival church was designed by an architectural firm from Cleveland, Ohio, and built at a cost of $80,000.

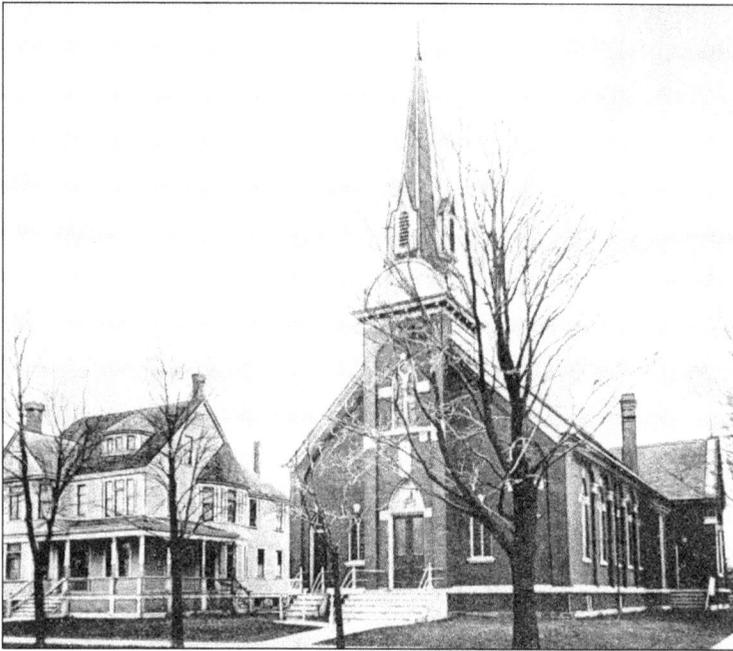

St. Joseph's Catholic Church. This church of brick with a slate roof was built in 1878 and located at corner of East Grand River Avenue and Fowler Street. Through the decades, the church underwent extensive renovations and was razed in 1961. Ground was broken for a new church building on Washington Street in July 1961, and the structure was dedicated in May 1962.

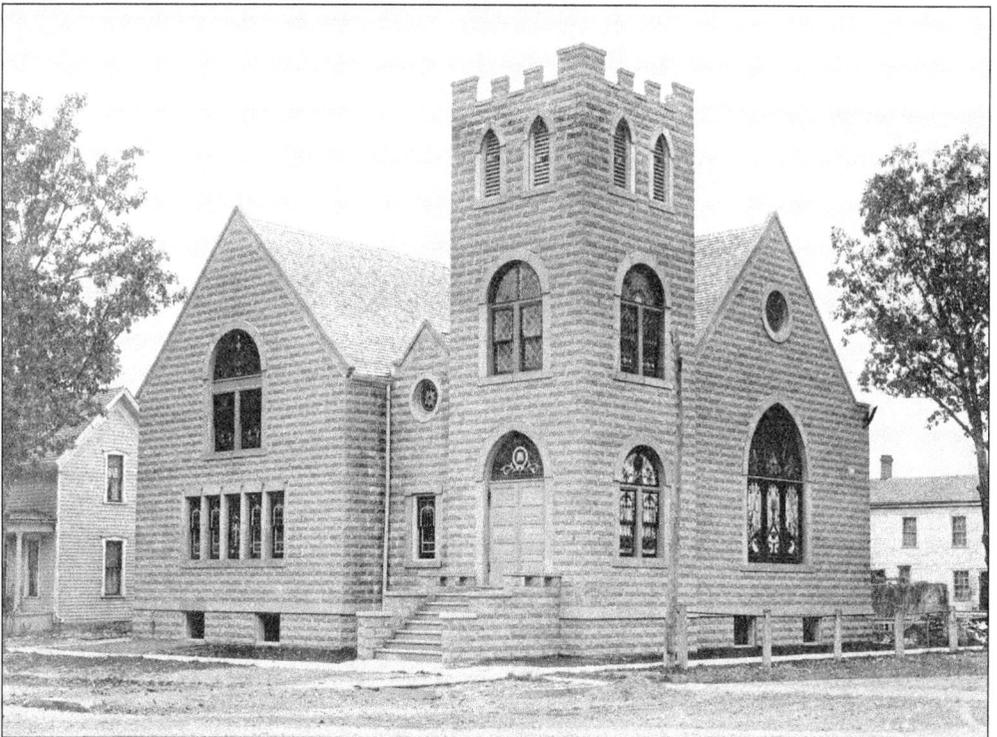

Evangelical Church. This church, which served the German-speaking residents of Howell, conducted services in German. A cement-block structure, it was located at the corner of Crane and McCarthy Streets. Howell's Church of the Nazarene currently occupies the site.

Seven

ATHLETICS AND
RECREATION

Since ancient times, athletic competition has been viewed as a way of teaching discipline, leadership, and a positive work ethic. Sports are built on teamwork, which is necessary to test skill levels of athletes. Participation in athletics helps individuals prepare for the rigors, requirements, and responsibilities of life and creates a sense of identity in the community. Howell's athletic teams have been a source of pride over the decades, and numerous teams have won championships in football, basketball, and baseball.

Recreation provides brief diversions from daily routines and an escape from the workweek. Opportunities to have fun and relax and refresh the body, mind, and spirit are imperative for a healthy lifestyle. These include family gatherings, picnics, boating, fishing, ice-skating, reading, writing, and other activities.

Athletics and recreational gatherings bring people together who have similar interests and provide opportunities for fun and friendship. Photographs in this chapter document some of Howell's past high school teams, including the 1904 state championship baseball team. That legendary squad produced three professional baseball players. Also, unpublished recreational images taken at a local outing show women competing in boxing, running, and a tug-of-war contest. Major-league baseball Hall of Fame member Ty Cobb is shown in a photograph holding his catch after a day of ice fishing in Howell.

LLOYD "CORKY" EARL. On the 1918 football team, Corky played left halfback. This photograph shows him standing in front of the post office on North Michigan Avenue wearing his leather helmet, no protective pads, football pants, and the latest in football shoes.

FOOTBALL TEAM, 1896. In the autumn of 1896, Howell formed its first football team. Taking a time-out from practice, the team poses in front of the rather rickety-looking goalpost.

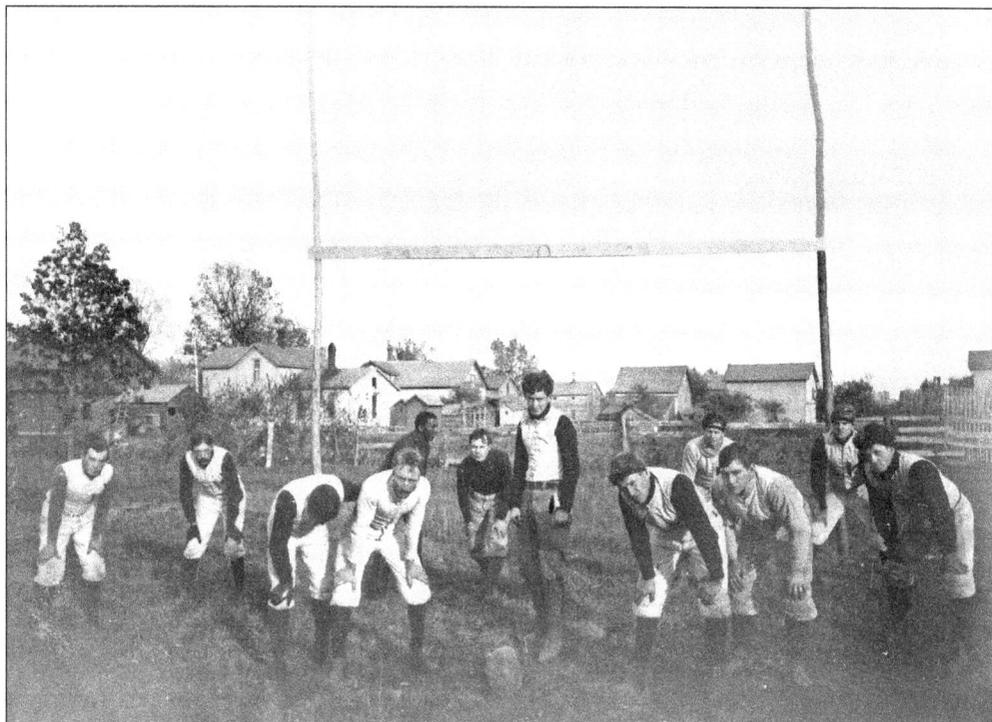

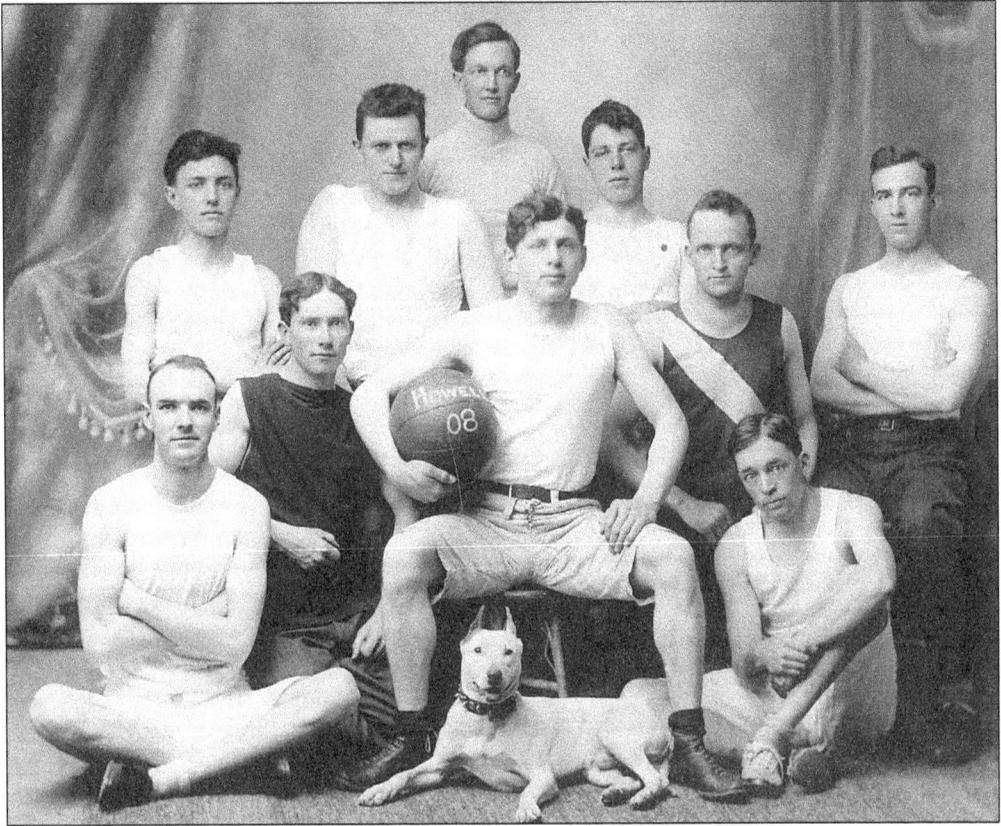

HOWELL HIGH SCHOOL'S 1908 BASKETBALL TEAM. Pictured from left to right are (seated) William McPherson III, unidentified, August Schmidt (holding the basketball), Reverend Brooks, Emil Bode, and unidentified; (back row) William McPherson Spencer, Albert "Curly" Barney, unidentified, and Charles Van Winkle. A Staffordshire terrier, also known as a pit bull, is the team's mascot.

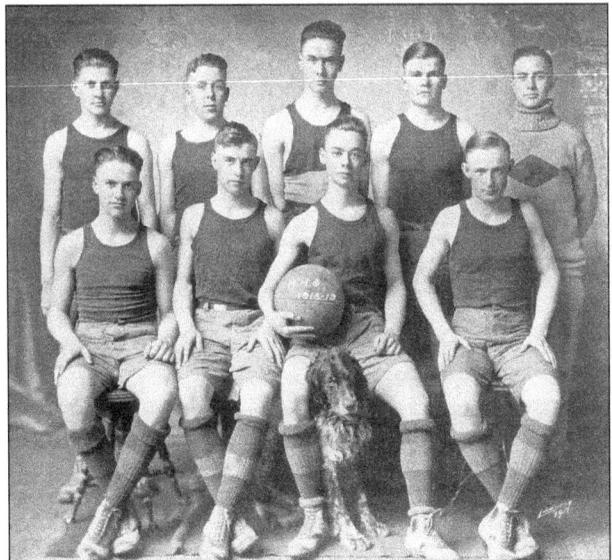

HOWELL HIGH SCHOOL BASKETBALL TEAM, 1918–1919. These teammates proudly pose in their basketball uniforms. The team's mascot sits front and center.

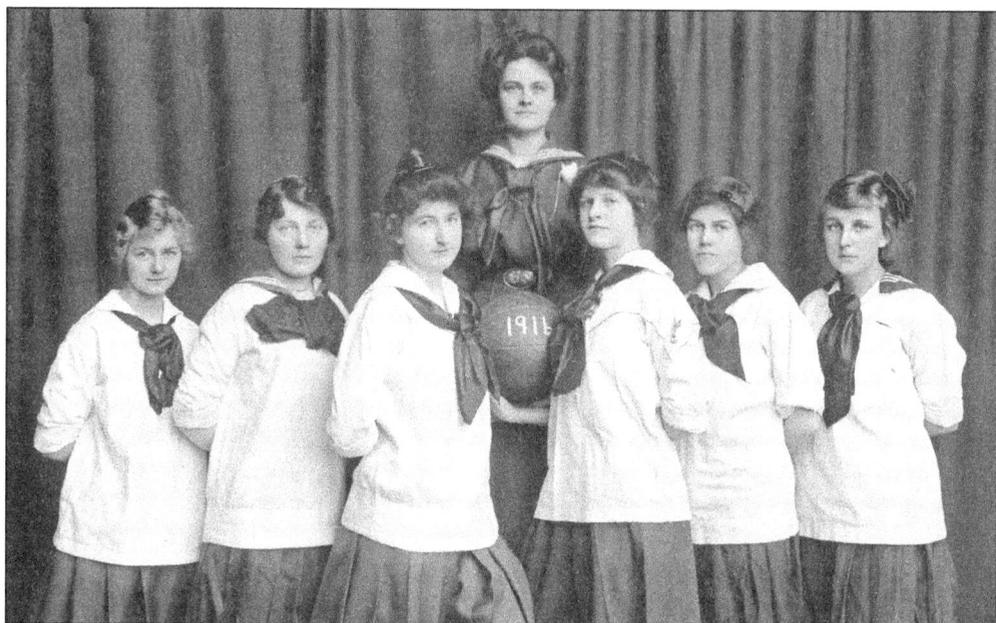

GIRLS' BASKETBALL TEAM, 1916. Their games were slow, the floor was marked off into zones, with guards confined to one zone, forwards to another, and so on; and there was not much running about or body contact. The players wore middy blouses and voluminous bloomers that ended just below the knees and exposed their calves. Team members here include, from left to right, Thelma Brayton (married name), Viola Joslin (Garland), Mildred Wall, a Mrs. Balke (coach), Blanch Bush, Elizabeth McFadyen, and unidentified.

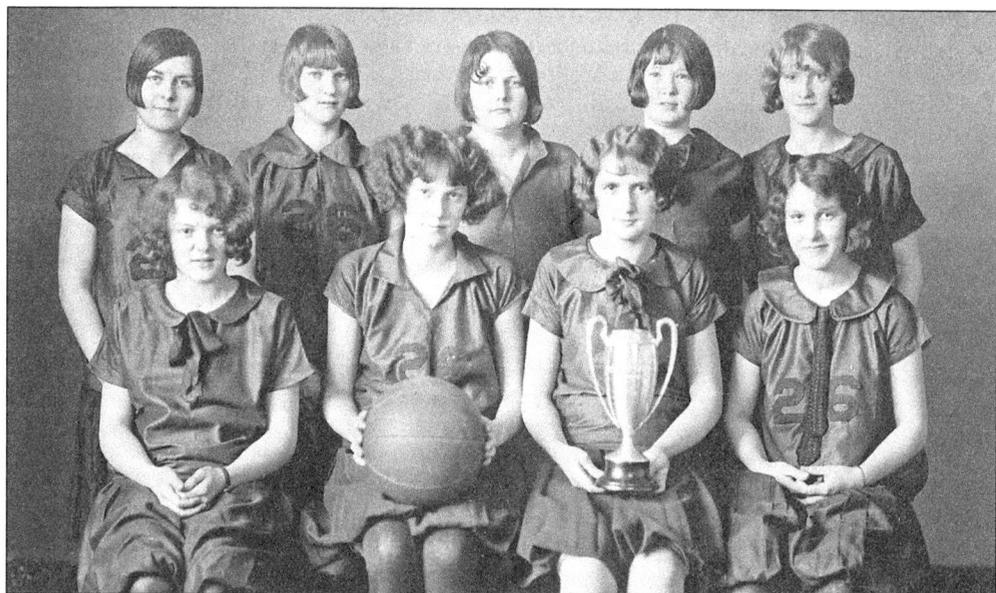

GIRLS' BASKETBALL TEAM, 1926. The student council presented a trophy cup to the 1926 team. This team won the Girls' Interclass Basketball championship two years in a row. According to what is written on the back of the image, members of the team are, from left to right, captain Ruth Dankers, M. Wells, W. Botsford, M. McCleer, B. Howlett, M. Pate, M. Richeson, and B. Monroe.

BASEBALL TEAM, 1899. Pictured in this team photograph are, from left to right, (first row) Clive Beurmann, Curly Barnes, and Ray Newcomb; (second row) Bill Fournd, coach Charlie Beach, E.P Nagterig, Arla Bailey, and Leon Stowe; (third row) Charlie Smock, Art Gifford, Ken Burman, and Howard Morgan.

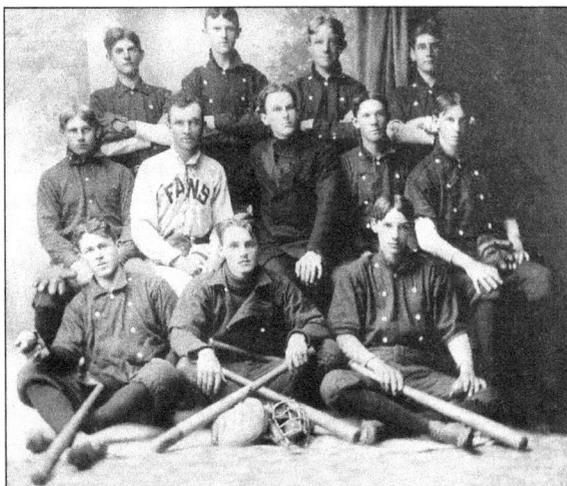

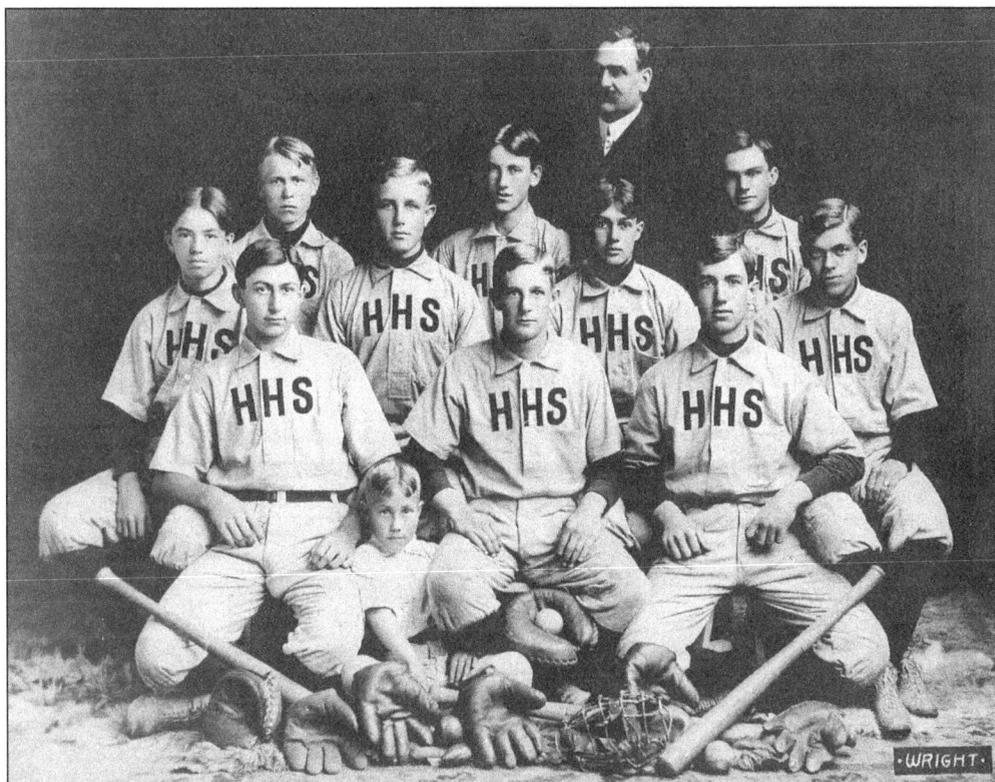

STATE CHAMPIONS, 1904. Members of this team were runners-up to Flint in the 1903 state championships. Not to be denied in 1904, they only lost a single game and won the title. Three members of this championship team went on to play professional baseball. Pictured from left to right are (first row) right fielder Lynn Lewis, mascot Clark Wimbles, catcher Ray "Pat" Newcomb, and second baseman Ernest Brown; (middle row) left fielder Charles "Jockey" Jewett, pitcher (and captain) Roy "Buster" Newcomb, third baseman Bert Tooley, and substitute Leland Young; (back row) shortstop Irving Young, first baseman Olin Morgan, manager (and school superintendent) J.K. Osgerby, and center fielder Hugh Finley. Tooley played shortstop for the Brooklyn Dodgers in 1911 and 1912. Brothers Ray and Roy Newcomb played for various minor-league teams.

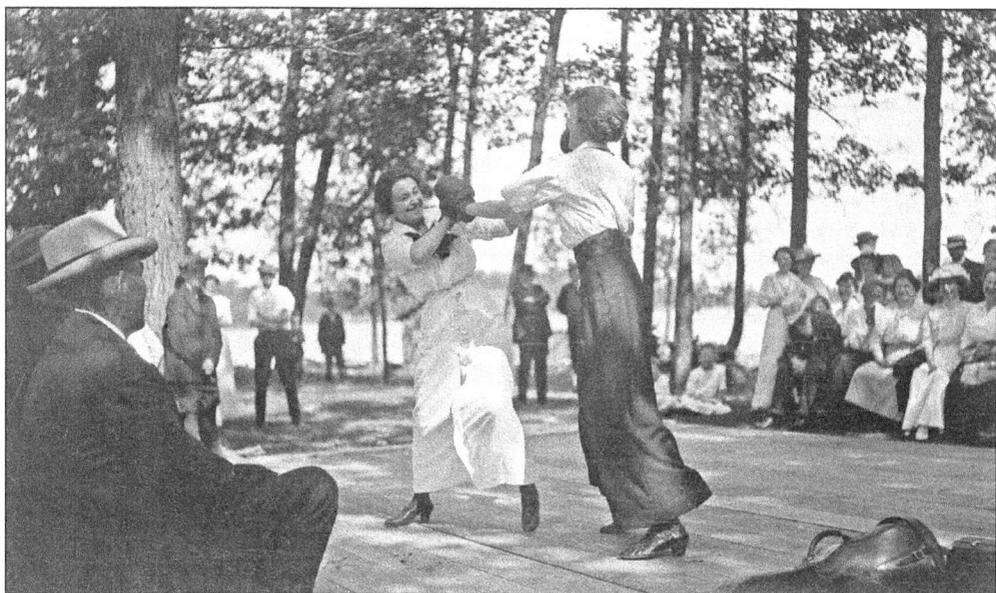

PUGILISTIC ENDEAVORS. Two Howell women practice the art of boxing at a picnic held at Lake Chemung in the early 1900s. The spectators, anxiously anticipating a knockout punch or perhaps a bloody nose, cheer on the combatants. With faster, longer-range punches, most notably the jab, the classically trained boxer can gradually wear down her opponent.

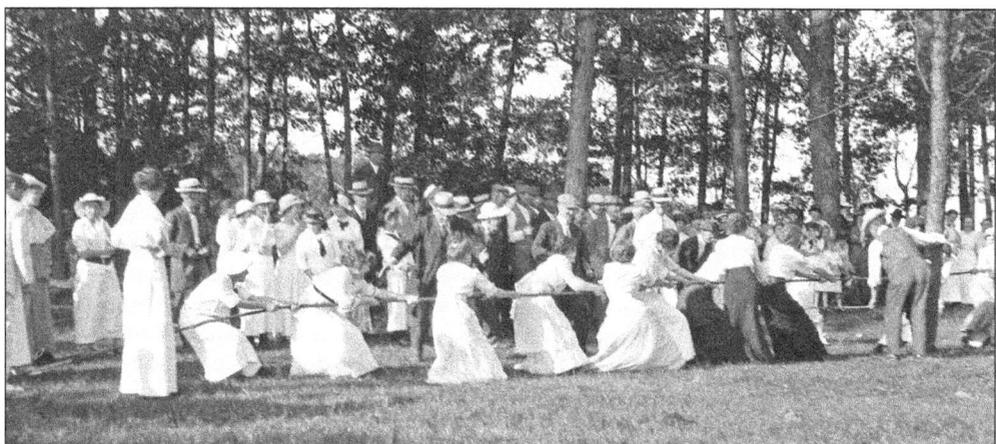

TUG-OF-WAR BETWEEN THE WOMEN. Each September, a tug-of-war was the first interclass activity of the school year. Members of Howell's senior and junior classes would square off, and according to records the junior class usually won the event. The ladies in this competition are attending an outing at Lake Chemung. It is evident by their posture that they are engaged in a contest of strength and endurance. Spectators, mostly men, are yelling encouragement to the participants.

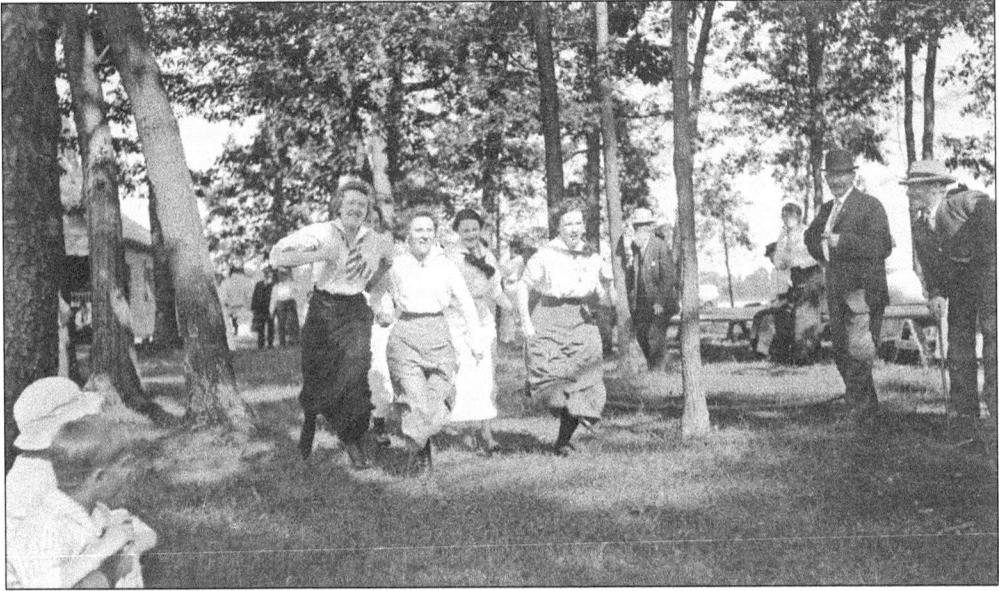

WOMEN RUNNING. These five young women are racing in a competitive running event. A spirited dash down the length of the course might not set a speed record, but it would still provide the thrill of victory. The young woman who was triumphant received the laurel wreath for her competitive efforts.

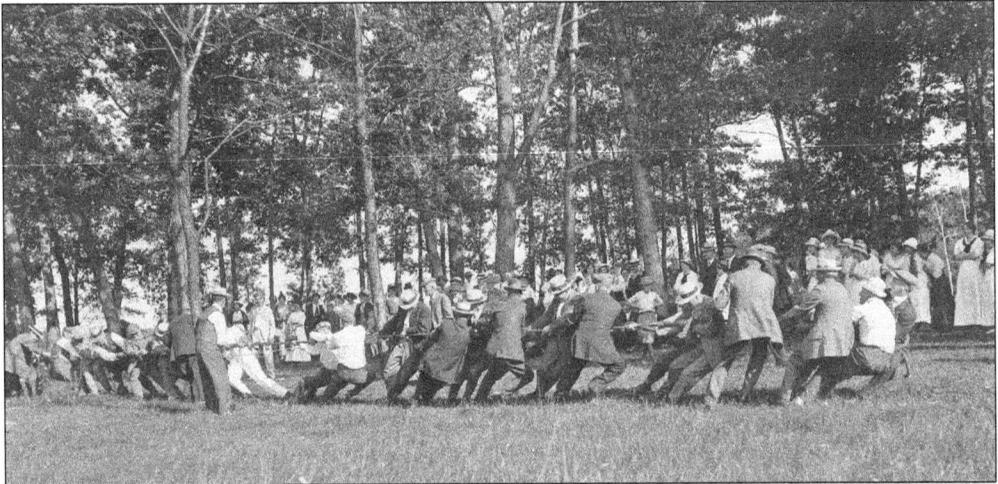

TUG-OF-WAR BETWEEN THE MEN. The popularity of this sport in the early 1900s was recognized as it was made an Olympic sport from 1900 to 1920. The tug began when the rope's centerline was directly above a line on the ground, and once the contest commenced, each side attempted to pull the other team across the centerline, while the spectators cheered their team to "Pull! Pull! Pull!"

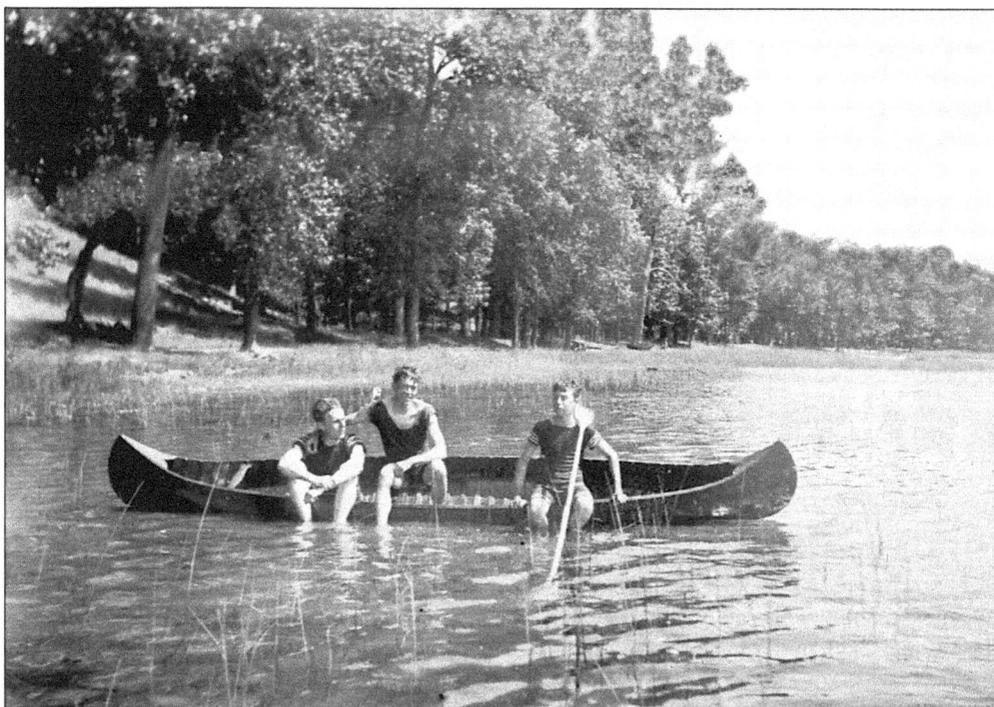

BOYS IN A CANOE. Whether fishing, swimming, or canoeing, these three boys are enjoying a lazy summer day on Howell's Thompson Lake.

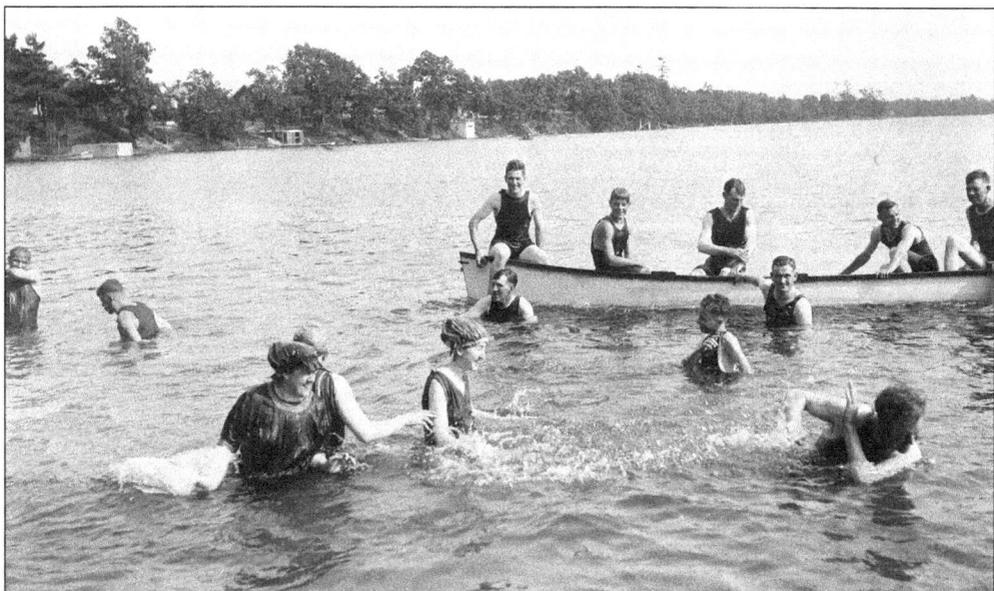

SWIMMING ON A HOT SUMMER DAY. The cool waters of Lake Chemung provided people a brief respite from the steamy dog days of summer. Picnics, family reunions, and social gatherings were often held at various lakes near Howell. Swimming, boating, fishing, sunbathing, building sand castles, and singing around campfires were always part of a day's events at the lakes.

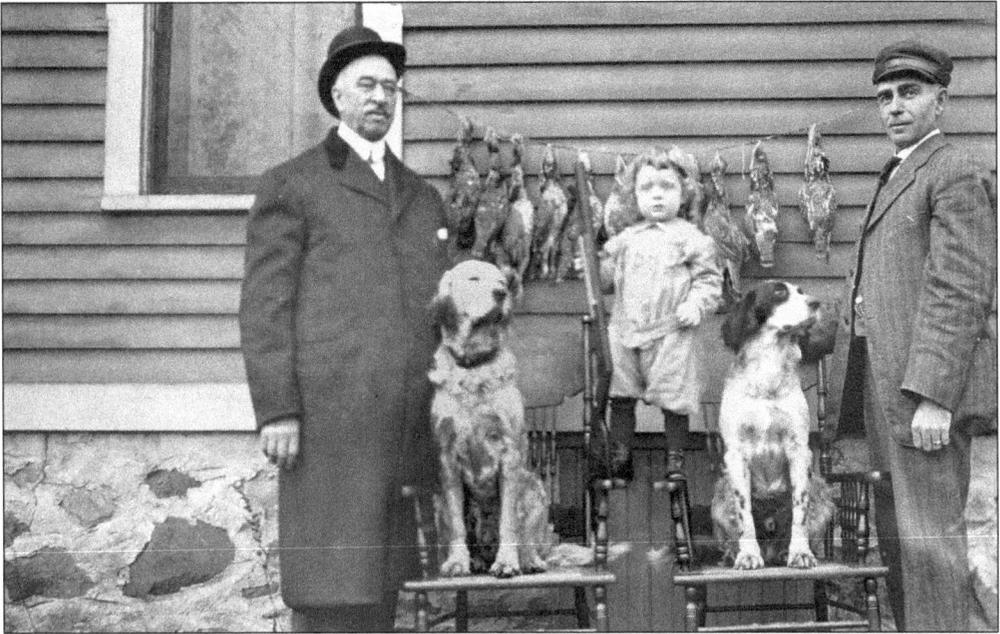

TRAPSHOOTING CHAMPION. Charles Jewitt (left) was a champion trapshooter and the world champion glass-ball marksman. He owned a local hardware store and specialized in plumbing, steam fitting, and electrical supplies. In August 1919, Jewitt became a member of the Sons of the American Revolution.

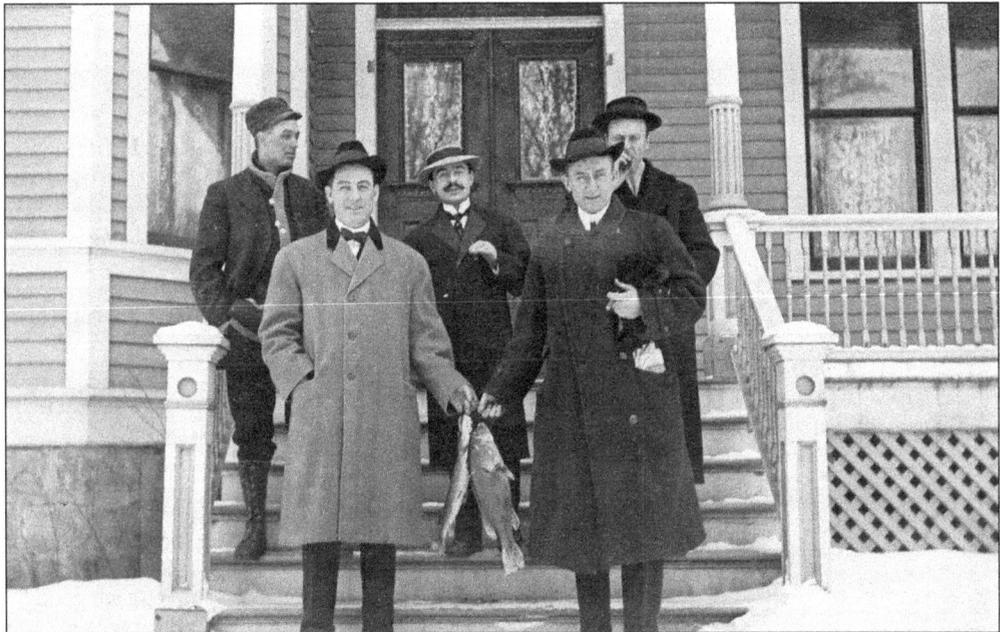

TY COBB, THE "GEORGIA PEACH," WITH FISHING BUDDIES. Howell's Bert Tooley (left), a shortstop for the Brooklyn Dodgers, and Ty Cobb, a member of the Detroit Tigers, pose in front on the steps of the rectory of St. Joseph's Catholic Church, showing off their catch. In back, Bill Dawson (left) and Fr. James Thornton (center), who cared for Howell's Catholic community from 1905 until 1916, stand with an unidentified man on the steps behind Tooley and Cobb.

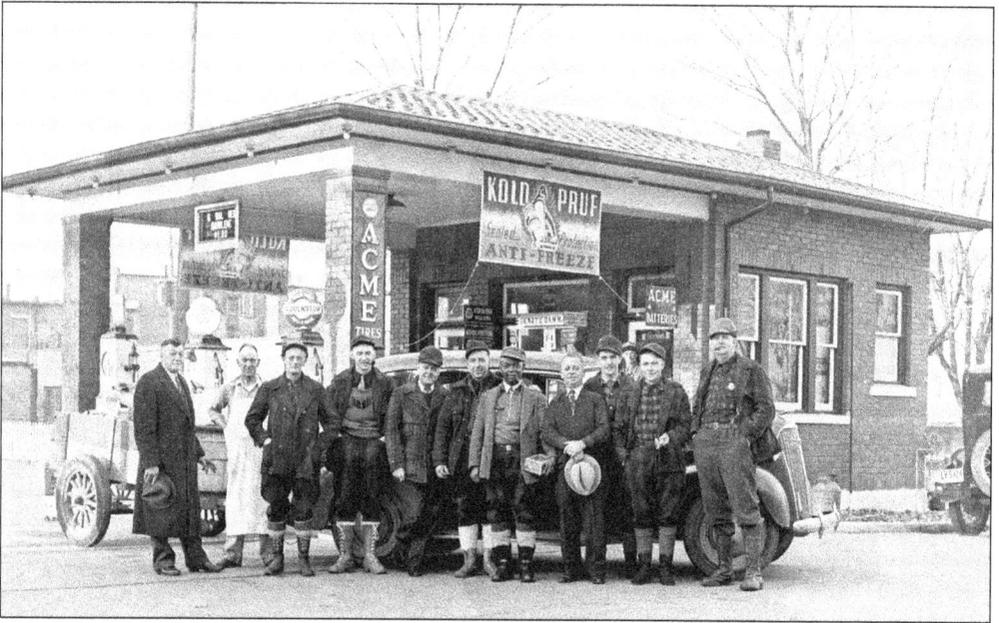

DEER HUNTERS. Seen in November 1939, friends have gathered after making preparations to go deer hunting. They met at the Conoco gas station, at 202 North Michigan Avenue, and with cigars in hand had their photograph taken prior to leaving for their hunting camp. This group includes, from left to right, Frank Hagman, Art Hagman, Doc Chase, Henry Hagman, John Hagman, Hank Damman, Hughie Hobson, Ebson Swann, Claude Miller, Leslie Montague, and Charlie Vincent; in the background is John Winegar.

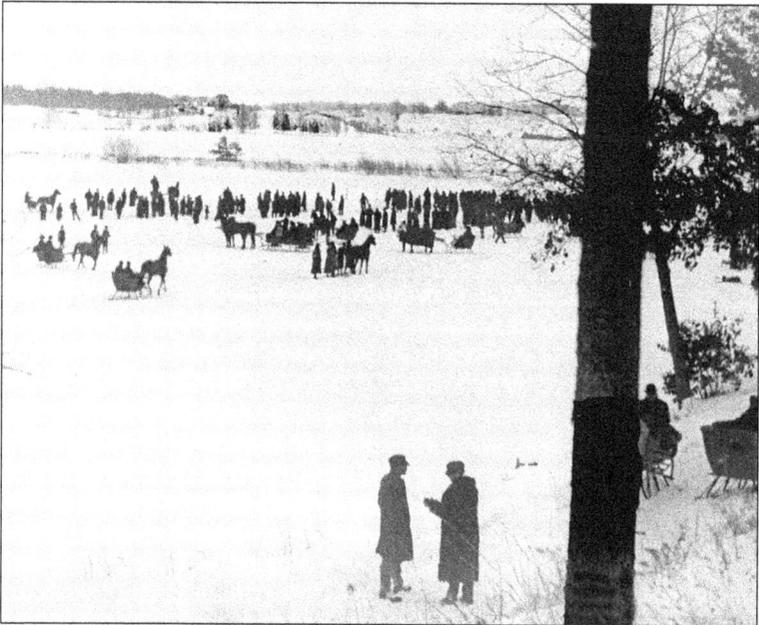

ICE RACES. In the winter, when the lakes were frozen and the ice good and thick, ice fishing, skating, sledding, and horse racing with sleighs were popular seasonal activities.

Eight

FAIRS, FESTIVALS, AND PARADES

Homecomings are an American tradition, providing an opportunity locally for family and friends to return to Howell from around the country to reconnect with people, places, memories, and traditions. They are usually built around a central event such as a county fair, parade, or other celebration.

The golden age of county fairs is considered from 1870 to 1910. Livingston County's fair, which began as an agricultural event, was considered an institution during that same era. The old fairgrounds were located east of town, north of Grand River Avenue, where the current Ann Arbor Railroad tracks are now. The excitement engendered by the annual Howell Fair created wonderful opportunities to bring the community together and highlight peoples' crafts and agricultural skills. Numerous competitions and exhibits were held at the fairgrounds, including livestock (encompassing dairy, poultry, sheep, and swine), midway shows, rides, musical groups, and pie-eating contests. There is nothing like the spirit evoked at a county fair.

Parades have been an integral part of Howell's history from its earliest celebrations of Independence Day and Memorial Day. There is just something about a parade that gets people's attention and causes them to stand at curbside, applauding and cheering as floats and marching bands pass by the crowd. Visual spectacles and loads of excitement are experienced when there is a parade on Grand River Avenue. In the 1890s and early 1900s, floral parades were a local specialty. Stunning floral decorative displays covered carriages, wagons, horses, and later automobiles.

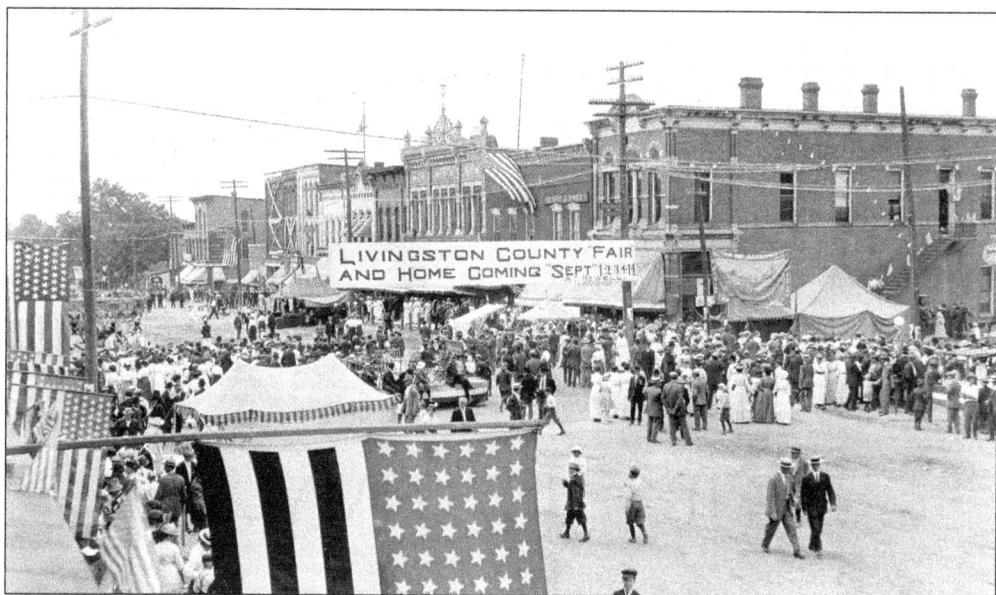

LIVINGSTON COUNTY FAIR AND HOMECOMING. Excitement filled the air, and vendors' tents and booths lined the streets during Howell's September 1914 Livingston County Fair and Home Coming. A bandstand was erected in the middle of Grand River and Michigan Avenues. Both young and old, local folks and visitors spent time strolling the main streets or walking to the fairgrounds to view horse races, livestock, poultry exhibits, and a variety of entertainment.

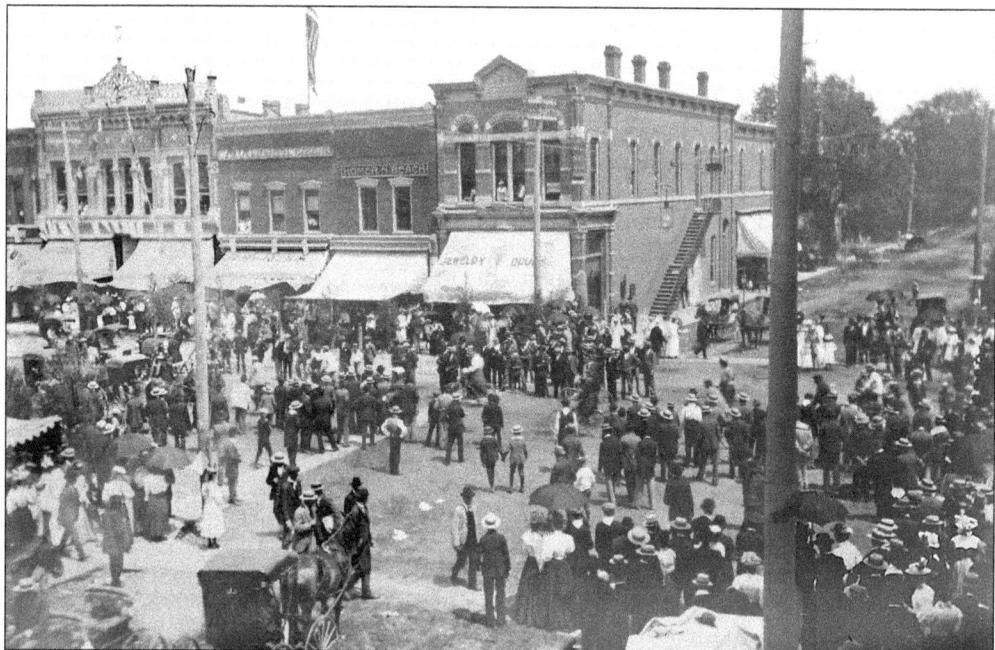

LADIES FLORAL PARADE, 1900. This image was taken at the main intersection of Grand River and Michigan Avenues. At the tail end of the September 1900 Ladies Floral Parade came the bicyclists, numbering at least 10. Spectators watch as women and men pedal westward on Grand River Avenue. Apparently, the men prefer straw hats and the women parasols to keep the hot sun off their heads.

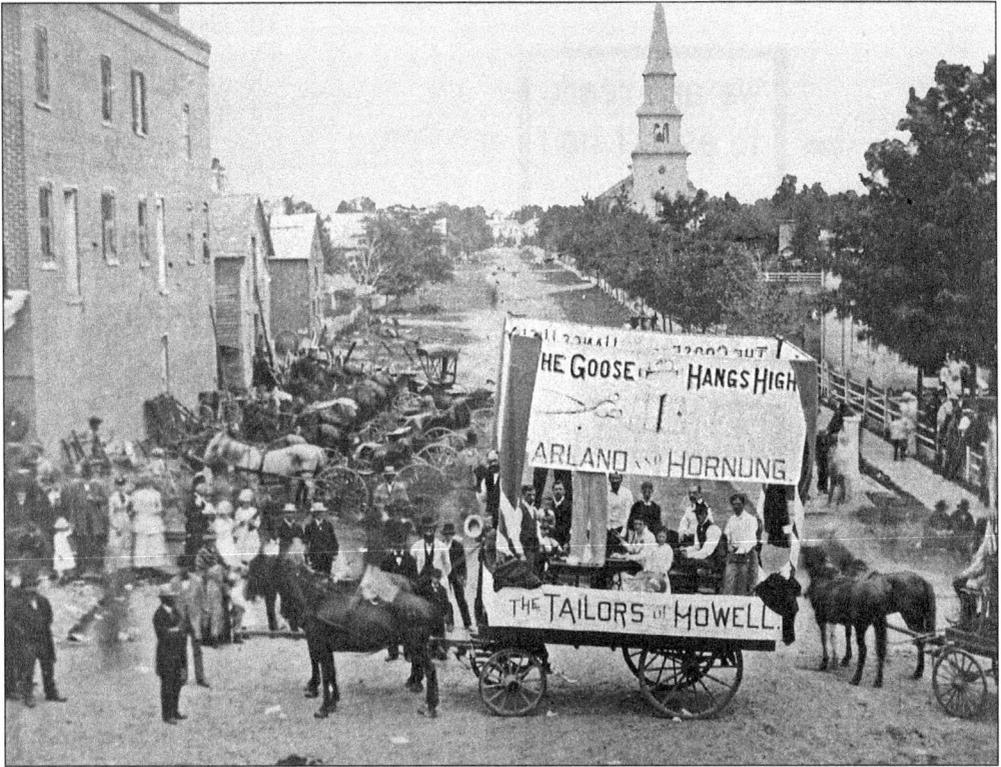

"THE GOOSE HANGS HIGH." 1876 was America's centennial year, and celebrations were held on July 4, Independence Day, in cities, and villages across the country. Howell was no exception, and this image shows one of the floats that participated in the parade. Garland and Hornung were local tailors. The banner "The Goose Hangs High" refers to a 19th-century saying that meant all is well and future prospects are bright. The horses and wagon rest at the intersection of Grand River Avenue and State Street. In the background is the First Baptist Church of Howell, and on the right is the west side of courthouse square.

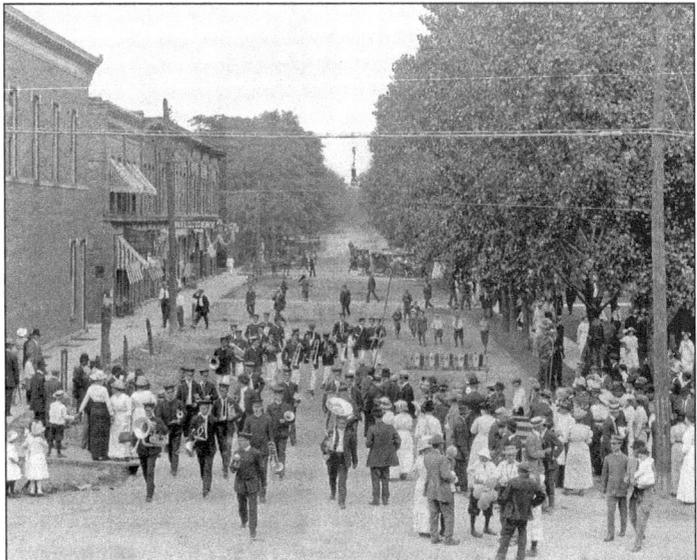

PEANUT ROW. Looking north on State Street at the section known as "Peanut Row," the annual parade, which was an activity of the street fairs, had come to completion when this photograph was taken in September 1910. Two bands that had marched in the parade are carrying instruments while walking toward Grand River Avenue. In the right center, boys are playing a baseball arcade game. On the west side of the street are a millinery shop and restaurant.

THE GREAT STREET FAIR. This wonderful graphic advertises the 1900 Street Fair. There was a parade, music, and attractions, which included a trapeze and tumbling act, hot-air balloon ascensions, and stalls along Grand River Avenue where cattle and sheep were shown. A floral parade, held in the afternoon, was sponsored by the volunteer fire department, local women's groups, and the Knights of the Maccabees.

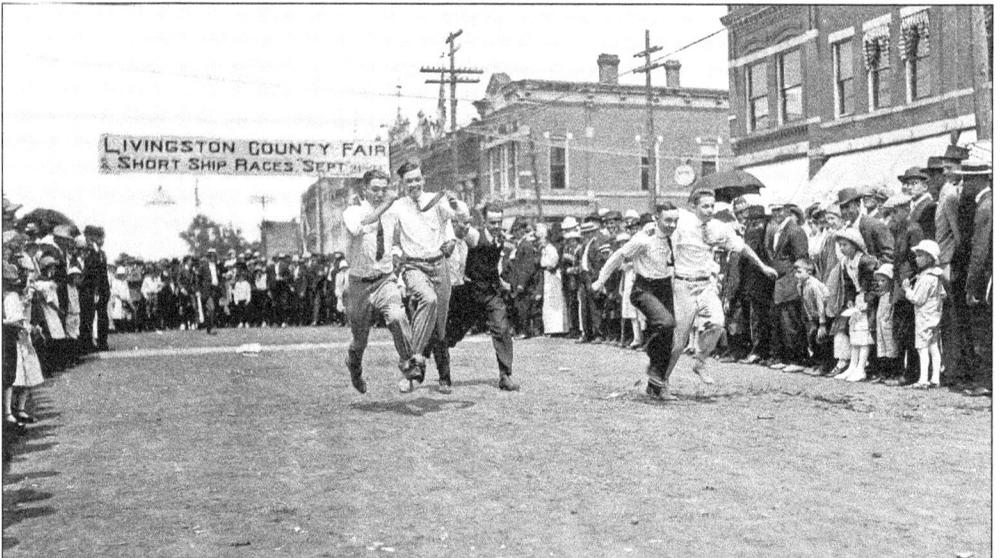

THREE-LEGGED RACES. At the September 1912 Livingston County Fair and Short Ship Races, attractions and activities along Grand River Avenue included sack races, three-legged races, and a race for elderly gentlemen. This image shows several teams of boys, each of whom has a leg tied to his partner, hobbling down Grand River as the crowd cheers them to victory.

LIVINGSTON COUNTY FAIR. The *Pinckney Dispatch* published this advertisement promoting the September 1–4, 1914, County Fair. The fairs were held Tuesday to Friday. Popular events included horse racing, aeroplane flights, agricultural and home exhibits, and an exciting midway with action-packed rides and games of chance.

Next Tuesday is the Grand Opening Day of

The Livingston County Fair at

Howell, Mich., Sept. 1, 2, 3, & 4

DON'T MISS A VISIT TO THIS GREAT INDUSTRIAL, AGRICULTURAL AND HOME EXPOSITION

Racing Program

$2,000 in Purses

WEDNESDAY	THURSDAY	FRIDAY
2:30 Trot	2:19 Pace	2:24 Trot
2:22 Pace	2:16 Trot	2:30 Pace
	2:16 Pace	Free-for-all Pace

DAILY AEROPLANE FLIGHTS
By Bert Williams

CAPT. WEBB'S TRAINED SEALS
MANY MIDWAY ATTRACTIONS

THE BEST HOLSTEIN CATTLE
Exhibit ever seen in the second largest Holstein Cattle County in America.

Family Tickets, good for all four days, cost only $1.50. Single admission tickets 25c

For any information write to

ROY C. HARDY, Secretary
Howell - - - Michigan

BLUE RIBBON. Elijah B. Hasley's team of horses won the highest award at the fair in his division for the team and gig contest.

QUEEN OF THE FAIR. Wearing the sash of county fair royalty, the queen keeps her eyes on the goose and gander at the poultry exhibit. Geese, roosters, and hens feast on corn tossed on the ground. To the left, three young men wear the fashionable white dusters common for anyone driving a car in 1900.

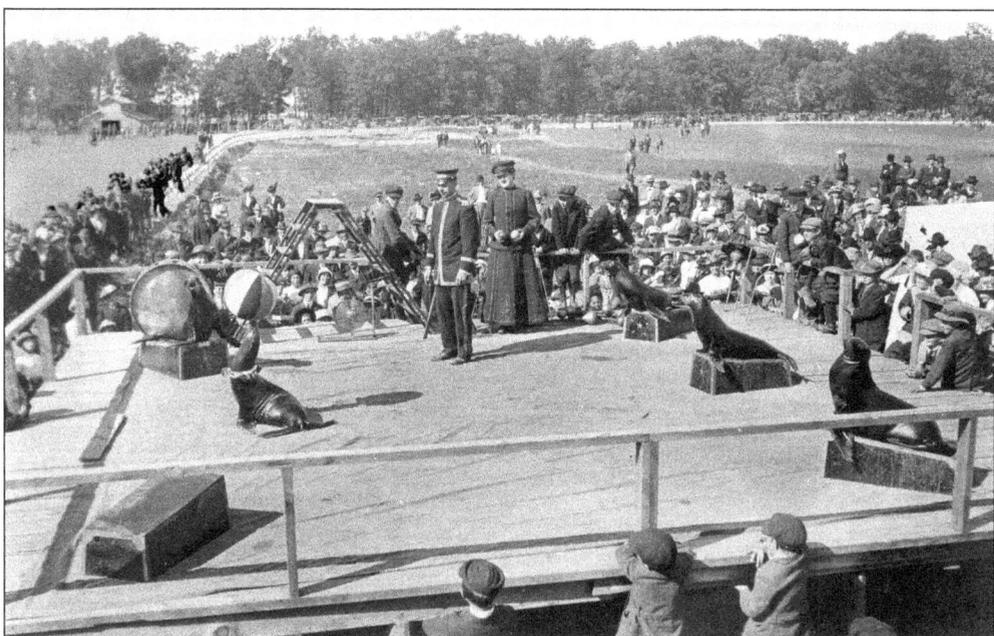

CAPTAIN WEBB'S TRAINED SEALS. Local folks marveled at Capt. Thomas E. Webb's Trained Seals and Sea Lion Band. The seals, which were trained at Tonawanda, New York, performed on numerous instruments, including cymbals, bells, and drums. They also blew into specially constructed horns, balanced drumsticks, carried flaming torches, jumped around, and climbed ladders.

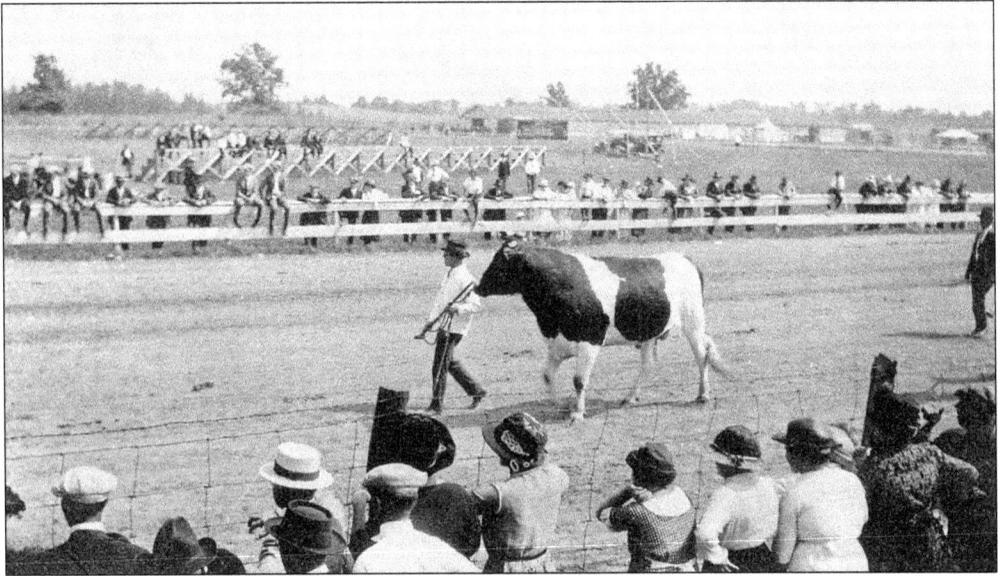

PRIZEWINNING HOLSTEIN BULL. The best Holstein cattle exhibit ever seen locally was in the second-largest Holstein cattle county in America.

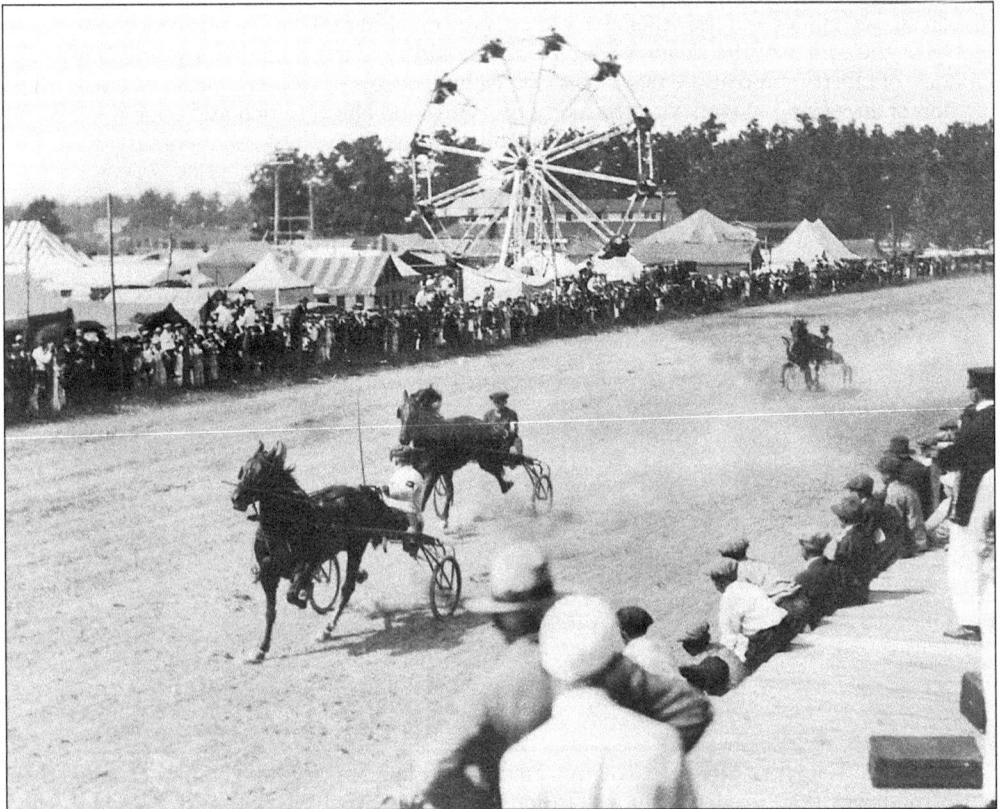

HARNESS RACING AT THE FAIR. Sulkies are two-wheeled carts ridden by the jockey, or driver. The dust is flying as the trotters are on the straightaway and heading to the finish line. In the background, the midway is lined with tents, and a Ferris wheel stands out against the sky.

THE COLUMBIA. The last float in the 1900 floral parade was the "Columbia." The sides of this patriotic float are two immense American flags with stripes of red and white roses and the field of blue with shirred bunting and silver stars. A shield of flowers forms the back. Two young boys, one dressed as a sailor and the other as a soldier, stand on either side of a flower-bedecked cannon placed at the center of the float. A young man dressed as Uncle Sam and a young lady as the Goddess of Liberty stand at the rear of the float. The Goddess of Liberty represents Uncle Sam's mission of dispensing liberty, with the aid of his Army and Navy, to rich and poor alike. A boy in overalls and torn hat represents the poor, and a girl in fancy dress represents the rich. The float is drawn by two white horses trimmed in red and blue.

"SUNFLOWER" RECEIVED THE BLUE RIBBON. Frederick Lee and his wife and family decorated their horse-and-buggy float in such a unique fashion that it won first prize in the 1895 floral-themed parade. The horse and carriage were decorated with a winning "Sunflower" theme. The ladies' parasols and wagon wheels are all sunflower designs. They are posed in front of the Lee home on South Walnut Street.

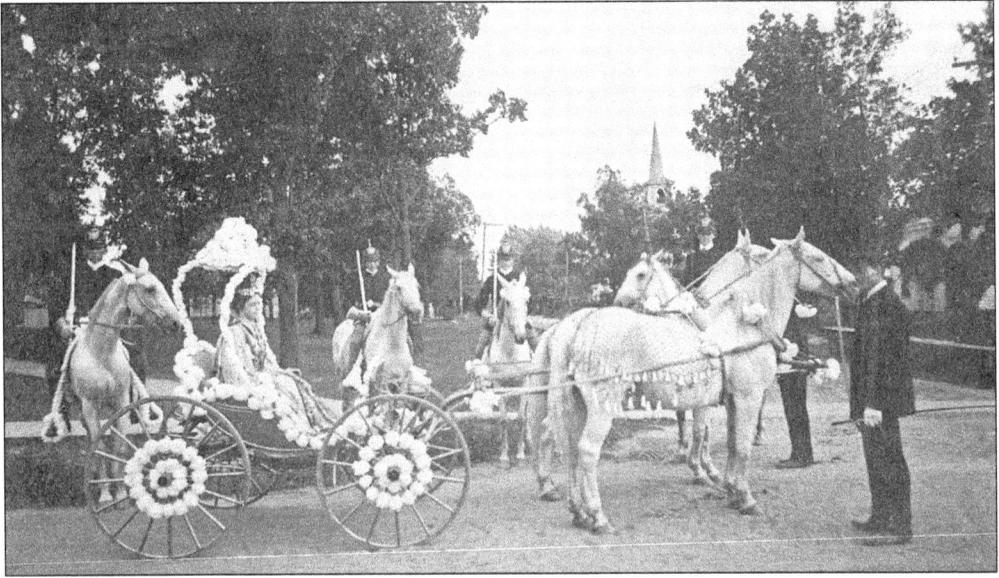

THE QUEEN OF THE 1900 FLORAL PARADE AND STREET FAIR. Julia Benedict rides in an old-fashioned carriage known as a phaeton. The queen is escorted by four uniformed knights on white horses, carrying swords. The body of the phaeton is gilded, lined with royal purple, and trimmed with double white poppies. All the horses are trimmed in purple and white. The two horses drawing the phaeton are accompanied by two footmen. The queen's costume—a white satin gown, white lace overdress spangled with beads, and her crown entirely of beads—was rented from Detroit.

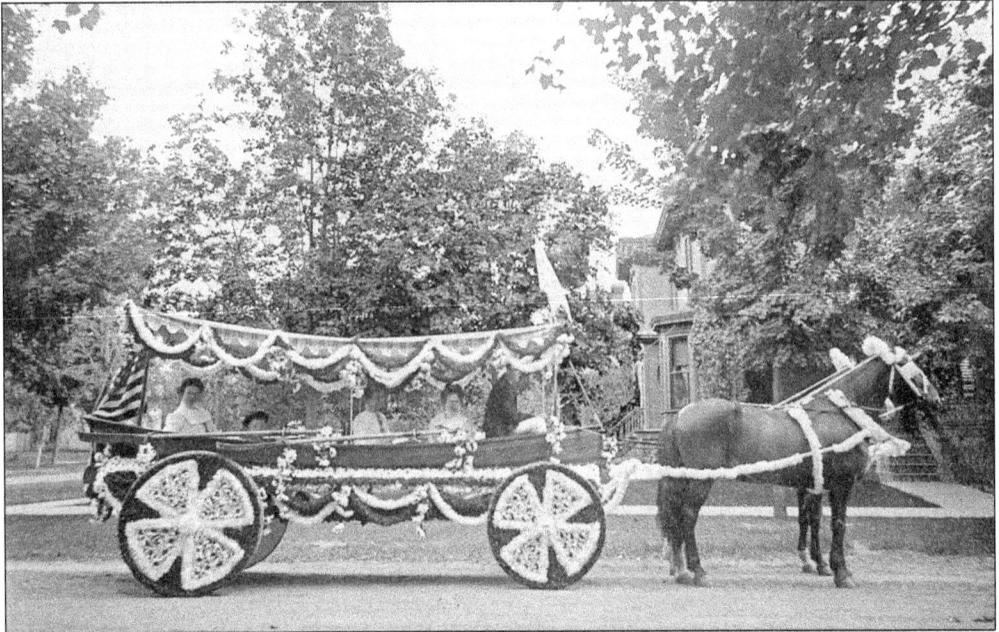

THE HOWELL OUTING CLUB. The club's novel float for the 1898 Street Fair and Floral Parade seen here is a rowboat, placed upon a wagon with an awning as a canopy over the boat. The entire float is richly decorated with pond lilies and a variety of other flowers. On close inspection, the float is a boat complete with two sets of oars. Waving from the bow of the float is the club's silken streamer, and the American flag is flying proudly at its stern.

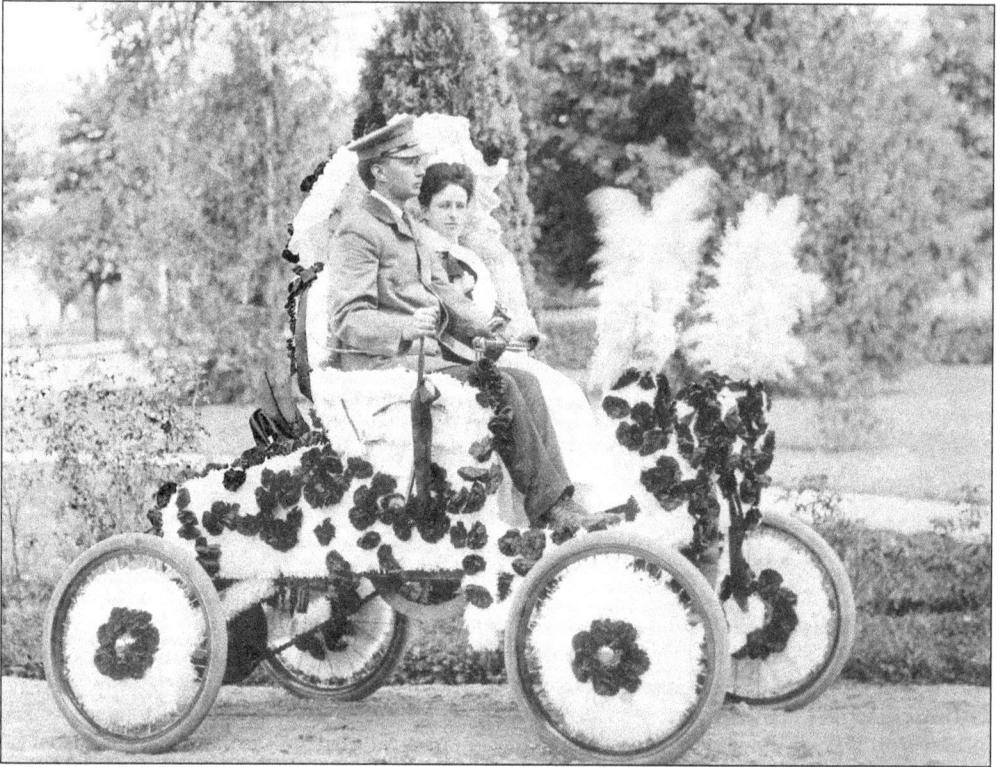

MURRAY RUNABOUT. R.B. McPherson and his wife drive their 1902 Murray Runabout, which is decorated with flowers and feathers, to the annual floral parade. The vehicle was only manufactured for two years and was made by the Church Manufacturing Company in Adrian, Michigan.

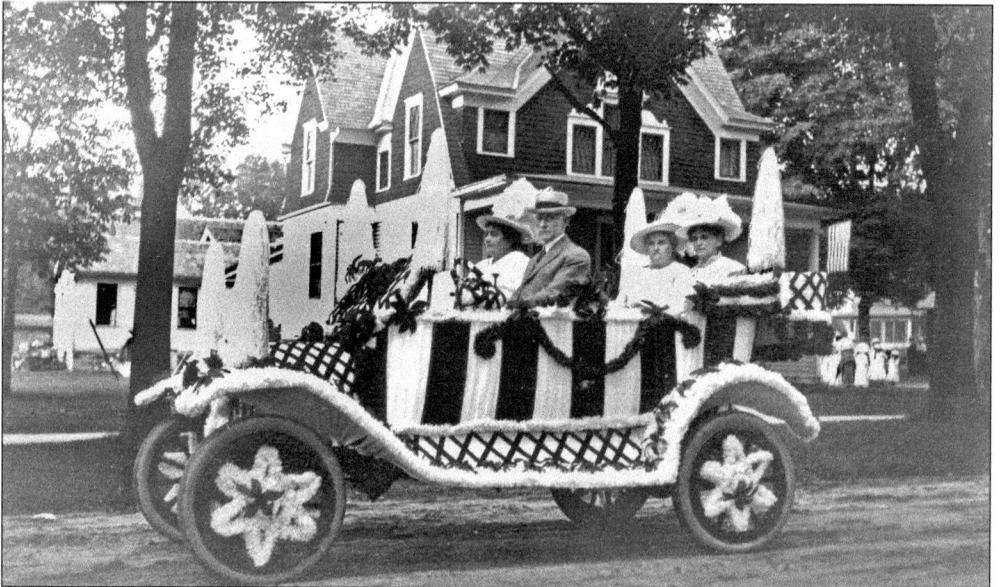

INDEPENDENCE DAY. D.D. Monrill's family car is beautifully decorated with flowers and crepe paper for the July 4, 1915, Independence Day parade. Floral stars are attached to the wheels, and six large pompons dangle from a car that is wrapped in red, white, and blue crepe paper.

Nine

CLUBS AND FRATERNAL ORGANIZATIONS

Since the founding of Howell, many social groups, benevolent societies, fraternal organizations, literary societies, and social clubs have contributed to the culture of the city. These organizations provided opportunities for people with common interests to develop fellowship and friendships. Cultural opportunities have resulted from many of these groups. Philanthropic ventures have resulted in scholarships for young men and women to continue their education. Well-known authors and lecturers have been hosted by these organizations. Howell's women's clubs have been an indomitable force in building the community. The Pioneer Society was organized in July 1871, and membership was based on being a descendant of residents who settled in the area prior to 1855.

The first fraternal organizations in Howell were the Independent Order of Odd Fellows, chartered in 1849, and Masonic Lodge 38, chartered in January 1850. Other groups soon followed, like the Maccabees, Knights of Pythias, and the Good Knights (a temperance organization). Clubs such as the Rotary, Lions, and Jaycees contribute to many community functions and charities. The Ladies Library Association, the Friends of the Library, Howell Garden Club, Questers, Daughters of the American Revolution, Eastern Star, and others are bulwarks of the town. Military veterans' organizations include the American Legion, Marine Corps League, Veterans of Foreign Wars, and Women's Auxiliary. Civil War veterans had their memberships in the Grand Army of the Republic. The Sons of Union Veterans of the Civil War remains an active organization in the community. Boy Scouts, Girl Scouts, Cub Scouts, and Brownies are successful youth groups. Many of these organizations were established as service clubs or were created for voluntary or charitable activities. Others were created and devoted to hobbies, sports, or political and religious causes.

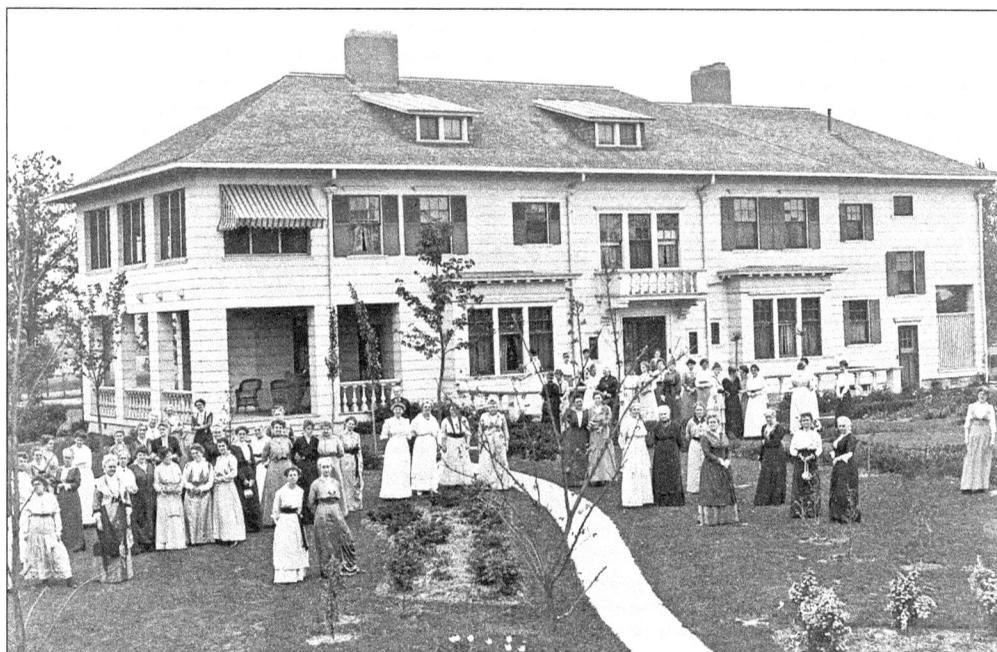

HOWELL WOMEN'S CLUB.
R. Bruce McPherson invited
the Women's Club to celebrate
the completion of its new home
in 1915. The club, established
in 1891, was instrumental in
establishing a local library. The
women of this organization
provided the funding for
the Library Fountain, a
cherished fixture on the lawn
of the Carnegie library.

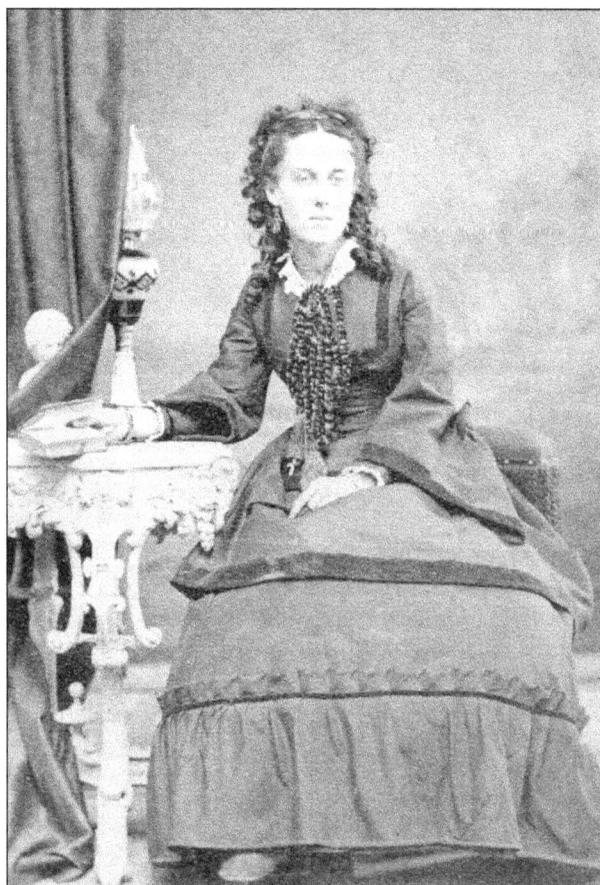

HARRIET RANNEY GAY. The
wife of Milo L. Gay, Harriet was
elected as the first president of the
Howell Women's Club. Shown
here in a 1860s carte de visite
image, Harriet also served as
the first president of the Ladies
Library Association in 1875.

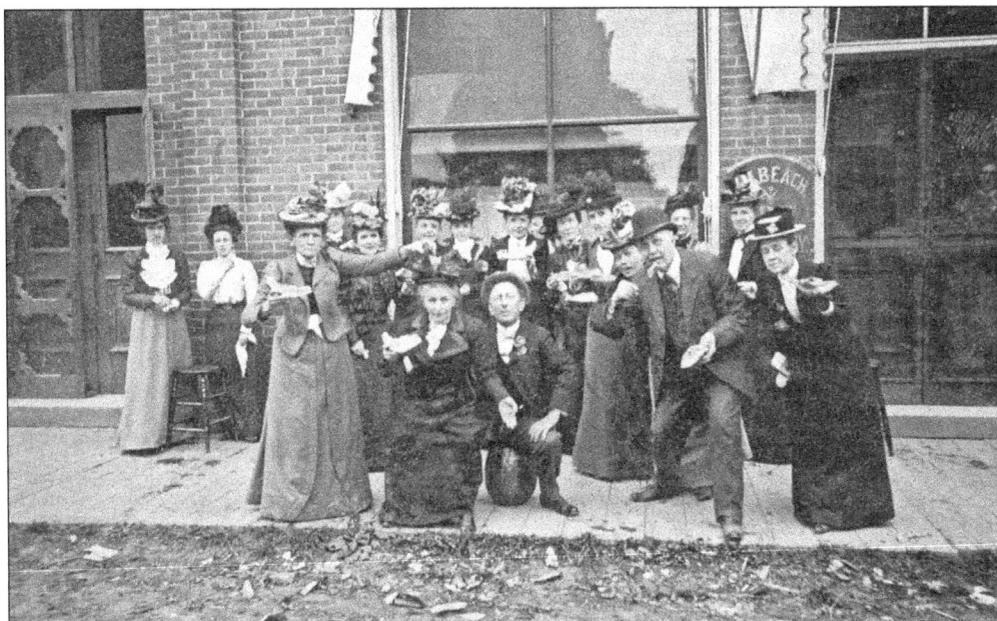

DAUGHTERS OF THE AMERICAN REVOLUTION. The Philip Livingston Chapter of the Daughters of the American Revolution received its charter on April 19, 1909. The names on the charter include Martha Emilie Beach, Cordelia Elizabeth Sexton Bullock, Grace E. Knapp, Addie Monroe Garland, Maude Kneeland Gough, Adaline W.L. Huntington, Alice A. Lee, Isabel McPherson, Rosa Lee McPherson, Florence Knapp Rumsey, Lucretia E. Smith, and Kate Smith Stowe. This image, taken in 1905, includes a number of ladies who would join the DAR. They are enjoying the sweet flavor of a summer watermelon in front of William M. Beach's millinery store.

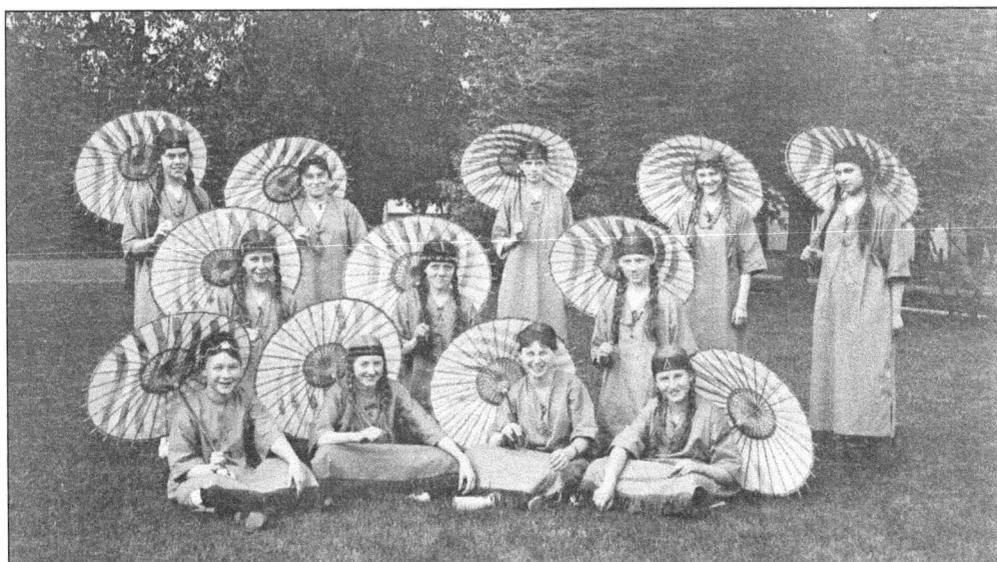

CAMP FIRE GIRLS. Gathered on the Carnegie library lawn after the June 14, 1915, Flag Day activities, Camp Fire Girls have their picture taken with their parasols, which have American flag designs and their Native American dresses, headbands, and pigtails. Founded in 1910, Camp Fire Girls was the first nonsectarian organization for girls. It emphasized camping and outdoor activities. The club's watchword was "Wohelo," which stands for "*work, health,* and *love.*"

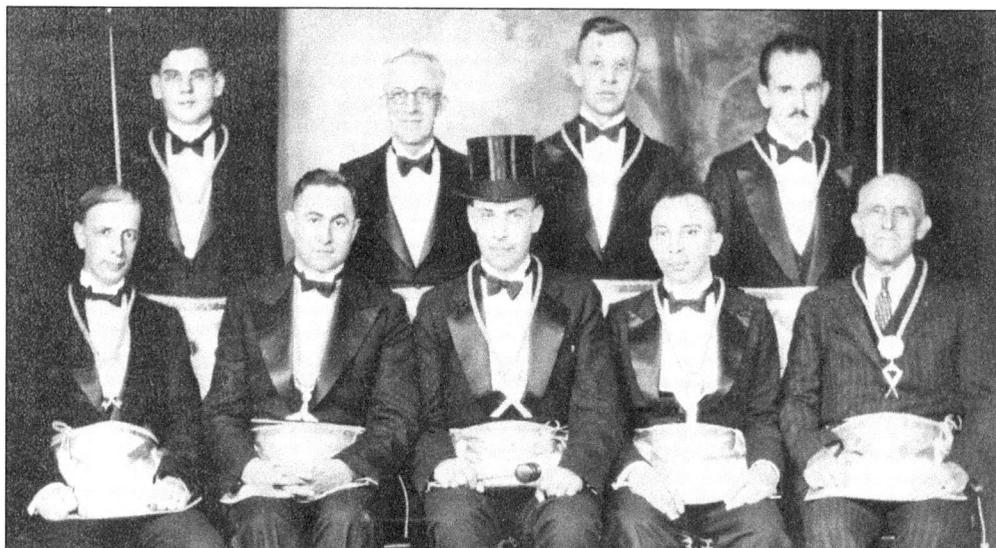

MASONIC LODGE NO. 38, F&AM. This lodge was chartered in January 1850. In 1929, the year of the disastrous stock-market crash and the beginning of the Great Depression, Berthold Woodhams served as the worshipful master of Howell Lodge No. 38, F&AM. His officers include, in front from left to right, Albert Smith, treasurer; Ernest A. Ross, senior warden; Bert Woodhams, worshipful master; Clark H. Pasmore, junior warden; and Eugene A. Stowe, secretary. In the back row on the left is Harold D. Chubb, and on the right is Earl Adams.

ORDER OF EASTERN STAR, CHAPTER 372. This image was taken on the occasion of the installation of the 1911–1912 officers for OES Chapter No. 372, which was chartered in 1908. The officers include, from left to right, (first row) Mattie Hamilton, Edith Wines, and Grace Knapp; (second row) Mary Howe, Edith Greene, Ed Beach the Worthy Patron, Rosedal Lansing the Worthy Matron, and Mabel Beach; (third row) Carrie Winegar, Rhua Peavy, Laura Wright, Mary Payne, Grace Bush, Grace Goodnow, Hester Woodruff, Maude Gough, and Frane Hardy. This chapter of Eastern Star celebrated its centennial in 2008 and continues to provide financial support to Michigan's Masonic Home at Alma, scholarships for local students pursuing higher education, and many local charities.

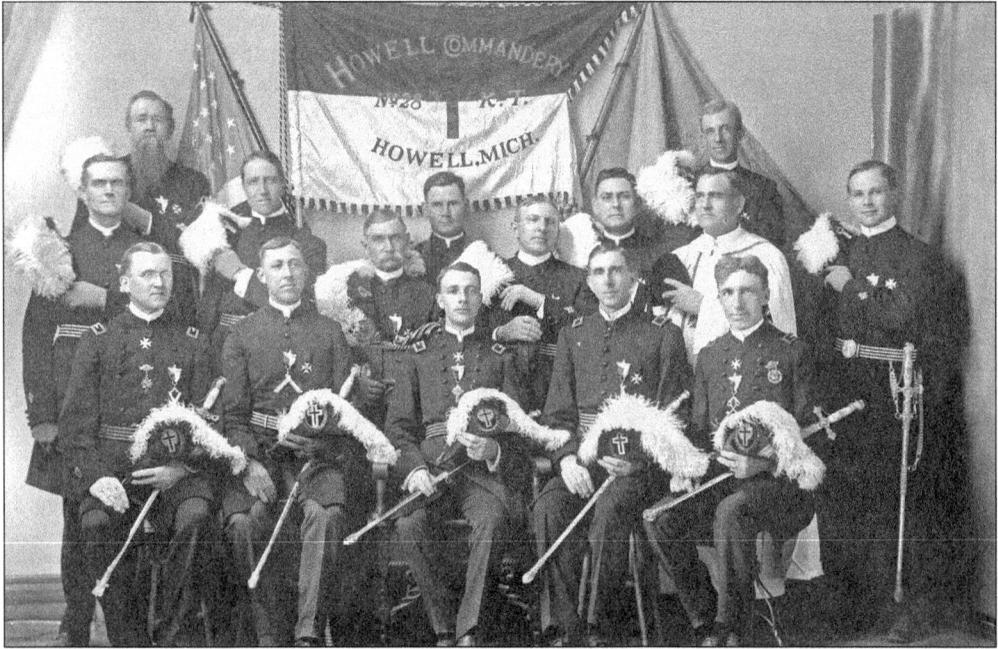

HOWELL COMMANDERY NO. 28. Chartered on April 7, 1870, this Masonic order was extremely active in Howell. Wearing their plumed chapeaus and carrying their swords, members marched in parades, participated in drill competitions, and in 1913 sponsored a statewide conclave in Howell. In this photograph, their commander is Albert Smith (front row, center).

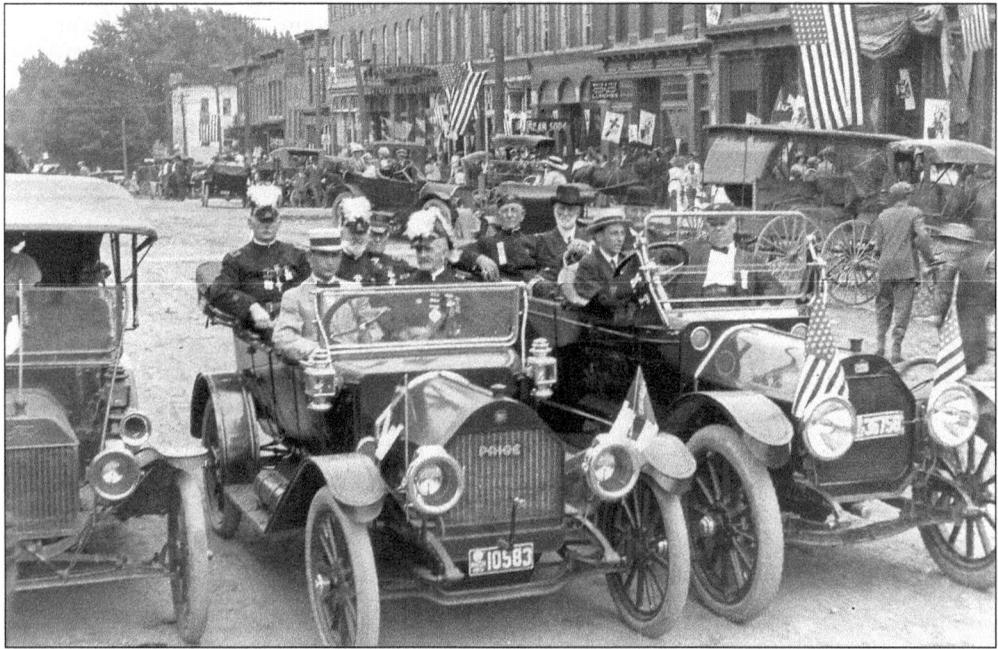

KNIGHTS TEMPLAR CONCLAVE, 1913. This image was taken near the intersection of Grand River and Michigan Avenues and shows members of the commandery being driven through town. The car in the center, driven by Elmer Smith, is a 1912 Paige. The car on the right is being driven by Henry Spencer.

CLEAVE, HOWELL.

SONS OF UNION VETERANS OF THE CIVIL WAR. Created in 1881, the Sons of Union Veterans organized Waddell Camp No. 14 in Howell. This photograph, an 1880s cabinet card, shows a local member wearing his 1881 membership badge, which is hanging from a red, white, and blue ribbon. (Courtesy of Glen Fincham.)

COURTHOUSE STEPS. Posed on the steps of the courthouse, this group of 1890s well-dressed young gentlemen includes, from left to right, (front row) Bob Gifford, Bert Newell, Ned Cavell, unidentified, and James Van Kuren; (back row) John McPherson, Will Porter, two unidentified, and Rex Gilbert.

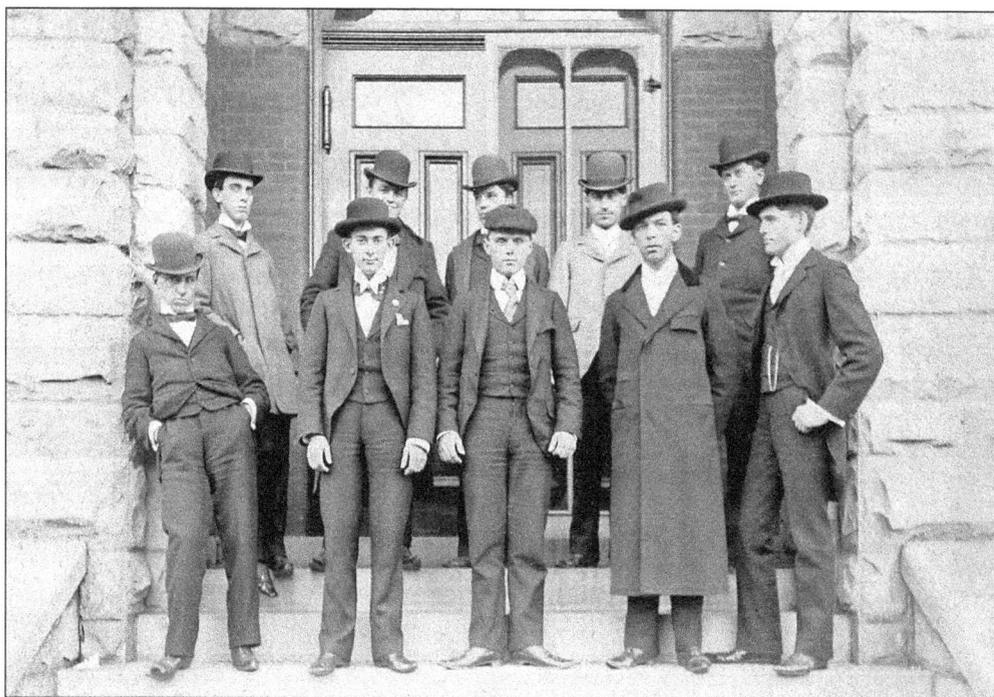

HOWELL DRIVING CLUB MEMBERS. Gathered for a group portrait, members of the Driving Club have finished their midday repast, lit their cigars, put on their coats and hats, and are prepared to leave the Livingston Hotel's restaurant for a Sunday afternoon drive through the county. On Sunday afternoons in 1917, the Howell Driving Club assembled in front of the Carnegie library for summer excursions through Livingston County. The club members drove in groups on local country roads and assisted each other if a flat tire needed repairing, mechanical or engine problems occurred, or if a vehicle was stuck in a ditch.

ROTARY. Chartered on May 5, 1924, past presidents of the Rotary Club had their photograph taken at their 25th anniversary celebration and dinner in 1949.

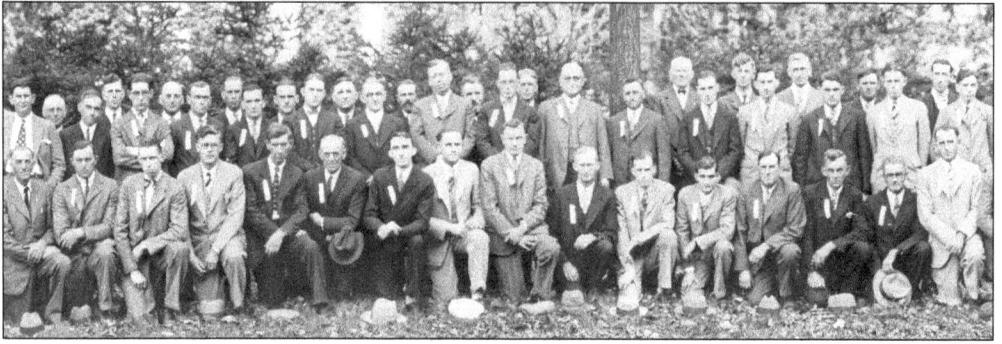

KNIGHTS OF COLUMBUS. This illustrious organization was formed in 1927, and the first group of Howell men initiated into this order, the class of 1927, contained 55 members. This Catholic fraternal organization, the Knights of Columbus, John R. Daly Council No. 2659, raises funds for local charities.

LIONS CLUB. The Howell Lions Club was chartered on May 15, 1939, and Russell D. Woodruff served as its first president. In this 1950s photograph, club members perform in a minstrel show at the high school. Minstrel shows were a popular form of entertainment in the 19th century and in the first five decades of the 20th century. Lions Clubs are dedicated to helping the visually impaired and the blind. The Lions' Leader Dogs for the Blind program is well known throughout Michigan.

Ten

THE BOLD HEARTED

A legacy of war, bravery, and sacrifice is woven into the fabric of the Howell community. During the Civil War, Livingston County sent 1,166 men to serve with Union armies. Local men first shed their blood in Virginia's Peninsula Campaign. The first Howell casualty was John V. Gilbert of Company I, 5th Michigan Infantry. Gilbert survived his wounds and later joined the Fifth Michigan Cavalry serving as a saddler. After the war, he returned to Howell, working as a harness maker. Local men fought and were wounded or killed on the fields at Fredericksburg, Gettysburg, Vicksburg, and Atlanta and some died at Andersonville Prison camp.

In 1898, the Spanish-American War erupted, and again Howell men answered the nation's call to arms. Men like Judge Willis Lyon served in Cuba, where he contracted yellow fever, which almost took his life. In 1917, when the country went to war with Germany, once again men and women responded to President Wilson's appeal for soldiers. Many young men volunteered to serve, and others were drafted into the armed forces. Twenty-six Livingston County men died in that conflict. Hundreds of Livingston County women and men joined the Red Cross and worked on the home front to provide assistance where needed.

World War II began on December 7, 1941, when American forces were attacked at Pearl Harbor. During the four years of war, hundreds of Livingston County men and women answered the call of their nation and served in that conflict. In 1950, soldiers from Howell were sent to Korea, and a decade later boys from the community were fighting in the rice paddies of Vietnam.

In the recent wars in Kuwait, Iraq, and Afghanistan, Howell's courageous sons have been required to stand on the front lines of freedom and serve the nation. In each of these conflicts, local soldiers have shed their blood—and some have made the supreme sacrifice.

Those who have died have their names inscribed on the soldiers' monument on the grounds of the Livingston County Courthouse. People are encouraged to go to the corner of Grand River Avenue and State Street and visit monument, read the names of Howell's heroes, say a prayer, and give thanks to those who protect this country's freedoms.

Lt. Hudson B. Blackman. On June 19, 1861, Henry Blackman entered service at age 29 as a 1st lieutenant in Company I, 5th Michigan Infantry. He served as regimental quartermaster and was promoted to brevet major in the US Volunteers at the end of the war. In 1867, Blackman built a home at 507 Barnard Street and became a partner in the Howell Foundry. He was a member of the First Presbyterian Church of Howell and in 1878 became a charter member of Howell's Shooting Club. Blackman died in May 1896 and is buried at Lakeview Cemetery. (Authors' collection.)

Capt. Andrew J. Itsell. Following graduation from normal school, Andrew J. Itsell enlisted in the 1st Michigan Sharpshooters. He later received a captain's commission and command of Company K, 10th Michigan Cavalry. Two brothers, Stephen and Paul, also served with him. After the war, Itsell moved to San Francisco, California, where he married, became a professor of education, and fathered two daughters. (Courtesy of the Massachusetts Commandery Military Order of the Loyal Legion and the US Army Military History Institute.)

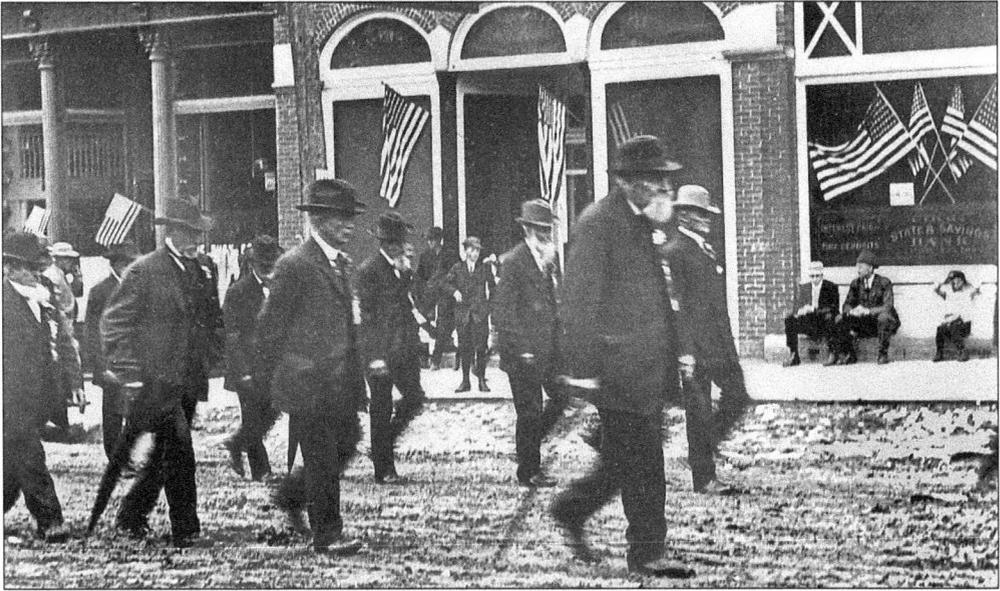

CIVIL WAR VETERANS, 1914 PARADE. Memorial Day was traditionally commemorated on May 30, and early in the morning streets, homes, and businesses throughout Howell put on a patriotic appearance. Flags were at half-mast, and every nook and corner of the village was decorated with the national colors. Floral arrangements and wreaths intended to decorate veterans' graves were frequently taken to the GAR Hall, which was located over Sweet and Newell's store on Grand River Avenue.

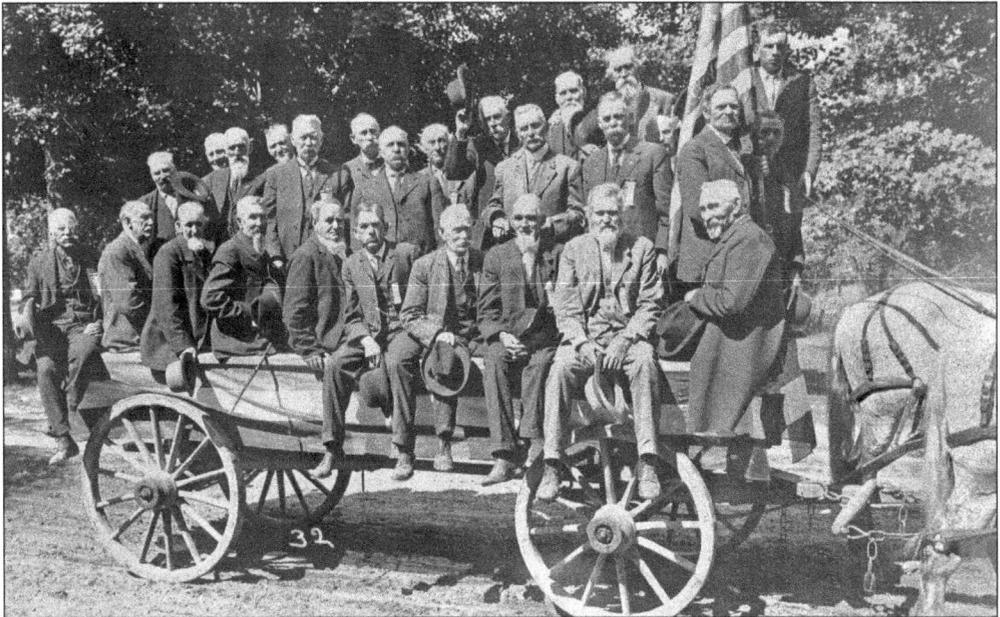

VETERANS OF THE CIVIL WAR. Old soldiers proudly holding the flag of Howell's Waddell Post No. 120, Grand Army of the Republic, climbed aboard this wagon in September 1898 for Howell's floral parade. Their GAR post was named for Lt. Andrew D. Waddell, who recruited local men to serve in Company I, 5th Michigan Infantry. Many of these veterans decorated the graves of their comrades on Memorial Day.

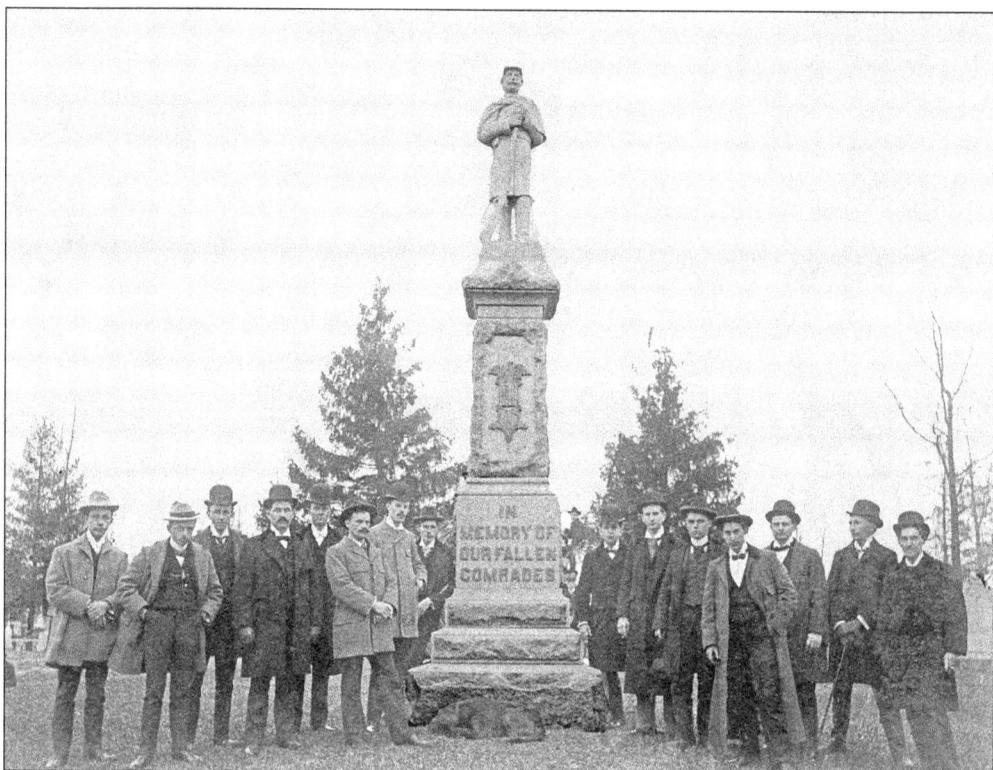

CIVIL WAR MONUMENT. The unveiling and dedication of Howell's monument to Civil War veterans took place on Memorial Day, May 30, 1895. The soldier atop the statue stands at rest and looms large and ever vigilant at the entrance to Lakeview Cemetery. Members of the Grand Army of the Republic, the Women's Relief Corps, and Sons of Union Veterans of the Civil War marched behind Howell's Cornet Band to the cemetery for the patriotic ceremony. The keynote speaker was Detroit's mayor and Michigan's future governor Hazen Pingree. Half the men in this photograph are identified and include, on the left, Ed Garland and Bruce Hickey. James Van Keuren leans against the monument. On the right side from left to right are Will Brooks, two unidentified, Bert Newell, Ed Shields, Bruce McPherson, and Percy Dudley. (Authors' collection.)

IN MEMORIAM. When a local veteran died, members of the GAR post wore black funerary ribbons, with an American flag (missing on this ribbon) below the eagle. The ribbons were printed and decorated in silver and were a testament to the service of their comrade. In August 1891, the Grand Army of the Republic held its 25th national encampment in Detroit. More than 30,000 veterans of the Union armies attended this event. Marching in the grand parade, 50 members of Howell's Waddell Post No. 120 were led by the Howell Junior Band. Howell veterans attending the encampment wore white ribbons printed with the GAR badge. Livingston County provided 1,166 soldiers who fought for the preservation of the Union. (Courtesy of Dick and Mary Hutchins.)

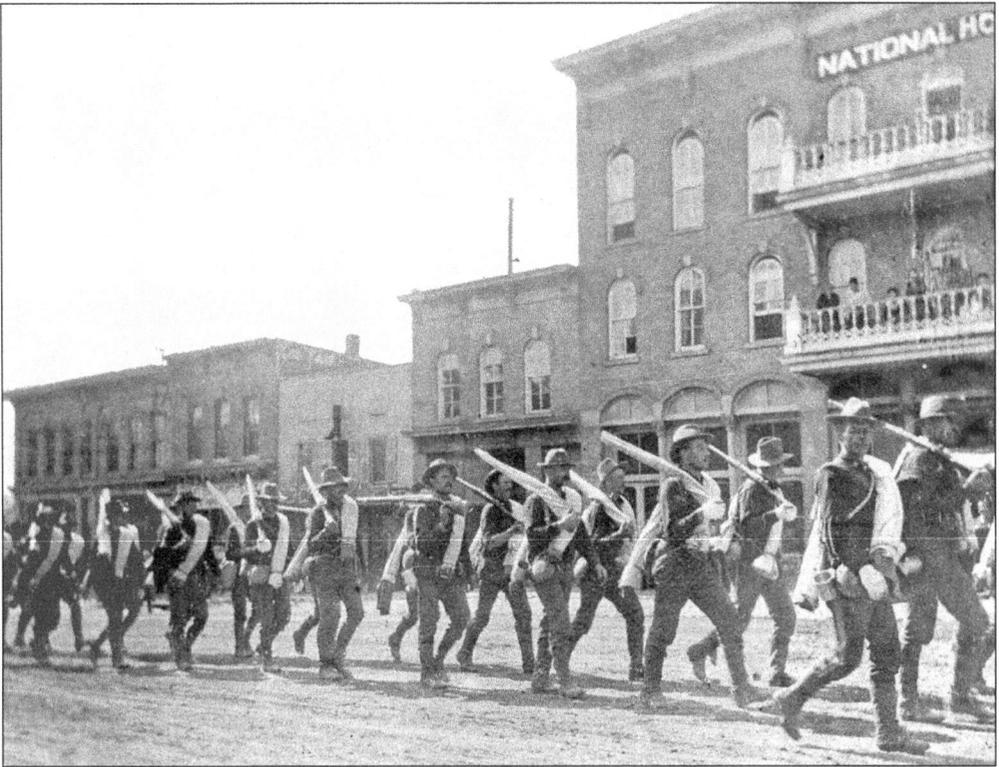

SPANISH-AMERICAN WAR. In 1898, the nation went to war against Spain. Local men volunteered for military service and received training at Island Lake, near Brighton. In this image, soldiers are marching past the National Hotel on Grand River Avenue. On June 11, 1900, shortly after the war ended, Adm. George Dewey and his wife, Susan, paid a brief visit to Howell. Schools were dismissed, and many students and residents marched behind a local band to the Pere Marquette Depot, where Mrs. Dewey threw flowers to the crowd.

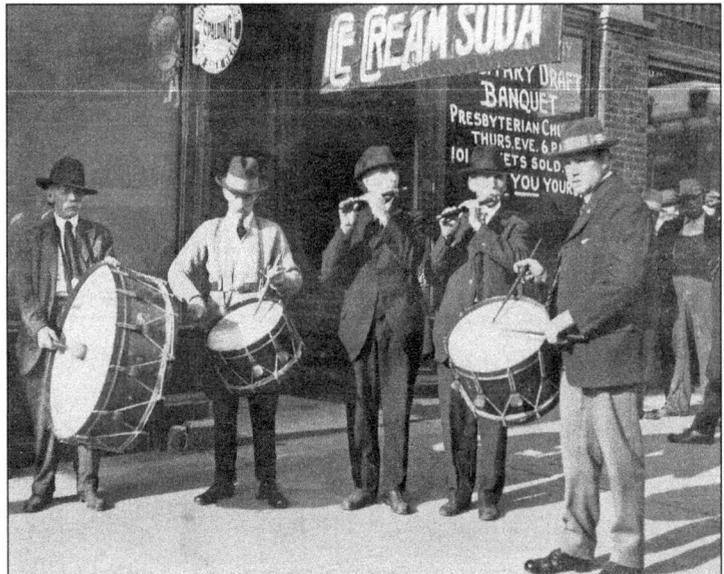

FIFERS AND DRUMMERS. Veterans of the Civil War and members of the GAR Waddell Post No. 120 play fifes and drums to rally support for the military draft banquet at the First Presbyterian Church of Howell. The identified musicians are Harvey Brockway (far left), Bill Trowbridge (second from left), and Charles Ayres (third from left).

RED CROSS LADIES. Standing in front of James Montgomery Flagg's famous recruiting poster depicting a pointing Uncle Sam with the caption, "I Want You," are local Red Cross volunteers. They include, from left to right, Henry Beurmann, Agnes Shuter, Sue Barnes, Edna Young, Nellie Hickey, Grace Gilbert, and Mrs E.G. Pipp. The local Red Cross was organized on April 16, 1917.

Important! - - Immediate !

WAR! WAR! WAR! WAR!

RED CROSS MEETING TO-NIGHT

Tuesday, June 19, 1917

AT

Howell Opera House

SPEAKERS FROM DETROIT
All Come. Don't Fail.
Overflow Meeting if Necessary.
Be a Unit for a Multitude.
Help Quickly. Help All.

HELP NOW - - - TO-DAY

RED CROSS BROADSIDE. This flyer announces a meeting to support the soldiers in World War I to be held at the Howell Opera House on Tuesday, June 19, 1917. War had been declared.

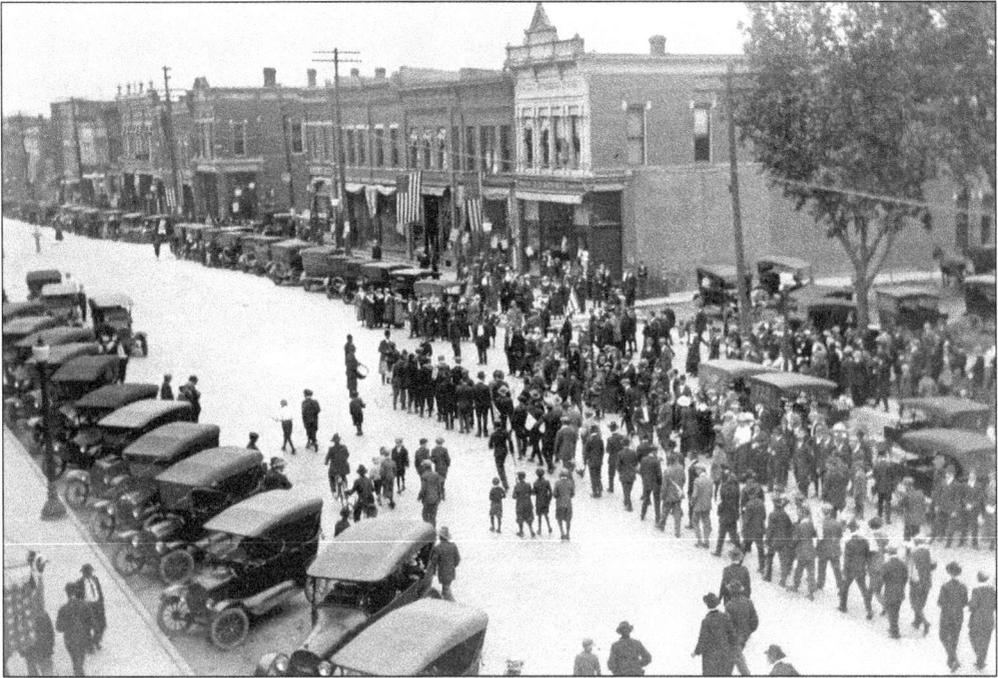

RECRUITS MARCHING TO THE COURTHOUSE. The Selective Service Act was passed on May 17, 1917, and required all men between the ages of 21 and 35 to register for the draft. Led by fife and drums, this column of men marched to the Livingston County Courthouse to be inducted into the Army.

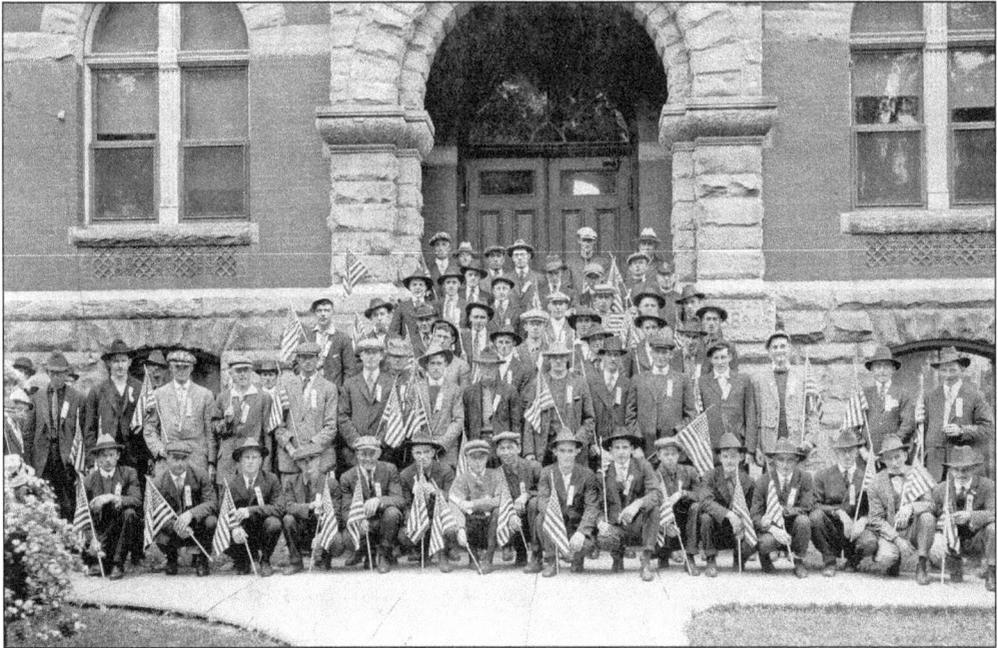

WORLD WAR I. Patriotically posed in front of the courthouse on May 29, 1918, this is the second group of Livingston county men recruited into the Army. Each man shows his patriotism by holding an American flag and is ready to go fight in the "war to end all wars."

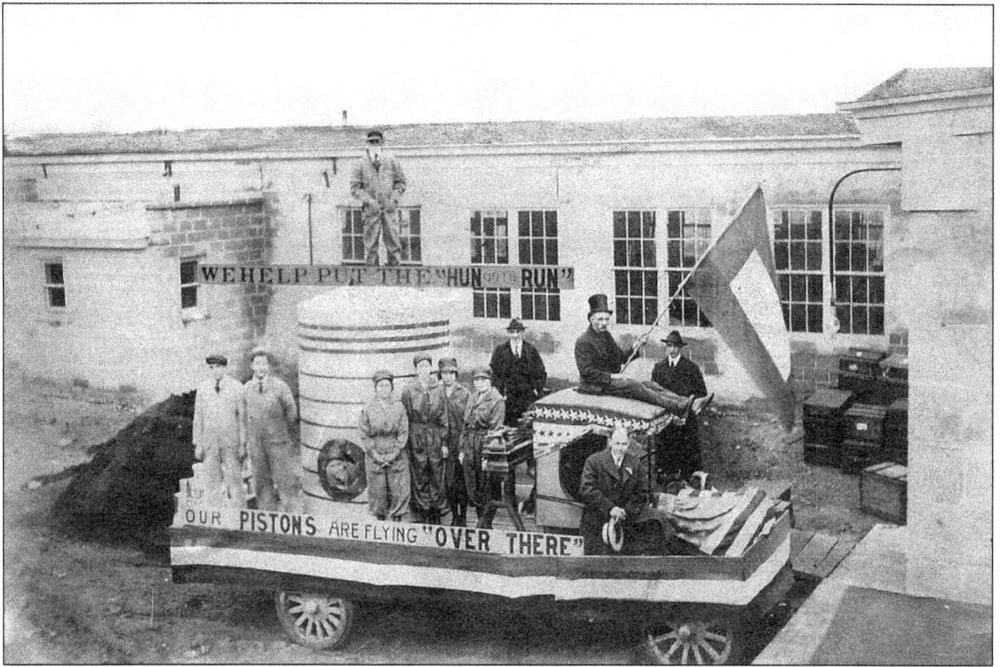

WORLD WAR I VICTORY PARADE. This decorated float is from a local factory that manufactured pistons for cars, trucks, and airplanes used in the Great War. On the float are banners stating, "We Helped Put the Hun on the Run" and "Our Pistons are Flying 'Over There.' "

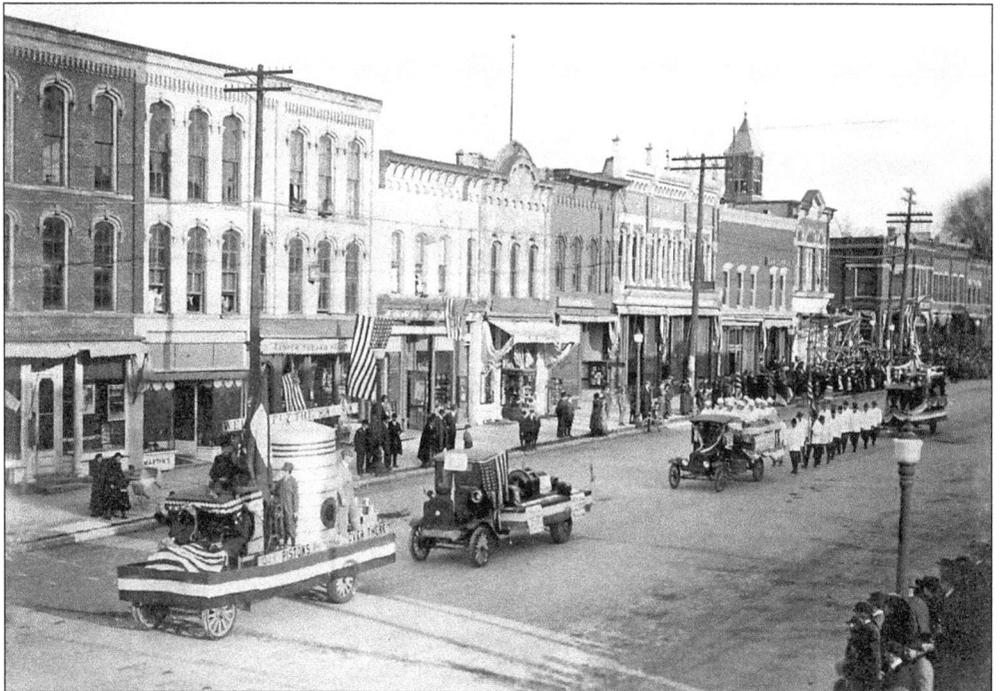

VICTORY PARADE. The Great War ended on November 11, 1918. A grand parade was held to celebrate the victory over Germany. This photograph shows several floats, marching units, and bands passing in a westerly direction on Grand River Avenue.

SCRAP HARVEST. Howell's October 1942 community scrap pile was part of a national effort to provide resources for the war effort. In October 1942, the US War Production Board spearheaded a scrap drive with a goal of gathering 17 million tons of metal for use in the Allied effort against the Axis powers. National, state, and local governments organized and promoted scrap drives to cover shortages in basic materials such as metals, rubber, and paper.

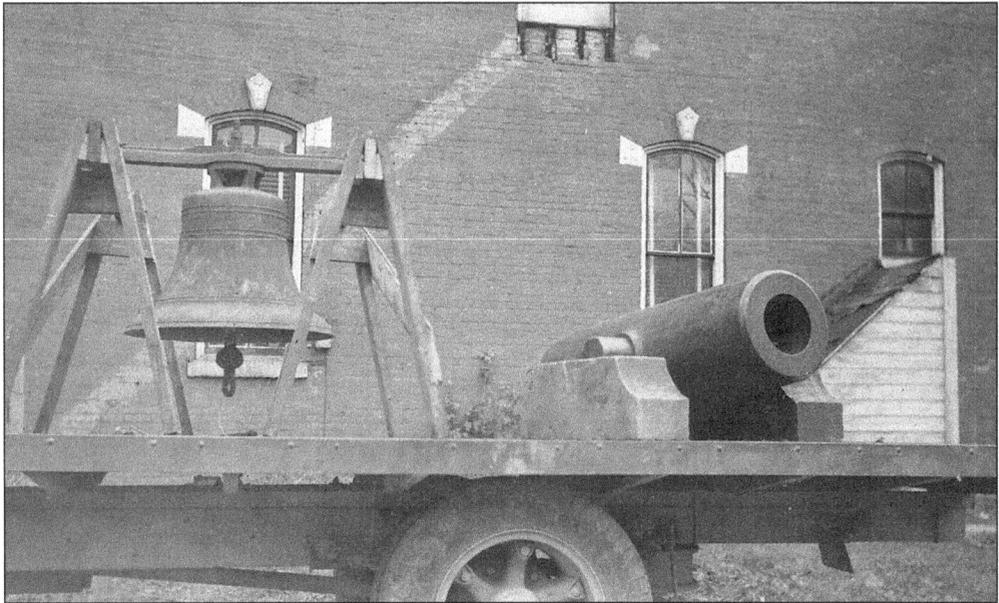

FIRE BELL AND CANNON. It was decided to sacrifice the historic Civil War cannon and original 1847 courthouse bell to the October 1942 scrap drive. When the original courthouse was razed in 1887, the bell was saved and mounted and placed inside the bar railing of the circuit courtroom. The search for scrap metals led to the old cannon, bell, and other relics in the county.

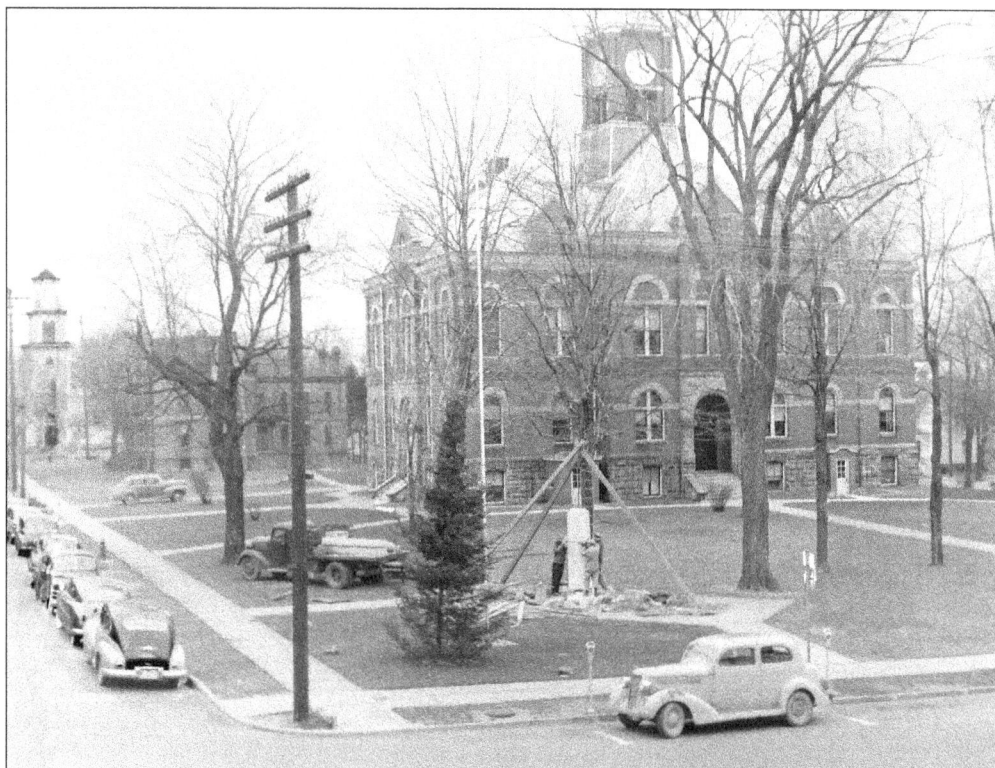

LIVINGSTON COUNTY'S WAR MEMORIAL. With the end of World War II, Livingston County supported the construction of a monument that would memorialize the names of local men who made the supreme sacrifice. The monument is dedicated to those who fought and died to preserve Americans' freedoms. Taken in 1948, this photograph shows workers setting the center memorial stone at the southwest corner of the courthouse square.

ARMED FORCES DAY, MAY 19, 1951. Local soldiers of the Heavy Mortar Company, 125th Infantry Division, are pictured at the Howell National Guard Armory located on Grand River Avenue next to the Howell Movie Theater.

BIBLIOGRAPHY

City of Howell. *Sesquicentennial Walking Tour Committee. A Walk Through Time. Seven Walking Tours of Howell, Michigan.* Howell, MI: Haviland Printing and Graphics, 1988.

Crittenden, A. Riley. *A History of the Township and Village of Howell, Michigan.* Howell, MI: Livingston Tidings Print, 1911.

Ellis, Franklin. *History of Livingston County, Michigan.* Philadelphia: Everts & Abbot, 1880.

Hutchins, Richard G. *Howell Goes to War, 1861–1865.* 2006.

Jaehnig, David L., ed. *The Howell Bicentennial History.* Howell, MI: the American Revolution Bicentennial Committee, City of Howell, 1975.

———. *The Howell Bicentennial History Photographic Supplement.* Howell, MI: the American Revolution Bicentennial Committee, City of Howell, 1975.

Miller, Alice, Susan Reifert, and Emma Weingarner, eds. *100 Years of DAR With the Philip Livingston Chapter.* Howell, MI: Philip Livingston Chapter, NSDAR, 2008.

Payne, Kenneth M. *The Honor Roll of Livingston County, Michigan, U.S.A. 1917–1918–1919.* Brighton, MI: The Brighton Argus, 1920.

Smith, Elisha H. *The History of Howell, Michigan.* Lansing, MI: John A. Kerr and Company, 1868.

Visit us at
arcadiapublishing.com